C/R/E/A/T/I/V/E
newsletters
& annual reports

designing information

ROCKPORT

First published in the United States of America by:

Rockport Publishers, Inc.
33 Commercial Street
Gloucester, Massachusetts 01930-5089
Telephone: (978) 282-9590
Facsimile: (978) 283-2742
www.rockpub.com

ISBN 1-56496-761-1
10 9 8 7 6 5 4 3 2 1

Designer:
Tinker Cavanagh
TinkerDesign

Cover Images on pages:
24, 31, 47, 58, 59, 70, 71, 97, 117, 140

Printed in China.

C/R/E/A/T/I/V/E
newsletters
& annual reports

ROCKPORT PUBLISHERS

designing information

A/ C/ K/ N/ O/ W/ L/ E/ D/ G/ M/ E/ N/ T/ S

Thank you to all the designers, editors, and publishers who allowed us to get inside their heads and catch a few creative thoughts as they zipped by.

A special thank you to Darlene D'razzio. Without her help, phone calls, organizational skills, and creative input, we never would have finished.

—Rita Street and Roberta Street

C/O/N/T/E/N/T/S

F/ O/ R/ E/ W/ O/ R/ D

Information is as valuable as gold. However, information in publications doesn't have to be dull, boring, or downright indecipherable. Desktop publishing has changed all that.

With the advent of design software that includes prepress features, today's artist controls the creative process. No longer tied down by the laborious process of mechanical paste-up, artists can spend their valuable time doing what they do best—building beautiful, fanciful, engaging work that actually sells data to readers.

Along with all this freedom, however, has come a growing stage—a stage that definitely rates form high above content. For *Designing Information*, we've found digital designers who cherish the basics—simplicity and readability—over faddish looks. Of course, a few we've chosen, such as MTV Network's *The Pages*, come pretty close to jumping over the too-wild-to-read cliff. However, even this out-there publication maintains the sometimes delicate balance between form and content.

We've also provided a diversity of examples. Flip through these pages and you'll find sophisticated font usage, wacky illustrations, low-budget paper choices, impressive photography, can't-miss templates, even publications that rely solely on ingenious text layout to create effect.

Whether you're a pro or a newcomer, it is our hope that this book will inspire you to push your talents further while remaining true to the basics of good design.

—Rita Street and Roberta Street

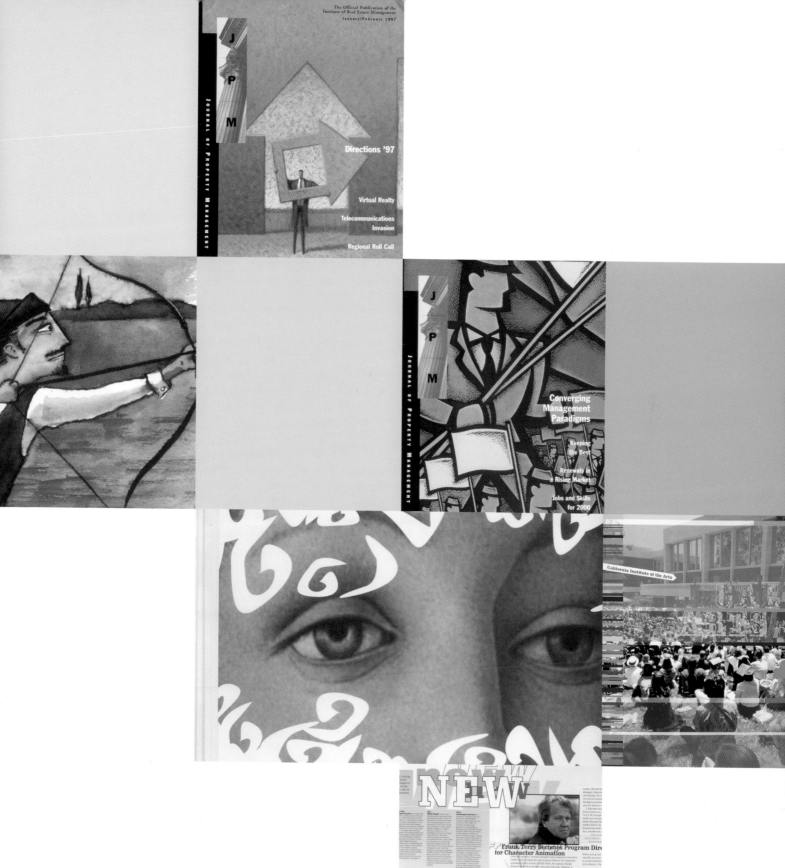

N/ E/ W/ S/ L/ E/ T/ T/ E/ R/ S: Far From Kids' Stuff

It was the summer of '79, and I was a bored 12-year-old. It was time to find a new hobby. *Write, design, and publish your own newsletter*, the school counselor suggested in her "what to do this summer" newsletter.

"O.K.," I thought, ". . . Sure, why not?"

I remember riding my bike down to the local library to find books on newsletter design to get me started. Back then (and it really wasn't that long ago), the only thing I found for inspiration was a tips-and-tricks booklet on typesetting using the typewriter (remember those?). Since the ability to hit Shift-Command-J to justify columns had yet to be invented, you had to type out your text twice in order to do it perfectly: first time, adding slashes (/) at the end of each line, then re-typing the same text but adding extra spaces, based on how many slashes there were. Tedious.

I also remember the challenge and tension of creating a publication that looked as if all the pieces fit together, yet having each article distinguishable enough that the reader knew what to read and where to go. Choices for fonts were limited to typewriter Courier, hand-lettering, and the few Letraset rub-on alphabet sets I could afford to buy on a seventh-grade allowance.

Why this little walk down Nostalgia Lane? I guess it's my way of saying we've come a long way in a short time! Today, newsletters come in all shapes and sizes. They are no longer the newsletters of even ten–fifteen years ago . . . the "ditto-ed" blue pages with that fragrant smell, two-column text set in Times Roman and Helvetica with indistinguishable photographs. Thanks largely to the Macintosh revolution of the '80s, creative newsletter design is alive and well. There is no "typical" newsletter look anymore. Neither do newsletters play second fiddle to glossy pubs. What was previously possible only for magazines with big budgets for typesetting, photography, and art is now possible for the newsletter.

As you read through this book, you'll notice how different designers tackle the same problem issue after issue: getting readers to notice and read their newsletters. You'll also experience how each designer deals with the day-in, day-out challenges of working on a newsletter (do any of these client "quotes" sound familiar?): budgetary concerns ("shouldn't take that long with a computer, right?"); amateur photography ("can you do anything with this Polaroid?"), time/schedule constraints ("can I have this tomorrow morning?"), corporate political games ("my boss hates the color purple"), text versus visual ("what's more important?"); and the meaningless "word count" ("how long does it have to be?").

Just as that little typesetting tips-and-tricks booklet inspired me, it is our hope that this book on creative newsletter design will inspire, stretch, and engage you to be creative in the way you approach your own work.

—Joshua C. Chen

Creative Director, Chen Design Associates

working
s the
cation to
aculty,
take on
itments.

Video
lice Tanaka has worked in
eo and film since 1979, and
works have been seen in
atres, on television, at muse-
s, and in university screen-
s ever since. Her national
nibitions include the Museum
Modern Art, New York, and
1991 and 1993 Whitney
nnial. Her international exhi-
ons include: Feministrische
nst Und Kultur, Germany,
son de La Culture, France,
ller Muller Museum,
land, The Finnish National

Music
Mark Trayle has been per-
forming and composing music
professionally since 1983. He
specializes in electronic music
and has performed his work
around the world. He was the
sound designer on the virtual
reality installation, "Virtual
Brewery Adventure" for
the Sapporo Brewery in Japan,
received three Arts Inter-
national grants for travel to
European festivals, and in 1988
he received a grant from the
National Endowment for the

Theatre
Christopher Barreca has
designed 150 productions on
Broadway, Off-Broadway,
in opera, regional theatre, and
dance, as well as film. He
restructured the design
program at the prestigious
Meadows School for the Arts at
Southern Methodist University,
and he comes to CalArts as
the new Head of Design. Among
his works include *Chronicle of a
Death Foretold* by Gabriel Garcia
Marquez on Broadway, the pre-
miere of the opera *Scourge of the*

A/ N/ N/ U/ A/ L R/ E/ P/ O/ R/ T/ S : Judging the Best

For more than forty years, the annual report has become one of the most important documents produced by a corporation. Once seen as merely a financial report, this document has become the ideal spokesperson, identifying a company's personality, product, and performance.

As director of the Mead Annual Report Show, a competition that has been recognizing the very best in annual report design since 1956, I have had the privilege of being associated with four annual judgings. Each year five nationally recognized annual report designers choose from hundreds of entries submitted, basing their selections on the appropriateness of the design, imagery, and text as it relates to the client.

What is interesting about this process is that five completely different individuals with various influences, experiences, and styles instinctively understand what makes an annual report communicate. Even though each may be swayed by a particular element when casting vote, it is the annual report that executes all the necessary elements effectively that prompts further discussion and recognition. One of the questions that is repeatedly asked after the judging process is over is "why were these particular books chosen?" What makes them special? Invariably the answer is that the books speak honestly and directly to the shareholder, providing adequate information about past performance and future projections paired with groundbreaking design.

Straightforward information, however, is not always enough to set the tone for a company. That is where good design becomes a factor and where trends evolve. Often, companies that produce similar products or offer similar services are acutely aware of their competition and know exactly how they position themselves and communicate to potential investors. Because of the availability of information through the various modes of communication, this can also be seen in the graphic arts community. Those recognized for their work are often the ones setting the style and the standard for the industry.

Yet it is the book that can break away from these influences that transcends time. No matter the economic condition of the country, the newest fashion trend, or the latest electronic capability, the book still must speak to the audience and define the company through effective design. Several companies already have achieved this type of reputation for delivering meaningful messages in association with provocative design year after year—Progressive, Herman Miller, and Northrop Grumman (featured on pages 52–54) are just a few.

Annual reports have become the cornerstone from which companies are branching off into CD-ROMs, Websites, and other forms of communication to create and promote their identity. Creating an annual report that communicates in multiple media gives it longevity; perhaps these will be the annuals that transcend time.

Trends come and go. The true success of a book can be seen when it continues to receive recognition and provoke conversation years after its production. Then a designer knows he or she has done the job well for both the client and the shareholders while maintaining the integrity of good design.

—Julie Busse

Director, Mead Annual Report Show

leisure

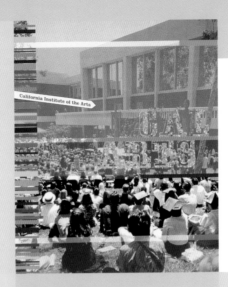

California Institute of the Arts

Rancho La Puerta TIDINGS

Summertime!—the great outdoors at Rancho La Puerta. Our early morning hikes get us going as we greet the dawn on Mount Kuchumaa. Views and cool breezes join us in Oaktree Gym, our beautiful open-sided exercise pavilion.

Cool pool waters host the expanded water-exercise program: including waterworks classes, water circuit, and the popular Aqua Plus class (treading water with buoyancy cuffs on your ankles in a small deep-water pool). Two Water Weeks will delight those of you who love water and outdoors combined. Bring a straw hat, long-sleeved shirt, and lots of sunscreen to enjoy these great workouts!

Research in osteoporosis prevention now shows that flexibility and strength exercises keep bones strong. Yoga fits the bill on both counts! Summer specialty programs include ever-popular yoga of both Iyengar and Ashtanga styles. Also this summer, various experts in Body Conditioning teach a classic, incredibly effective alignment and strength method

have two "Watsu" experts delighting us with the way they combine shiatsu massage techniques and relaxed floating in warm water. Watsu will open you up to a whole new experience! (Appointments are limited and there will be a fee.)

For the more reflective, our Meditation Week helps you learn (or refine) the Zen approach to being present in our lives. Dance Week and Aikido Principles Week complete our offerings.

I know you'll benefit from the greater depth of tuition and experience each of these special weeks offers. Summer at the Ranch is a time of learning and growth, expanding horizons, and shared age-old knowledge in each ancient discipline, from Aikido to Yoga—an adventurous time for everyone!

I look forward to seeing you soon. Have a very happy summer! —*Phyllis*

Welcome!
from Fitness Director Phyllis Pilgrim

🌼 IN THIS ISSUE...

Summer Theme Weeks and Special Rates

New Gyms and Health Centers

Olive Oil Production at the Ranch: Notes from a Harvest

Murals With an Ancient Power

Bill's Cocina Recipes

A Different Kind of Shower

A Tribute to Chris Drayer

Hiking at

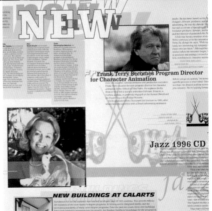

NEW

Frank Terry Becomes Program Director for Character Animation

Jazz 1996 CD

NEW BUILDINGS AT CALARTS

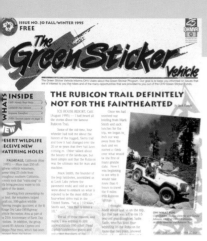

ISSUE NO. 30 FALL/WINTER 1995
FREE
OHMVR

The Green Sticker Vehicle

The Green Sticker Vehicle informs OHV Users about the Green Sticker Program. Our goal is to keep you informed on issues that are of interest to you the riders and of the many opportunities that are presented to you out of the OHV Green Sticker Funds.

WHAT'S INSIDE

NEW
DESERT WILDLIFE
RECEIVE NEW
WATERING HOLES

THE RUBICON TRAIL DEFINITELY NOT FOR THE FAINTHEARTED

Need to get the word out about your theater company's new season? Own your own arts and crafts shop, but can't reach potential buyers? Just gone public with your chain of sporting goods stores and have to produce your first annual report? This section focuses on design that deals with special needs.

As you peruse these newsletters, you'll see that each has found a unique solution for presenting a sense of "experience." For example,

Whether they highlight the arts, sports, or travel, the publications in this section have one thing in common—each is designed to sell an experience.

take a close look at *The Green Sticker Vehicle*, produced for the Off-Highway Motor Vehicle Recreation Division of California State Parks by California State University, Sacramento. From the jazzy masthead with its green "tire-tracks" to the tipped-in illustrations and pictures—everything about the cover says "go!" Even the contents box, bordered with a wavy line, seems to be set in motion.

In addition, many of the "Leisure" newsletters feature striking redesigns. There are as many reasons for enhancing or redesigning a solid layout as there are publications. However, most leisure-related newsletters do so to recapture a changing audience. For example, each year ReVerb, Los Angeles, reinvents its design for *CalArts Current*—the newsletter for the California Institute of the Arts—as a celebration of the new school year and its new arrivals.

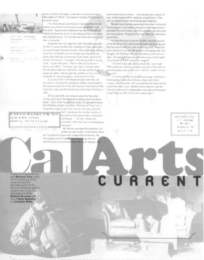

CalArts
CURRENT

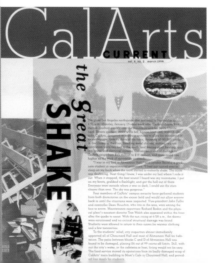

CalArts
CURRENT
the great SHAKE

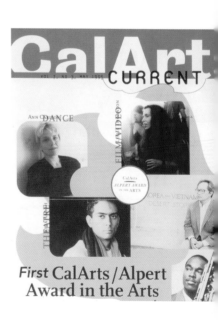

CalArt
CURRENT

First CalArts/Alpert
Award in the Arts

C/H/A/P/T/E/R

1

the arts

The School of Music presents the annual "Spring Music Festival", featuring faculty, students and guest artists performing

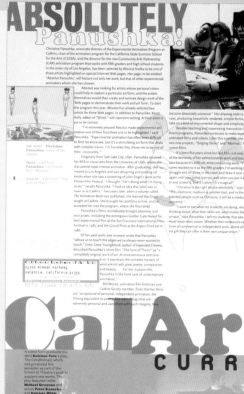

A well-made arts publication is a metaphor for the organization or company it presents. A shining example, *CalArts Current* reflects the independent university it covers: its electric page design, like the school, contains a barely-restrained energy. This "sizzle" echoes the exciting atmosphere of the CalArts campus and its various art disciplines: reading the newsletter is like taking a walk on the campus, or watching a performance.

Powerful synergy between product and publication is a hallmark of good design—but it is especially critical for arts publications, which often must convey topics or events that might seem less tangible to the reading public than goods or services. The selections presented here are a valuable study in building a metaphor for a particular organization or corporation. Well-made graphics highlight the chosen subject and offer interesting solutions for such inflexible design elements as season calendars or sponsor acknowledgment pages. Notice how fact-based sections get added spice from simple illustrated motifs or elegant choices of sans serif type.

PUBLISHED BY THE AMERICAN INSTITUTE OF ARCHITECTS NEW YORK CHAPTER VOLUME 59 NUMBER 1, OCT. 1995

OCULUS

Brennan Beer Gorman
Kuala Lumpur

The Liebman Melting Partnership
Moscow

Robert A.M. Stern
Fukushima

Polshek and Partners
Oman

Kohn Pedersen Fox
Frankfurt-am-Main

William Louis
Jakarta

Jerry Davis
Singapore

HLW
Kuwait

David Beer
Surabaya

Richard Olcott
Chambéry

HOK
Bombay

Richard Meier
Ulm

Swanke Hayden Connell
Istanbul

Steven Holl
Helsinki

Peter Eisenman
Tokyo

Bruce Fowle
Shanghai

Yann Leroy
Hong Kong

Richard Hayden
Caracas

Charles Gwathmey
Zürich

John Gerring
Seoul

Exporting
Architecture:
New York

t h e p a g e s

If you mixed Entertainment Weekly *with* Spy *and added a touch of an underground 'zine, this is what you'd get. Published by MTV Networks' Creative Services department,* The Pages *covers the worldwide happenings at Nickelodeon, Nick at Nite, TV Land, VH1, M2, and of course, MTV.*

TRIM SIZE is 10" x 13 1/2" (25cm x 34 cm)

SIXTEEN-PAGE, TWO-COLOR MONTHLY

Spring Hill Incentive 100 Offset 70 lb. TEXT STOCK

BODY FONTS INCLUDE Gill Sans, Bell Gothic and others

CIRCULATION: 5,000

FEATURE COPY LENGTH: 1,000 words

LAYOUT PROGRAM: QuarkXPress

HARDWARE: Macintosh

EDITOR: Cheryl J. Family DESIGNERS/CONTRIBUTORS: Jason Chappelle, Noel Claro, Mike Eilperin, Wendy Lefko, Mia Quagliarello and Ken Saji.

Too Hip

When editor Cheryl Family started *The Pages* she had a definite feel in mind for the publication. Remembers Family, "Well, you can imagine that it was a challenge to come up with a design that could compete graphically with what our channels had on and off the air. So I decided to give *The Pages* an underground look, sort of grassroots and, for lack of a better term, disenfranchised. It's definitely of the people, by the people, and for the people."

Size Wise

The unusual size of this newsletter is meant to cut through the clutter on employees' desks so that they will pick it up and give it a few minutes of their time. The original format was actually larger than the current 10" x 13 1/2", but readers found it difficult to handle on their subway rides to work. "It was just too big," she says, "and tended to invade other people's space." Family also made the layout more reader-friendly. Originally, type ran vertically as well as horizontally; again, this caused a bit of a snag for cramped commuters.

Templates? What Templates?

Family refers to *The Pages* as "down and dirty," and everything about its design certainly fits this dynamic description. There is no real template for the layout. Each page stands on its own, and often resembles a grunge band handbill. "I like to think of it as incredibly well-thought-out chaos." However, as the newsletter grows, small concessions to typical design set-ups will ultimately creep in to save time and provide some sort of organization.

Experimental Graphics

In keeping with the underground feel, designers experiment with background colors, tints, and duotones. However, Family admits that this doesn't always work to the benefit of design. Sometimes the freewheeling approach makes for some muddy spreads. Yet, more often than not, the serendipity inherent in trying the unexpected pays off in striking new looks.

The Pages designers also play around a great deal with fonts. In fact, as far as they're concerned, too much is never enough. This, along with wacky headline treatments, makes for a highly energetic layout.

Say No to Non-Exclusives

Press photos rarely appear in this publication. The editorial staff owns one little Olympus camera that gets passed around from staffer to staffer, from event to event. Says Family, "Because of our vantage point at rehearsals or just around the office, we get some great off-beat photos of celebrities." These candid treasures aren't treated specially—they're developed at the local one-hour photo, scanned, and masterfully slapped on the page.

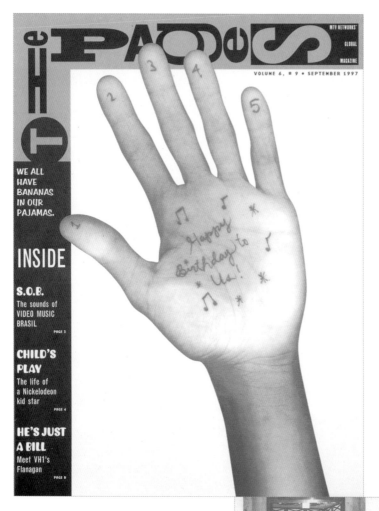

THE PAGES

MTV NETWORKS' GLOBAL MAGAZINE

VOLUME 6, # 9 • SEPTEMBER 1997

WE ALL HAVE BANANAS IN OUR PAJAMAS.

INSIDE

S.O.B.
The sounds of VIDEO MUSIC BRASIL
PAGE 3

CHILD'S PLAY
The life of a Nickelodeon kid star
PAGE 4

HE'S JUST A BILL
Meet VH1's Flanagan
PAGE 8

THE OUTPOST INDEX

Overheard at the candy bin:

"Um...Could we get a guard over here?! This isn't all you can eat, you know!"

In a popular 80s movie, a disembodied voice from beyond whispers, "If you build it, they will come." But, as a wiser disembodied voice would say, "If you build it *and offer free food,* they will come in droves, scam passes from each other like papal indulgences, and then eat everything in sight." On June 25, The Outpost, The Lodge's satellite location on the concourse level of 1515 Broadway, opened for business with a free food kick-off for

Global Grapevine

Our correspondents in London, Düsseldorf and Atlanta gave us an ear- and eyeful this month. Jayjay Epega, Assistant/Coordinator, Studio/Facilities, MTV Europe, gave us the skinny on her department's retreat to Portugal (along with photographic evidence). Fräulein Carol Cate, Manager, Programming/Viewer Services, Nickelodeon Germany, wrote to us at the summer's start, gleefully announcing the office's access to company-wide e-mail. And finally, Sal Dalvi, Account Manager, Affiliate Sales and Marketing, Southeastern Region, let THE PAGES know what it was like to be in the hottest city in the world (Atlanta) on the cusp of the 1996 Summer Olympics.

RE: TREAT
On June 13, MTV Europe's Studio/Facilities department set off for Quinta de Lago, Portugal, taking along Philip McDavell, Senior Vice President/Chief Financial Officer, and Ashley Gauton, Vice President, Information Services, along for the ride. There was a lot of departmental bonding, and among other important issues, we discussed our aim to make all departments involved sexier! (Marketing holds pole position at MTV Europe!)

This quest began with the staff attending The Patio nightclub to celebrate the close of all official meetings. England beating Scotland 2-0 in the playoffs for the European Cup and [everyone] letting their hair down. Staying power was shown by Colin Riley [Manager, Library], Fiona Simons [Post Production Coordinator], Grant Kingham [Head of Facilities], Howard Monaghan [Technical Manager] and myself, who all partied till dawn! —**Jayjay Epega**

I'm anxiously awaiting the arrival of the latest film release here. THE GRADUATE. Actually, MISSION: IMPOSSIBLE will be opening in Amsterdam next weekend — road trip. Auf Wiedersehen. —**Carol Cate**

LET THE GAMES BEGIN ALREADY!
The Olympics are definitely having an impact on our office and our city. In many ways, no one really knows how we'll feel the impact of the Games — we'll just wait and see. I have noticed that we are having more meetings to discuss how the office is going to handle the Olympics. Our office is on the outskirts of the actual "Olympic Ring." However, we are smack in the heart of Buckhead, which will be a magnet for our international visitors. In addition, bicycling [events] and the marathon are passing directly in front of our office. The result is that security is so tight that our building put combination locks on all the bathrooms. I guess they don't want any

THIS JUST IN — HUMAN RESOURCES NEWS

Below are a few bits of helpful information from Human Resources to keep you satisfied until the next issue of THE HaRd FACTS slides into THE PAGES.

THE SPECIALIST
All members of the Aetna Health Managed Care Plan should note a change in policy on specialist referrals. Referral authorization for treatment of certain chronic illnesses has now been increased to 12 months, upon recommendation by your PCP (Primary Care Provider). The extended referral period applies to specialties such as allergies and immunology, cardiology, endocrinology, infectious disease, pulmonary medicine, oncology/hematology, neurology and rheumatology. Also be aware that this is only applicable to specialists within the Aetna network; for those seeing specialists out-of-network, Aetna will continue to determine medical necessity every 90 days. That's nothing to sneeze at.

NETWORKING ON THE NETWORK
Exploring your options, but can't pick up a copy of the latest job postings? (Or maybe you're just lazy.) Good news: MTV Networks Job Postings can now be accessed on e-mail. Follow these easy steps and — whaddya know — the postings are as good as yours:
1. Go into e-mail and select "COMPOSE."
2. For "TO," select MTVN JOB POSTINGS from the global address list.
3. For "SUBJECT," type JOB POST.
4. Click on "SEND."
You'll not only receive the listings within minutes, you'll also get instructions on how to post for your dream job once you've found it. You have a new chance each week to peruse the postings — as with the hard copy, new postings are available on-line beginning every Tuesday. ¿Preguntas? Call Geri Kalinsky, Manager, Staffing Resources, at (212) 258-7893.

PERKS
It's what's brewing.
MTVNers in the Times Square area of Manhattan may be spending more than they need to at local businesses. Pick up a Preferred Buyer's Card at the Employee Events office (on the concourse of 1515 Broadway) and a cheaper world will open up to you. Get discounts at Ellen's Stardust Diner, Bean Bar, Pie in the Sky Pizza, 47th St. Photo, Blimpie and China Peace, among others. Just don't spend all your money in one place.

Wondering what to do with the kids this weekend? Lucky for you, they can be cheap dates at Discovery Zone. MTVN employees can purchase tickets for a penny shy of $4 to be used at any Discovery Zone in the world. Adults and children two years of age and younger are admitted for free. Interested? Send a check or money order payable to Discovery Zone to JoJo Barnes, Employee Events (address above).

The NATPE Monthly

NATPE is the acronym for the National Association of Television Program Executives. To keep members up-to-date on events and workshops produced by NATPE throughout the year, the Creative Services department developed The NATPE Monthly.

TRIM SIZE is 7 7/8" x 11" (20 cm x 28 cm) with gatefold

SIX-PAGE, FOUR-COLOR MONTHLY (free to members)

Topkote Dull Book, 100 lb (150 gsm) TEXT STOCK

New Baskerville BODY FONT

CIRCULATION: 15,000

FEATURE COPY LENGTH: 750 words

LAYOUT PROGRAM: QuarkXPress

HARDWARE: Macintosh

EDITOR: Beth Braen, NATPE vice-president of creative services. DESIGN: Ross Waldorf and Ken Camner of Dog Ear Design based in Los Angeles, California.

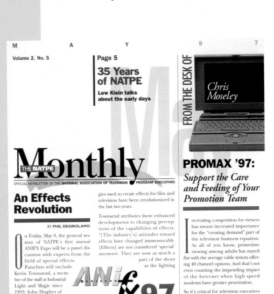

To Color or Not to Color?

When editor Beth Braen met with Dog Ear Design to discuss a new layout for The NATPE Monthly, she brought a lot of newsletters with her. "I showed them examples of what I wanted and what I didn't want. Mainly I explained that whatever we came up with, it had to be colorful and yet have a lot of white space."

Artists Ken Camner and Ross Waldorf took this statement literally. When they built their template, they decided to alternate colored backgrounds with large areas of white. For example, if the statistics column, "Bytes From Baseline," has a pastel green background, then the adjacent "Washington Update" will lie on top of white (opposite page, top). This allows the reader's eye to relax and easily define areas of interest.

Carefully Woven

Camner and Waldorf create texture in their work by placing elements with contrasting attributes next to each other. Notice how the soft edges of the U.S. flag illustration placed next to the hard edges of the word "Washington" create energy in the "Washington Update" headline.

Once Is Never Enough

No one wants to start the day with an angry call from a member upset over a misspelled name. To avoid embarrassing copy mishaps, Braen hires top-notch freelancers, writers she knows will provide lively copy that has been fact-checked. After designers lay out a story, Braen reads it several times, then sends it to her staff for double and triple copyediting passes. Before The NATPE Monthly goes to press, it gets a last look from the NATPE president. "No one knows our membership better than Bruce Johanson. He's definitely been known to catch a few caption errors—the ones that we can't see after the third or fourth reading," says Braen.

Word Power

Type can be used to activate an otherwise quiet area. Camner and Waldorf suggest running type vertically on occasion or, like an illustration, allowing it to cross the borders of an adjacent feature.

Here a Font, There a Font...

The Dog Ear artists use more than twenty different faces in The NATPE Monthly, a choice they actually warn against. Says Waldorf, "If you're just getting started, try not to use too many fonts. It's typically a dangerous choice because it can make your layout look cluttered. Because The NATPE Monthly requires so many little headlines and breakouts, we decided to forego this rule of thumb. However, we're very careful to place fonts that complement each other side-by-side."

Washington UPDATE

The Election Impact on FCC's Policy Agenda

With President Clinton's re-election, you can expect the administration to re-nominate the FCC's current Common Carrier Bureau Chief, Regina Keeney, to the Commission's vacant Republican seat as soon as the 105th Congress convenes in January. President Clinton also has the option to nominate a new Democratic Commissioner if the administration decides to replace the highly esteemed Commissioner Jim Quello, who currently is serving in an expired term.

"If" is the operative word, because no one inside the Beltway is quite sure how the Republican-led 105th Congress will react to the FCC nominees from the Clinton White House. For example, if new Senate Commerce Committee Chairman John McCain (R-AZ) favors a Republican other than Kinney, he

NATPE View
The Online Virtual Marketplace

This month marks the launch of NATPE's virtual marketplace online, NATPEView. This business-to-business web site is designed to give television industry professionals information on member companies and their product (programming) in a way that is easy to update and available 24 hours a day, 365 days a year. "As the traditional program selling season is being spread out over the calendar year, it makes sense to provide continually updated information on available programming to a global audience," said Ron Gold, NATPE senior vice president of marketing. The online exhibition has a search engine that allows users to cross-reference information based on a company's name, the type of company or program type.

Log on to the latest addition to NATPE-VISION (http://www.natpe.org), the ever-growing NATPE web site. For information on how your company can be a part of NATPEViews contact Ron Gold or Jennifer Baker at 310-453-4440 or Mike Brennan at 609-589-4845.

For a fun-filled interactive preview of NATPE '97 in New Orleans, check out the latest NATPE CD-ROM available this month. Practice your cajun, explore the nuances of New Orleans and access information that will make your trip to NATPE '97 a success. If you have not already received the CD-ROM, you may fax a request to 310-453-5258.

New CD-ROM

A sneak peek at the latest CD-ROM from NATPE

Prime Time

CONTINUED FROM THE COVER

Then Carsey-Werner's *Townies* meets Witt-Thomas's *Pearl*, whose exec producer Don Reo faces another of his creations, *John Larroquette*. "It's kind of like watching your mother-in-law drive off a cliff in your new car," said Reo. "You have mixed emotions."

Star Trek: Voyager travels to 9, facing a comedic onslaught including three high-profile newcomers: Bochco/Tarses' *Public Morals*, CW's *Men Behaving Badly* and WB's *Jamie Foxx*. Then at 10, Universal faces itself when promising rookie *EZ Streets* meets grizzled veteran *Law & Order*.

Will the season's changes click or crash? Stay tuned.

As a freelancer specializing in television, Harvey Solomon writes articles, scripts, proposals and speeches. His phone and fax number is 213-938-5845.

THE NATPE MONTHLY

Executive Editor – **Beth Braen**
Editor – **Todd Barasch**
Copy Editor – **Gary M. Johnson**
Graphic Design – **Dog Ear Design**
Print/Print Production – **Koehler & Co. / D.I.S.C.**

For more information on articles, events or services, please call:

1-800-NATPE-GO

or access NATPE on the World Wide Web
http://www.natpe.org

Monthly
NATPE

The NATPE MONTHLY is published by the National Association of Television Program Executives. 2425 Olympic Boulevard, Suite 550E, Santa Monica, CA 90404. 310-453-4440 • Fax 310-455-5258

Washington UPDATE

Broadcasters At Risk?

With the FCC's April voice on a compromise start-up schedule for DTV, the contentions over broadcast digital spectrum debate appears resolved. However, a new policy fight that could impact broadcasters is brewing in Washington over the First Amendment rights of distillers to advertise on television. In a dramatic White House "call to arms," President Clinton encouraged the FCC to launch an inquiry into the possible offers of liquor advertising on children, an inquiry that FCC Chairman Hundt has been advocating for months. Thus far, Hundt's efforts have been frustrated by stiff resistance from Commissioners Quello and Chong, who insist that the FCC should defer to the FTC and Congress. Echoing that concern, Senator Burns (R-Mont.), the Senate Communications Subcommittee chair, gave public notice that the Senate would hold hearings if the FCC attempted to regulate liquor TV advertising. The formidable Congressman John Dingell (D-Mich.) also weighed in on the liquor ad front in an earlier letter to Chairman Hundt where Congressman Dingell signaled his concerns about the FCC replacing the appropriate federal oversight by the FTC of broadcast advertising.

One thing is certain, as spring moves forward into another torrid Washington summer, the liquor TV ad fight is not going away, particularly if Chairman Hundt secures a third vote from a new FCC appointee. If an inquiry is launched on liquor advertising and a formal rulemaking is ultimately adopted, the big question is whether a commission proposal that focuses solely on liquor while excluding beer and wine could withstand First Amendment judicial scrutiny. And if beer and wine are included, what impact could this rulemaking have on broadcasters who annually air more than $600 million of advertising from the beer and wine industries?

For those who thought the V-chip package and tougher KidVid rules were unlikely in 1996, 1997 could be another surprise act in the family values public policy plan that is still center-stage in the federal city.

Washington Update was written by Mickey Gardner, NATPE's Washington Counsel.

TV Spots on Preventing Handgun Violence Offered

CALENDAR

IMPORTANT EVENTS AND HAPPENINGS
ADDITIONAL INFORMATION ON ALL NATPE EVENTS CAN BE FOUND ONLINE AT:
http://www.natpe.org

May 8-11

NATPE's First Annual Animation & Special Effects Expo
Los Angeles 1997

The definitive, high-tech information source for television, film, commercial production, interactive, CD-ROM, multimedia and new media. Experience four days of seminars, workshops, showcases and a job fair plus a state-of-the-art exhibition floor. ANAFX is nothing less than the marriage of art and commerce. Registration kits have been mailed. CALL TODAY to get your passport to the world of animation and visual effects.

May 14

Free Interactive Teleworkshop: Our Brand New World
Free satellite teleworkshop sponsored by the NATPE Educational Foundation (see related story on page 4).

June 5-7

NATPE at PROMAX, Chicago

Your winning Audience: What You Don't Know About Them CAN Hurt You will be presented by NATPE at the annual PROMAX & BDA Conference & Exposition on June 5 from 2:30-3:30 p.m. Audience research plays a vital role in today's high-value television business. Find out what resources are available for your station beyond traditional ratings and focus group research. Learn how to get the right information for your station and use it effectively, creatively and innovatively. Panelists include: Peggy Emmerman, NBC; Liz Huszarik, Warner Bros. Media Research; Kathy Restivo, WGN-TV, Chicago; and Nuzee Tanager, Nielsen Media Research.

ALSO COMING FROM NATPE IN 1997...
• Worldwide day-long seminars to be held in Tokyo, Japan in July and Cartagena, Colombia in October.

NATPE recently participated in the NCTA annual convention in New Orleans. Moderating our session entitled "Cable Programming: What Business Is It of Yours?" was Doug McCormack, president & CEO of Lifetime Television (far left). Joining Doug were panelists (left to right) Jim Sharp of Comedy Central; Paul Lowenstein, ASI Entertainment; Susan Whiting, Nielsen Media Research; Debbie Currier, Baseline; and Gary Lico of Cable Ready.

Educational Foundation

PROMAX '97

CONTINUED FROM THE COVER

Variety, December 1996
"1996 was a year marked by the triumph of marketing as the content of films, TV shows and Broadway tuners on parade..."

The New York Times, January 1997
"It says something about this dusk television season that many of its most inventive moments come from network promos for shows..."

The term branding has become almost trite—it's thrown around so indiscriminately. But the message is important. The days of "if we build it, they will come" are gone. That's why sending your promotion teams to PROMAX will deliver an ROI to your company's bottom line.

Top 5 reasons why your promotion team needs to go to PROMAX:

5. Idea-Sharing: Creative people benefit from seeing how other people create demand.

4. Think Outside the Box: Speakers like Oprah Winfrey, futurist Faith Popcorn and television promotion leaders push promotion & marketing people out of the ruts we all can get into.

3. Professional Development: Seminars on budget management, sales promotion, promotion blocking & tackling make this an educational conference.

2. New Production Techniques: Spots from around the globe demonstrate fresh thinking for everyday promotion.

1. Creative Inspiration: Renewing the creative spirit is key for your people who are fighting the audience battle to generate revenues and contribute to success and sweeping changes.

So the message of PROMAX International is for television management to make the care and feeding of your promotion warriors a priority. Sending them to the conference is a vote of confidence in their value and support for the learning experience PROMAX provides.

Last year, we welcomed 6,000 promotion, marketing and design professionals from over 50 countries to our 41st annual conference. This year, we'll meet in Chicago, June 4-7, for an even more valuable gathering of marketing and advertising professionals in electronic media.

You'll never find a better investment for your promotion team than to support their participation in PROMAX.

Chris Mosley is Senior Vice President, Marketing, for Discovery Networks U.S. and the Chairperson of PROMAX International 1996-97.

Chris Mosley

FREE!

fed twice.

live feed and taped re-feed, as well as being available on videotape.

The next teleworkshop is scheduled for Wednesday, May 28, and tackles the challenges of branding your program or station in a multichannel, multimedia environment. Panelists slated to participate in "Our Brand New World" include Valerie Crane, Research Communications Ltd.; Bob Klein of Klein & and Jim Moorehok of Warner Bros, with others to be announced.

In discussing why stations and others should tune in to this session, Bob Klein said, "It's a cinch TV stations can't do business as usual because the corporate environment isn't 'business as usual.' There are too many other choices out there now to think the only goal of branding is to differentiate yourself from other stations and networks."

Watch issues of the biweekly NATPE Facts for satellite coordinates and additional information on the panels.

Oculus

Published by the American Institute of Architects New York Chapter, Oculus gives architects and enthusiasts an inside look at design trends, commissions, and new or unusual commercial buildings, homes, and neighborhoods.

TRIM SIZE is 7 1/2" x 11" (19 cm x 28 cm)

TWENTY-FOUR-PAGE, TWO-COLORplus spot-color
issued ten times per year

Finch Opaque 70 lb (105 gsm) TEXT STOCK

Bodoni Book BODY FONT

CIRCULATION: 5,000

FEATURE COPY LENGTH: 2,000 words

LAYOUT PROGRAM: QuarkXPress

HARDWARE: Macintosh

EDITOR: Jayne Merkel. DESIGN: Michael Gericke and Edward Chiquitucto of Pentagram Design Inc.

Design Metaphors

When Pentagram designers Michael Gericke and Edward Chiquitucto began work on *Oculus* they played around with the shape of the letter O. Taking a cue from the flag subtitle, "An Eye on Architecture in New York," they thought of O as a metaphor for the eye of the viewer or the eye of a camera focusing in on a building. For this issue, they used the O shape as both a frame and a border for a photo of Bausch & Lomb headquarters. By setting up a pattern and then breaking it with a strong shape, their design forces the viewer to zoom in on the highlighted image.

Power Covers

Great covers make or break a publication, especially one like *Oculus* that competes with high-budget consumer glossies on New York newsstands. Here's another example of eye-catching design. This rendering of the Karet Office Tower in Indonesia (left) looks like a spear stabbing at the heavens. Pentagram designers heightened this by allowing the image to cut into the flag. "After a publication has established a memorable identity," says Gericke, "designers can obscure the masthead with an image. It gives the cover more interest and engages the reader."

Smaller Can Be Better

Editor Jayne Merkel thought that making *Oculus* slightly smaller than a typical magazine would create interest. She also thought that it would make it easier for architects to fit the pub in their typically stuffed briefcases. "Besides," says Merkel, "The thinner look reminds you of tall buildings."

Balancing Text and Image

Oculus is made up of four thin columns, like skyscrapers standing together. Images appear in the outer column and are no wider than its borders. The exception to this are horizontal images sized to take up exactly two column widths (opposite page, top). Says Merkel, "In *Oculus*, images support the text, not the other way around."

To Color or Not to Color

Young designers often are afraid to create in black-and-white. If they don't use all the colors in the rainbow they worry the reader will feel cheated. In this sophisticated example, lack of color is an asset. Because the photos are so exceptional and the layout is so buttoned down, readers don't notice that *Oculus* is a black-and-white publication. In fact, color would detract from its mission—to inform through text.

Simple Shapes

Like many great architects, Pentagram artists know that it doesn't take much to really liven up a design. Here are two fun examples of simple shapes creating energy in a spread. The first uses circular shapes to form a familiar image. The other uses text to create a triangular shape that pulls the reader's eye across the page. Note how the use of large drop caps creates energy within the copy. Without these, the heavy title might be overwhelming.

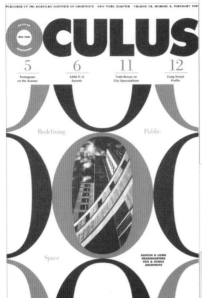

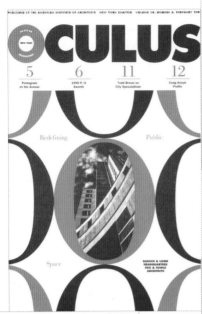

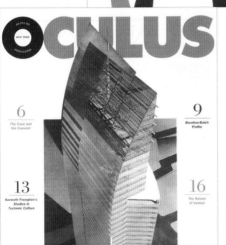

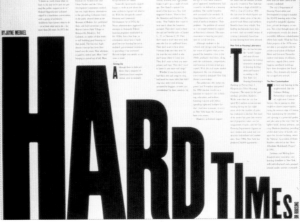

Published by Christie's—one of the world's most prestigious auction houses—to inform and educate the new collector.

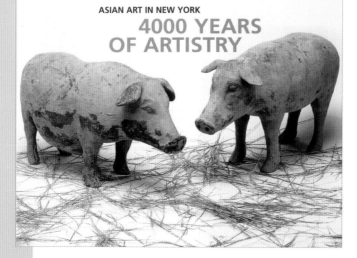

TRIM SIZE is 9" x 12" (23 cm x 30 cm)

TWENTY-FOUR-PAGE, TWO-COLOR, issued nine times per year

76 lb (115 gsm) matte TEXT STOCK

BODY FONTS INCLUDE Christie's Bembo and Frutiger

CIRCULATION: 50,000

FEATURE COPY LENGTH: 500 words

LAYOUT PROGRAM: QuarkXPress

HARDWARE: Macintosh

SENIOR EDITOR: Marissa Wilcox. Director of Creative Services, Skip Pollard; SENIOR ART DIRECTOR: Lynda Havell; DESIGN: Martin Schott.

Lighten Up

Christie's is famous for its auction catalogs. The functionality of these publications requires that each offering be photographed in even, museum-style light. Photographs are cropped similarly and laid out in a scholarly fashion.

When Skip Pollard began the recent redesign of *Christie's Art*, he moved away from the catalog format. Working with his creative staff and Meredith Ethertington-Smith of Christie's London office, he developed a playful look that appeals more to the publication's target audience.

Photos now float in text and, as Pollard points out, actually are treated with a bit of whimsy. "Our first issue," says Pollard, "features a shot of seventeenth-century terra cotta pigs. They are well-lit, but instead of placing them on a pedestal, we placed them in hay."

Rich Design

The *Christie's Art* template is not set in stone. The choice between two or three columns depends entirely on the look and focus of a particular spread—definitely a more magazine-like choice. However, the overriding rule is to keep the focus on art, rather than copy or headlines.

Notice how the "4000 Years of Artistry" headline (opposite page, middle)—although immediately legible—seems to recede into the background while bringing the images to the fore. Also, in keeping with the mission of the publication, photographers style the property as it might be for an upscale retail store window (a symbol of accessibility), but the historic nature of the elements lends a touch of aristocracy to the design.

What Was That Date?

Placing the monthly calendar of events on the center spread makes it more user-friendly—and easier to tack up on a bulletin board.

Drawing Them In and Keeping Them There

"In keeping with our goal to educate new collectors, our first issue [after the redesign] included a history of rugs and carpets (oposite page, middle). Although this sounds rather staid, it proved to be a fascinating topic," explains Pollard.

Adding an element of intrigue, the publication's designer used a simple trick. The two featured carpets are arranged so that an entire pattern is apparent but only a small portion of either rug is seen in full. As the reader begins to picture the entire rug, he or she is brought into the page. The placement also hints at movement, as if the images themselves are flying past the text on some mysterious journey of their own.

JAMES A. FFRENCH
HEAD OF CHRISTIE'S RUGS AND
CARPETS DEPARTMENT

RUGS & CARPETS

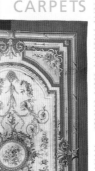

Larger than 6' x 9' is a carpet; smaller is a rug.
The general rules however, re...

FROM GRAND EXAMPLES OF CHINESE FURNITURE TO
DIMINUTIVE JAPANESE NETSUKE, SEPTEMBER SALES
OF ASIAN ART OFFER 4,000 YEARS OF ARTISTRY AT
CHRISTIE'S NEW YORK. WITH ESTIMATES RANGING
FROM $2,000 TO $200,000, A RICH ARRAY OF
PROPERTY WILL BE OFFERED IN CHRISTIE'S SALES OF
CHINESE PAINTINGS, JAPANESE WORKS OF ART

ASIAN ART IN NEW YORK
4000 YEARS of ARTISTRY

AND FINE CHINESE CERAMICS & WORKS OF ART—
ALONG WITH THE MR. & MRS. ROBERT P. PICCUS
COLLECTION OF FINE CLASSICAL CHINESE
FURNITURE, AND CHINESE CERAMICS, PORCELAIN,
IMPERIAL GLASS AND IMPORTANT BRONZES FROM
THE JINGGUANTANG COLLECTION, PART III.

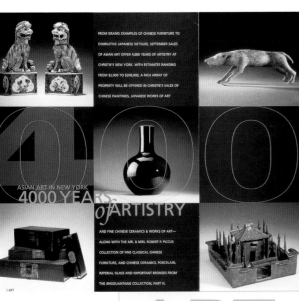

CHINESE CERAMICS
AND WORKS OF ART

by Pamela Unwin-Barkley

ART
SEPTEMBER
CALENDAR of
upcoming Sales

Christie's, 502 Park Avenue, 212-546-1000 • Christie's East, 219 East 67th Street, 212-606-0400 • Christie's Los Angeles, 360 North Camden Drive, 310-385-2600

SALE	DATE / LOCATION	ON VIEW
From the Pennsylvania German Folk Art and Decorative Arts Collection of Mr. and Mrs. Paul Flack On the Premises, Holicong, Pennsylvania	Saturday, 6 at 10 am and at approximately 1 pm on premises	September 4-5
The Nineteenth Century	Thursday, 11 at 10 am & 2 pm at Park	September 6-10
Antique and Fine Jewelry	Thursday, 11 at 10 am & 2 pm at East	September 6-10
Japanese Works of Art	Wednesday, 17 at 10 am at Park	September 13-16
The Mr. and Mrs. Robert P. Piccus Collection of Fine Classical Chinese Furniture	Thursday, 18 at 10 am at Park	September 4-17
The Jingguantang Collection, Part III	Thursday, 18 at 11:30 am at Park	September 13-17
Fine Chinese Ceramics and Works of Art	Thursday, 18 at 2:30 pm at Park	September 13-17
Fine Chinese Paintings and Calligraphy	Friday, 19 at 10 am at Park	September 13-16
Finest and Rarest Wines including the Collection of Belle and Barney Rhodes	Friday, 19 at 2 pm and Saturday, 20 at 10 am & 2 pm	

A selection of of brushpots from The Mr. and Mrs. Robert P. Piccus Collection of Fine Classical Chinese Furniture

SALE	DATE / LOCATION	ON VIEW
Sports Memorabilia	Saturday, 20 at 10 am & 2 pm at East	September 13-19
Fine Jewels	Tuesday, 23 at 6 pm at Los Angeles	September 6-9
Asian Decorative Arts	Wednesday, 24 at 1 pm at East	September 21-23
The Henry Stern Collection of Antique Glass Paperweights	Wednesday, 24 at 10 am at Park	September 20-23
French and Continental Furniture	Wednesday, 24 at 2 pm and Thursday, 25 at 10 am & 2 pm at Park	September 20-24
Fine European and Oriental Carpets	Tuesday, 30 at 10 am at Park	September 27-29
Furniture and Decorative Arts	Tuesday, 30 at 10 am & 2 pm at East	September 26-29
Spink America United States and Worldwide Stamps and Covers	Tuesday, 30 at 2 pm at Park	September 26-29

Schedule subject to change. Please call 212-373-5838 for more information

CalArts Current

CalArts Current, *a nine-year-old publication, celebrates the independent personality of the California Institute of the Arts. Headquartered in Valencia (just outside Los Angeles), the school and newsletter's shared goal is to nurture the progressive and creative spirit of its student body.*

EIGHT-PAGE, TWO-COLOR TABLOID issued three times per school year

GLOSSY TEXT STOCK

Elegans BODY FONT

CIRCULATION: 20,000

FEATURE COPY LENGTH: 750 words

LAYOUT PROGRAM: QuarkXPress

HARDWARE: Macintosh

PRODUCED BY ReVerb, Los Angeles, a studio employing California Institute of the Arts alumni Somi Kim and James W. Moore. PUBLISHED by CalArts Office of Public Affairs: Anita Bonnell, DIRECTOR; Chris Meeks, EDITOR AND WRITER; PHOTOGRAPHY by Steven A. Gunther and Rachel Slowinski.

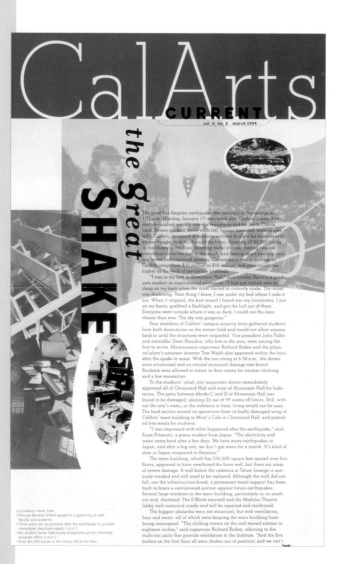

Stay Flexible

"We still use an adaptation of the *Current's* original template designed by Caryn Aono (CalArts director and design program faculty) simply because it is so flexible. Each page has six columns that can be divided in half plus twenty-four vertical modules," says Somi Kim.

In March of 1994, design took a back seat to a pressing editorial issue—the Northridge earthquake (left). Devastated by the temblor, parts of the main campus had to be shut down. However, classes continued at satellite locations. Says editor Chris Meeks, "Editorial became very dense at that time; we had to get out a lot of important information concerning class schedules, locations, and the progress of rebuilding. Since 1994 we have tried to return to our original concept for editorial—'keep it short and sweet.'"

Don't Overdo

The design of the *Current* is flamboyant and free-spirited, like the institute itself. But sometimes, as Meeks attests, design does not support readability. "I encourage the ReVerb team to experiment, but I also insist that each issue be easy to read. Illustrations laid behind text sometimes make copy illegible. Or it may not be clear where an article begins and ends. In these cases, I simply offer notes and we come to a creative compromise."

Creating the Look

Each fall, ReVerb creates a new flag for *CalArts Current.* Although the overall design remains similar in tone, the "new" look allows incoming students to feel that they have some ownership in the publication. This fresh approach also conveys a vital message to the arts community (and nearby entertainment industry); that the Institute is constantly evolving.

"We've always loved the calligraphic shapes of the ornamental swooshes on certificates and diplomas," Kim says, "so James and I simplified that inspiration into the single decorative element that you see in the flag."

Moore and Kim carried the motif through spring 1996, using swooping shapes created in Adobe Illustrator as backgrounds and frames for photo collages. Although the tabloid-size *Current* runs on medium-quality glossy paper, its creative team stays within budget by printing just two colors. Hues are screened back, combined, or manipulated to look like a full-color palette.

CalArts Course Catalog

"When I start laying out a spread I tend to focus on one area first. The most important element of this spread was the calendar, so I started with that. Then I tried to lay out the rest of the pictures and copy on diagonal lines, so that the readers' eye would move easily between the pages. Whenever I got stuck, I just start moving things—as if the elements were puzzle pieces—until the design felt right."

—James W. Moore

In 1996, Moore based his redesign of *CalArts Current* (above) on the university's class catalog, designed by ReVerb's Somi Kim and New York-based Heavy Meta's Barbara Glauber. This perfect-bound, four-color glossy "bulletin," (below) as it is called by the university, boasts a dazzling horizontal-line effect. "The colored lines that run throughout the design are based on the table of contents spread," says Moore. "Down the right-hand side we ran the names of all the schools, and, using the shape of the letters as a guideline, we extended lines horizontally across the page. That created a sort of barcode that works both decoratively and functionally as an index-element throughout the publication." Moore's use of similar design elements bridged the bulletin and the *Current*, and portrayed a unified sense of school identity.

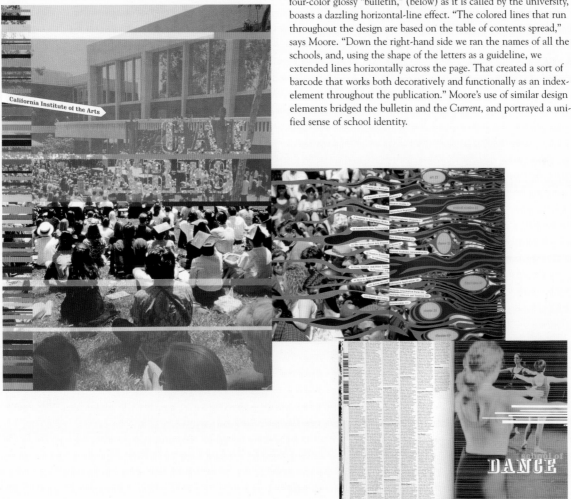

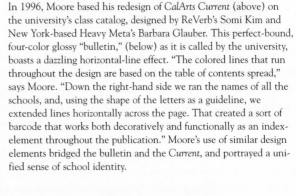

INTERNATIONAL STUDENT POPULATION
REACHES ALL-TIME HIGH

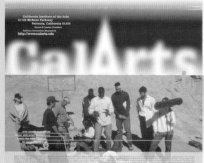

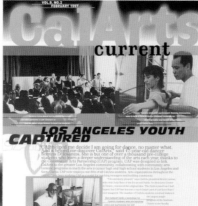

VOL 9, NO 2
FEBRUARY 1997

CalArts
current

LOS ANGELES YOUTH
CAPTURED

A CLOSER LOOK AT THE CAP PROGRAM:
PEOPLE-TO-PEOPLE
MULTIMEDIA DIGITAL ARTS WORKSHOP

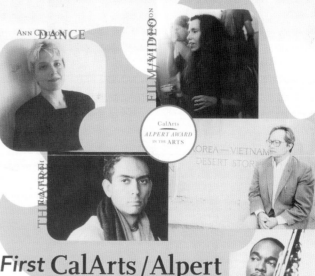

CalArts
VOL 7, NO 3, MAY 1995 CURRENT

ANN CARLSON DANCE FILM/VIDEO

THEATRE RESEARCH KOREA — VIETNAM DESERT STORM

CalArts
ALPERT AWARD
IN THE ARTS

JAMES MUSIC

First CalArts / Alpert
Award in the Arts
Recipients Announced

On May 5th, in a ceremony at the Biltmore Hotel in downtown Los Angeles, the first five recipients of the CalArts/Alpert Award in the Arts were announced. They are Reza Abdoh (Theatre), Ann Carlson (Dance), James Carter (Music), Mel Chin (Visual Arts), and Leslie Thornton (Film/Video). Each will receive a $45,000 award in support of their work and an additional $5000 for a residency at CalArts.

"I'm thrilled with the outcome," says Herb Alpert Foundation President Kip Cohen. "Through a national review process, CalArts and the Herb Alpert Foundation hoped to identify artists who have generated important bodies of work but may not be fully recognized outside their disciplines. For our tastes, these first five awardees fulfill the goals of the program to an almost uncanny extent."

CalArts/Alpert Award director Irene Borger worked with CalArts President Steven Lavine and Lynn Rosenfeld (director of special projects at CalArts) to design the Awards process. Ten nominators—who will be rotated each year and will remain anonymous—were selected for each discipline. Chosen

NEW FACULTY

NEW

Frank Terry Becomes Program Director
for Character Animation

New Trustee:
Luanne Wells

Jazz 1996 CD Released

NEW BUILDINGS AT CALARTS

New Pacific Writing

New Pacific Writing supports the growth of Mānoa: A Pacific Journal of International Writing, *published by the University of Hawai'i. It provides snippets of text from stories featured in upcoming editions, as well as news about the* Journal *and its activities.*

TRIM SIZE is 8 1/2" x 11" (22 cm x 28 cm)

FOUR-PAGE, TWO-COLOR QUARTERLY

Evergreen 70 lb (100 gsm) TEXT STOCK

GOUDY BODY FONT

CIRCULATION: 1,000

FEATURE COPY LENGTH: 250–500 words

LAYOUT PROGRAM: QuarkXPress

HARDWARE: Macintosh

EDITORS: Frank Stewart and Pat Matsueda.

DESIGN: Rowen Tabusa.

Creating a Feel

Designer Rowen Tabusa brings the feeling of the Pacific region to his design through hand-crafted imagery. For the background of the flag he scanned a piece of apa cloth—the vibrantly patterned material created by Hawai'ians with dyes made from native plants. Borders are also created out of various apa patterns. In addition, Tabusa drew a logo for *Mānoa*, the parent publication of *New Pacific Writing*, which is acknowledged on the back cover of each issue. This stylized view of an island-scape is reminiscent of a wood-cut.

Say More with Words

Because this publication is for readers and writers, designer Rowen Tabusa works to make the copy, rather than the images, stand out. Unlike most newsletters that pack in the text, this copy is double-spaced for easy reading.

Be Friendly

"Manoa can look somewhat imposing with its thick, book-like spine and small type," says editor Frank Stewart. "The goal of the newsletter is to draw readers into the journal; to interest them in upcoming issues by being friendly, accessible, and newsy." Tabusa's use of ample white space and simple graphics supports this mission. Like its home island, the layout is open and inviting.

C/H/A/P/T/E/R

2

sports

PERSPECTIVES
DOING BUSINESS IN CHINA IS MAKING A DIFFERENCE

Member loyalty gets focus in '97

WHAT BRINGS 'EM BACK TO REI?

ATTRIBUTE	REI BEST	ALL SAME	OTHER BEST
Knowledgeable salespeople	60%	22%	18%
100% guarantee	48	44	8
Highest quality products	51	32	18
Most consistent quality	52	33	15
Reasonable prices	44	27	29
Easy to return items	44	45	10
Experienced salespeople	60	22	19
Accessible salespeople	49	27	24
Carry products that I want	44	43	13
Sales help has technical information	62	19	19
When I call the store, I get the answers I need	46	42	12
Store carries the brands I like	41	42	17
Readily available sales help	48	29	23
Always have my size	30	54	16
Always have what I need	39	44	17

Grant sees REI member-led expedition to summit!

REI HELPS "REINVENT GOVERNMENT"

What could be more exciting than whizzing down a slope of powder on a brand new Ride snowboard? Probably the choice to invest in the company. However, even in the realm of sports, excitement isn't necessarily something a typical stockholder wants. For VSA Partners, the Chicago-based design firm chosen to create snowboard manufacturer Ride's 1996 annual report, the number-one concern was to convey, through visuals, that a manufacturer producing trendy new sports equipment has established a reputation worth banking on.

VSA's striking design, which combines the look of hip-hop, the beauty of the wintry outdoors, and views of highly skilled craftsmen and executives in business attire, evolved from Wall Street research.

Excitement isn't necessarily something your typical stockholder wants.

By doing their homework and checking out the company's perceived strengths and weaknesses in the investment community, they knew what they needed to show (and not show) to attract attention and build confidence.

As you peruse our feature on Ride and the other projects in this chapter, you'll see that good design doesn't just pop out of the air. If a design truly meets a client's needs, it must be built upon hours of legwork: learning not only what a client does but what the company has done, what it plans to do, how it is perceived by its target audience, and how the company sees itself.

The Green Sticker Vehicle

The potential audience of The Green Sticker Vehicle *is the 350,000 registered off-highway vehicle (OHV) owners and potential users in California. Chief among its missions is to educate the public on the location of approximately one hundred riding areas and the more than one hundred thousand miles of managed recreation trails and roads in California.*

TWENTY-PAGE, SIX-COLOR, TABLOID ISSUED BIANNUALLY
Vision Matte 45 lb (70 gsm) TEXT STOCK
WEIDEMANN BODY FONT
CIRCULATION: 40,000
FEATURE COPY LENGTH: 750
LAYOUT PROGRAMS: Adobe PageMaker and Macromedia FreeHand
HARDWARE: Macintosh
EDITOR: Priscilla Davis and Clifford R. Glidden, deputy director of the Off-Highway Motor Vehicle Recreation Division, a division of California State Parks.
DESIGN: Jim Molina of University Media Services, CSU Sacramento.

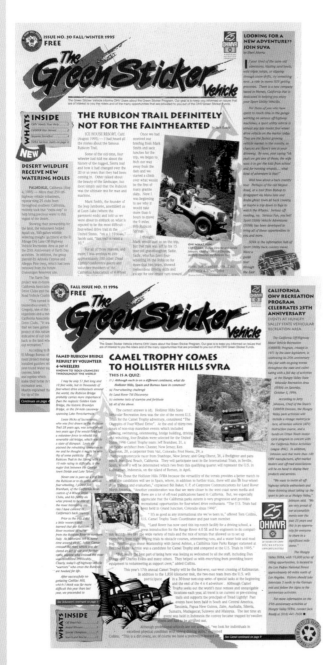

Stick to the Basics

It may sound simplistic, but when sitting down to rough out a flag and template, it pays to think about the mission of the publication. The *Green Sticker Vehicle* is dedicated to green issues: environmental management, volunteerism (such as building trails), and outdoor recreation that treads "lightly on public and private lands." Therefore, Molina uses green in both theme and look. The words "green sticker" included in the flag designate the actual sticker required to operate an OHV on restricted lands. These words overlay green brushstrokes that resemble tire tracks—the kind made by tires that have a minimal environmental impact. Together, these elements convey a sense of adventure and responsibility. He also used green as a base color in graphics, page-number icons, and for some screened backgrounds and headlines.

Strong Composition

Molina's basic grid comprises five columns. For an interesting spread in the Fall 1996 issue (opposite page, bottom), Molina created definition between articles by shading one story background green and another white. In the story with the green, he gives each column its own free-standing background with white space between each. This choice follows the outdoors theme in two interesting ways: in one respect, the columns resemble trees leading up to green hills; in another, they look like tracks racing up a hill. Images placed loosely along diagonals run from the top of the left-hand page to the bottom of the right-hand page, and from the top of the right-hand page to the bottom of the left. It's a good basic composition choice, pleasing to the reader's eye.

Design They'll Read

Ever wonder if your newsletter actually is read and not thrown away? Editor Davis says, "We know people like the *Green Sticker* and save their copies because, for example, they mail in photocopies of coupon offers rather than cut up their newsletters."

Keep It Active

Every page in *Green Sticker* is active. The tilting of picture and text boxes is especially appropriate since this publication is all about going up and down hills. Even the contents box features squiggly lines around its ragged border (opposite page, middle)—like the lines denoting movement of characters in comic strips.

Custom Graphics

All the illustrations in *Green Sticker* are custom made to fit the expectations of the readership. "Our audience is quite specific when it comes to vehicle type so we need to have all of them represented," Molina says. "All of our illustrations are designed and or redrawn in [Macromedia] FreeHand. Most are one color, but some are colorized for impact."

Molina adds that creating a balance between intriguing illustrations and color photos can be complex. "Remember," he says, "the point is to draw the reader to the article, not wow them with graphics."

SNOWMOBILER RECOGNIZED

CALIFORNIA ROCK CRAWLERS GATHER IN FRESNO FOR 37TH ANNUAL CA4WD CONVENTION

THE PRESTIGIOUS CALIFORNIA OHMVR COMMISSION 1995 AWARD WINNERS

PORTOLA VALLEY OFF-ROADER CHRIS CARTER

PLACER COUNTY SEARCH AND RESCUE OFF-ROAD MOTORCYCLE UNIT HONORED

CALIFORNIA OFF ROAD VEHICLE ASSOCIATION (CORVA)

After successfully negotiating Cadillac Hill, which I think was far more difficult this year than last year, we proceeded to

See Volunteers continued on page 6

NEW OHMVR OFF ROAD PALS PROGRAM

LOCAL CHP OFFICER AND MOTOCROSS RIDER TAKES TIME TO TALK WITH "OFF-ROAD PALS"

Continued on page 3

CASTROVILLE GIRLS TRAVEL TO SAN BERNARDINO TO BECOME "OFF-ROAD PALS"

Continued from page 2

The Next Level: Ride Inc.

1996 Annual Report

The theme of this report is spelled out in its title, The Next Level. Ride began as a snowboard manufacturer run by young outdoors enthusiasts. With the market for snowboards choked by competition, the company needed to express progressive business philosophies that make it stand out from the pack: the foresight to bring on "experienced leadership"; "the ability to maintain the interest of distributors" through new products; and "the technical and manufacturing capability to raise the bar."

TRIM SIZE is 6.5" x 9.75" (17 cm x 25 cm)

NINETY-TWO-PAGE, FOUR-COLOR ANNUAL

Simpson Starwhite Vicksburg and Fox River Rubicon STOCK

BODY FONTS INCLUDE Universe Condensed, Garamond

CIRCULATION: 40,000

LAYOUT PROGRAM: QuarkXPress

HARDWARE: Macintosh

COPYWRITER: Ken Schmidt. DESIGN: Curt Schreiber, Jeff Breazeale. All are staff members at VSA Partners Inc.

RIDE
1996 Annual Report

The Big Picture

The biggest challenge facing any annual report designer is what to include. "There's always so much to cover that ideally you'd want to have three hundred pages," says VSA partner Ken Schmidt. "However, no one wants to read three hundred pages of data—no matter how pretty you make your layout. So you have to take a helicopter view of the whole story. Sort of get above it all and look down."

Defining the Big Picture

VSA met with financial analysts to better understand Ride's perceived strengths and weaknesses. Overall they learned that Wall Street confidence in the snowboarding industry is waning. To combat this concern, Ride and VSA focus on three themes: Leadership Through Innovation; Brand Building for Competitive Edge; and Broadening the Revenue Base.

Through images and graphics, these areas (each of which is a section in the book) create a balance between the stability of Ride's manufacturing prowess and the edginess of so-called Xtreme sports. Some images convey the handcrafted quality of Ride products. Others show the courageous, sometimes otherworldly, appeal of Ride logos.

Mix It Up

Here (opposite page, middle right) artist Curt Schreiber frames the eyes of a Mona Lisa-like board logo with swirls of white. In other areas of the book the designers make the wild world of snowboarding look sophisticated. Here, one of the company's cutting-edge logos looks serious and businesslike inside a fanciful border.

Sometimes You Just Know It's Right

Image boxes with jagged edges frame photos show snowboard enthusiasts at play (opposite page, top). Often, portions of the same image overlay each other. On one hand, this is reminiscent of rocky crags and the wintry outdoors, even refractions in icicles. On the other, it feels like the careful planning that goes on in a boardroom—ideas that jump to the fore are carefully examined and reexamined.

Keeping a Balance

The Next Level opens with a double gate-fold (opposite page, bottom). The inside four-page spread shows the company's product line cleverly laid out with lots of white space. Although the arrangement of the boards in a sunburst shape brings an element of fun to the spread, the large amount of white space combined with images of the manufacturing and distribution process brings balance. This doesn't feel like a new over-the-top sport; it feels like it has a heritage akin to alpine exploration or climbing. Note how the colored banner in the middle ties all the elements together.

The next level

I. LEADERSHIP THROUGH
INNOVATION

Strengthen Ride's reputation
for technological leadership
and improve margins by:

Incorporating technology
that delivers tangible,
marketable consumer benefits.

Reducing the time to market
with products that
redefine industry standards.

Building more of our
snowboards in-house.

II. BRAND BUILDING FOR
COMPETITIVE EDGE

Maximize our competitiveness
and gain market
share profitably by:

Narrowing our brand focus.

Positioning Ride as
a full-line supplier.

Strengthening relationships
with retailers and consumers.

Increasing our visible
presence on the mountain.

Improving after-the-sale
service support.

III. BROADENING OUR
REVENUE BASE

Create improved levels
of financial performance and
customer satisfaction by:

Leveraging our brands
to build same-store apparel
and accessories sales.

Expanding apparel
and accessories
distribution channels beyond
current levels.

Extending our reach into
sporting goods either beyond
our core business through
our Special Products Group.

Ride, Inc.
8160 304th Avenue SE
Preston, Washington 98050
206.222.6015

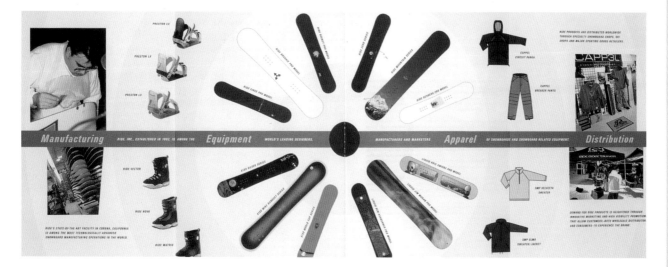

Compass

Recreational Equipment Inc., better known as REI, has been providing customers with "quality outdoor gear and clothing" since 1938. The company's appropriately named house organ, Compass, has served as a guide for employees since 1982. Its mission is to provide information pertaining to corporate strategies, store openings, and new products, as well as employee activities such as company-backed expeditions.

FOUR-PAGE TABLOID QUARTERLY

Sandpiper Mushroom 80 lb (120 gsm) TEXT STOCK

BODY FONTS INCLUDE Helvetica and Baskerville

CIRCULATION: 4,500, free to employees

FEATURE COPY LENGTH: 500 words

LAYOUT PROGRAM: QuarkXPress

HARDWARE: Macintosh

EDITOR: Cheryl Mikkelborg, corporate communications administrator for REI. DESIGN: Janis Olson of Janis Olson Design. Both are based in Seattle, Washington.

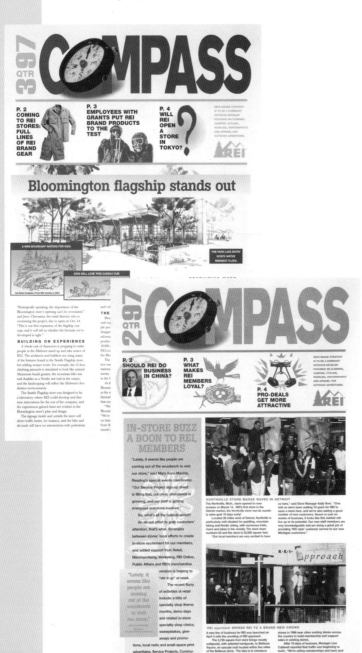

Less Is More

When *Compass* first hit the presses it was filled to the brim with information; even employee anniversaries and awards were included. After a reexamination of purpose, management decided to cut production back from monthly to quarterly and to focus on the big picture. Now *Compass* includes only pressing corporate topics and the most interesting employee stories. This makes designer Janis Olson's job easier and more rewarding. She fits everything in and still has white space left open so that readers can actually see her work.

Every Little Bit Counts

Design conception should take every element into consideration. Since REI is all about getting involved in outdoor activities, the design had to reflect a back-to-nature feel. Olson used muted, earthy tones for her colors, woodcut clip art, and, of course, recycled paper. "It's these subtle underpinnings," says Olson, "that make your work feel and look appropriate."

Keeping It Together

When Olson began work on *Compass* two years ago, she gave the publication a mini-redesign. The earlier version had an adventurous feel but was so graphics-heavy it was hard to read. Olson's current design uses fewer graphics but runs them at an increased size. In addition, she is careful about her use of colored type. The best time to use colored type, believes Olson, is when it can be a linking element between copy and artwork. In this spread the chart on "Member Loyalty" is screened in green and surrounded by a green border. The adjacent story is set in green type.

Spend the Money

Everyone has to stick to a budget, but there are some areas where designers shouldn't skimp. One of these areas, Olson believes, is clip art. "Young designers often start out with the clip art included in their computer purchase package. This is cheap art so it ends up looking cheap. For *Compass* we purchased an expensive package. However, it's like money in the bank because it's the only package I use. If you try to combine clip art libraries your design begins to look messy. Think of your clip art as a unifying factor."

A Little Trick

You don't always have to use clip art to create a dynamic illustration. To set off a photograph of a climbing harness (opposite page, middle right), Olson created a border of triangles and diamonds in QuarkXPress by reshaping polygon boxes and filling them with color.

P. 2
WILL REI OPEN A STORE IN TOKYO?

P. 3
WHAT MAKES REI MEMBERS LOYAL?

P. 4
PRO-DEALS GET MORE ATTRACTIVE

PERSPECTIVES
Doing business in China is making a difference

REI's store and mail order teams are reporting an increase in questions from customers about REI's policies on manufacturing in China and selling other vendors' products made there. Some people believe that if we cease selling any Chinese-made product, the economic pressure will bring a halt to human rights abuses in that country.

My recent trip to China, as part of a 16-member delegation from Washington state, confirmed for me that REI's current course is the only way to influence human rights practices in China, which we all recognize are terrible and in need of change. REI's position is that economic interaction will continue to improve the lives of average Chinese people and contribute to a "peaceful evolution," a theme I will return to in a bit.

The delegation was led by Washington State Senator Patty Murray and included representation from Eldec Cranes, Port of Seattle, Microsoft, Washington Wheat Commission, Boeing, US Bank, and Seafirst Bank. In 10 days, we visited Hong Kong, Beijing, and Shanghai.

It was an interesting time to travel to this area. Hong Kong reverts to Chinese sovereignty on July 1; and Most Favored Nation (MFN) trade status conferred by the US, along with China's application for membership in the World Trade Organization, are pending.

Senator Murray had the opportunity to officially address the Chinese Government on the issue of human rights. In a meeting with Chinese Vice Premier Li Langing, which I attended, she expressed the fact that human rights was a personal concern to her and the American people. She mentioned allowing the International Red Cross to visit Chinese prisons as a way to show small steps in the human rights area that would be helpful to those who support permanent MFN status or the vote arises in the US Senate. The delegation also talked about the potential of a "consumer backlash" against Chinese goods sold in the U.S. due to concerns about human rights.

This meeting and my trip in whole left me with the reaffirmed conviction that isolating China will not improve the lives of people in China, but that continued involvement there will. Two meetings in particular encouraged me that REI's course in China is correct. The first was a briefing with the U.S. Consul General in Shanghai. He stated that, at recent as eight years ago, the daily lives of citizens were strictly controlled by their work unit through State-owned enterprises. Ration coupons for housing and vital consumer goods were given out by these work units, but the rapid rise of private sector employment opportunities has changed this "iron rice bowl" control. "This represents the most dramatic change in China in 3,000 years," he stated.

The second encounter was with the Deputy Chief of Mission of the U.S. Embassy in Beijing. He, too, believes that China is experiencing a tremendous increase in the sphere of personal freedoms for the average citizen as more Western businesses operate in China.

Such experiences confirmed to my mind the premise of Nicholas Kristof and Sheryl WuDunn in their book, "China Wakes," that the enormous amounts of foreign investment, information exchange, and outside contact is creating a "peaceful evolution" in China. They write:

"Hard liners worry that the spread of American ideas, movies, novels, music, and even dance styles is all part of a broad conspiracy to undermine Communist rule. Of course, they give us too much credit. But what a great idea! Peaceful evolution, in the sense of exposure to Western ideas, helped bring democracy to Spain in the 1970s, and peaceful evolution has helped bring freedom to Taiwan in the 1990s . . . To get peaceful evolution, we need more contact rather than less. We need more trade, more cultural exchanges, more engagement. So if we're serious about trying to make China a more open place, we should be threatening not a cut-off of trade but an expansion."

The conclusion I draw from my readings, conversations and observations is that REI is correct in adopting a policy of engagement and trade with China. Our team and our customers can rest assured that our own products are being manufactured under safe and fair conditions. I have seen the factories myself and they are monitored regularly by the product sourcing group at THAW. You can also be assured that REI is helping to bring about positive changes in human rights in China while bringing our members quality, affordable goods. The strategy of engagement and trade is working today.

Wally Smith

Member loyalty gets focus in '97

WHAT BRINGS 'EM BACK TO REI?

ATTRIBUTE	REI BEST	ALL SAME	OTHER BEST
Knowledgeable salespeople	60%	22%	18%
100% guarantee	48	44	8
Highest quality products	51	32	10
Most consistent quality	52	33	15
Reasonable prices	44	27	29
Easy to return items	44	45	10
Experienced salespeople	60	22	19
Accessible salespeople	49	27	24
Carry products that I want	44	43	13
Sales help has technical information	62	19	19
When I call the store, I get the answers I need	46	42	12
Store carries the brands I like	41	42	17
Readily available sales help	48	29	23
Always have my size	30	54	16
Always have what I need	39	44	17

There's no doubt about it. Loyalty counts for a lot in this world, especially for businesses like REI that are facing more and more competitors.

Members who bring their business to REI year after year help make sure their cooperative will be here for the long haul.

Attracting and retaining the loyalty of members, so that they think of REI as their first and only source for outdoor gear and clothing, is the purpose of one of REI's three strategic objectives for building a competitive business. The strategic objective, in a nutshell, says that we need to understand what customers value and then deliver more of those attributes than our competitors do.

The first step is determining exactly what our customers value and to do that, Research Manager Ellen Moyer has designed a new survey method that replaces the old customer satisfaction and customer service surveys. The new Customer Satisfaction Surveys first ask members to identify the retailing attributes that are valuable to them, then asks them to rate REI and the competition on those attributes.

From 55 factors evaluated by respondents in late 1996, REI is focusing on the 15 rated most important by customers, which are listed to the left. "We're strongest in the most important factors, which is a great start," Ellen said. "By really focusing on those things that are most important to members, we can meet their needs and keep them for life."

To begin honing REI's relationship with customers, there are more than a hundred specific actions that have happened or will take place this year. REI's senior management team hopes to see the meter move on the next survey, which will be performed in August. A few of the actions include:

- Reinvesting in each store's payroll by reverting Sunday pay to regular full pay instead of time-and-a-half. Because more sales people can be scheduled using the savings, sales help is more accessible to customers.
- Providing focused product training curricula on camping gear and footwear, to bolster the knowledge of our experienced sales people.
- Purchasing a new Mail Order system that will allow customers to place orders around the clock.
- Translating the full holiday catalog into Japanese for the nearly 80,000 members in Japan.
- Sending Gear Mail e-mails via rei.com to customers based on the topics they want to hear about.

"There's no silver bullet that makes a difference, but by meeting hundreds of small unique needs, we become distinctive in the minds of members," said Dennis Madsen, executive vice president and chief operating officer. "The objective is about finding the things that strike a chord with our customers, that make them feel personally connected and rewarded for being a frequent customer of REI."

Grant sees REI member-led expedition to summit!

Supported by an $1,070 REI Brand Expedition Grant, six REI members successfully summitted Mexico's 18,411 ft. El Pico de Orizaba late in March. Hoping to convey to fellow mountaineers the Tacoma, Wash., climbers hauled more than 300 pounds of trash off the mountain's 13,000 and 14,000 ft. basecamps, depositing the trash in a designated landfill.

The team provided REI with expedition photos as well as in-depth REI brand product evaluations. The team gave high marks, along with suggestions for improvement, for REI's GeoMountain 4 tent and REI MT5 2 underwear. Of the tent, expedition leader Matthew Shupe said, "It's very easy to set up and take down and has good overall design, especially its dual entrances, vestibules, pole structure and fly attachment system."

The REI Brand Expedition Grant program is back this year after a one-year hiatus, along with the REI Brand Employee and Team Challenge programs. For 1997, REI has budgeted $24,000 for the expedition program, an increase of $14,000 over 1996 funding levels.

REI Brand Expedition grants give REI gear in support of a limited number of REI member-led extraordinary expeditions in the specialty shop activities. This support is designed to encourage REI members to use REI brand product and help build loyalty and word-of-mouth support for the REI brand. Grant recipients also provide REI the opportunity to market and publicize interesting expeditions it has supported, further building the REI brand identity.

REI members may acquire guidelines through retail stores or by writing REI Brand Expedition Grant Program, REI Public Affairs, P.O. Box 1938, Seattle, WA 98390-0800.

REI HELPS "REINVENT GOVERNMENT"

Harley-Davidson Inc.

1996 Annual Report

Chicago-based VSA Partners has a long-term relationship with its client Harley-Davidson. This is the sixth annual report the design firm has created for the motorcycle manufacturer.

TRIM SIZE is 7" x 11" (18 cm x 28 cm)

SEVENTY-FOUR PAGES, plus pull-out poster, FOUR-COLOR ANNUAL

Fox River Coronado 80 lb. (120 gsm) Text, Simpson Silverado 80 lb. (120 gsm) TEXT STOCKS

Cheltenham BODY FONT

CIRCULATION: 170,000

LAYOUT PROGRAM: QuarkXPress

HARDWARE: Macintosh

COPYWRITER: Ken Schmidt. DESIGN: Curt Schreiber, Ken Fox, Fletcher Martin. All are staff members at VSA Partners.

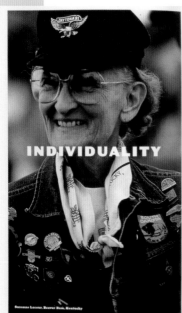

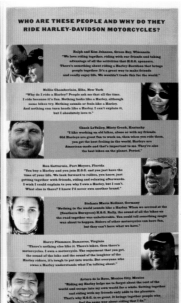

Bringing Worlds Together

A Harley owner could be anyone—the accountant next door, a local politician, even a grandmother. Part of the strength the company's brand lies in this universal appeal. However, not every investor connects with Harley culture. As VSA partner Ken Schmidt puts it, "Sometimes there's a bit of a disconnect between Wall Street investors and customers with Harley tattoos."

Bringing these two worlds together is a design challenge. For the 1996 annual VSA focused on the company's intangible assets—the qualities that make a Harley a Harley, and that make Harley riders so unique. VSA divided these qualities into categories and gave each category a striking one-word title like "Heritage" or "Freedom." These categories, combined to form the cover image, become section headings inside the book.

Each heading is explained through words and pictures that focus on people stories. The National Geographic-style layout lends credibility to what some might consider an alternative lifestyle. For example, this unusual shot of a H.O.G. (Harley cycles are dubbed "hogs," and local Harley Owner Groups use the H.O.G. acronym) owner with his son in Graceland (opposite page, top left) sheds light on the real personality of most Harley owners. This picture says Harley is about more than the open road; it's about real ideals, such as family.

Know Your Product

VSA has one rule for team members working on the Harley account—they must own Harleys. Otherwise, the partners believe, they won't know the product well enough to create a convincing design.

Not Quite Right? Do It Again!

There is an intentionally gritty feel to this design. The type is, as Schreiber explains, "no-nonsense. There's nothing fancy or new-wave here." Just like the product, "it's down and dirty."

The report, like a Harley, is also well-made. VSA designers seldom follow a grid or template for their annuals. Instead, they spend hours laboring over the creative balance of each page. This intensive work gives the overall product a handcrafted feel.

Keep the Reader on the Road

To create a feeling of movement between pages, VSA relies on a painted-background motif. These earthy tones of orange and ocher used to frame images or as background for text were actually painted on canvas and then scanned into the computer for layout.

Captain's Circle Couples Take 43rd Cruise

Onboard a recent Star Princess cruise, two couples both having 43 cruises and 397 days travelled, were honored at an onboard cocktail party. Pictured (left to right) are Cruise Director Billy Hygate, Ruth and Morton Grossman, Captain Robert Baker, Monica Guardino, Social Hostess Linda Stocum and Sal Guardino.

4

PRINCESS PEOPLE

Commodore Augusto Lagomarsini Retires

Stan Jamison Named New Commodore

12

13

Rancho La Puerta Tidings

In operation since 1940, Rancho La Puerta is one of the oldest and finest spas in the Americas. Its newsletter is as old as the spa and has seen many incarnations. Founder and owner Deborah Szekely produced early versions on a mimeograph machine. Tidings' mission is to form an emotional bond between former guests and the spa. It reminds them of the spiritual experience they had and how much they would like to return. Rancho La Puerta is located in Tecate, Mexico.

FOUR-PAGE, FOUR-COLOR TABLOID PUBLISHED THREE
 TIMES A YEAR

Evergreen Natural Matte, 70 lb (105 gsm) BOOK STOCK

BODY FONTS INCLUDE Garamond and Gill Sans

CIRCULATION: 30,000

FEATURE COPY LENGTH: 500 words

LAYOUT PROGRAM: QuarkXPress

HARDWARE: Macintosh

EDITOR: Peter Jensen. DESIGN: Laurie Mansfield Dietter.
 Both are San Diego, California-based freelancers.

Image Placement

When designer Laurie Mansfield Dietter lays out the center spread, she works like a painter. "I choose one dominant image as my base. This picture, typically a vista or beauty shot of one of the buildings on the complex, is always the biggest on the layout. I decide where to place additional images by zooming in and out. I step back and see how the spread looks as a free-standing image; then go back in and work on detail," explains Dietter.

Creating a Theme

"Obviously we don't have the room to take a standard magazine approach with a big headline, one nice big photo complemented by several others, captions, and lots of white space," says editor Peter Jensen. "We have to include up to ten different items in our center spread. But we tie this organized chaos together with a design theme."

Both Dietter and Jensen make numerous trips to the spa in order to develop themes. For the first issue of *Tidings*, Jensen wanted to report on the rock-art–style murals that grace two of the spa's new gyms (opposite page, top). Dietter picked up on this and used her own sketches of cave paintings from the area as her motif. Note how Dietter's illustrations ramble across the page—a technique that keeps the reader's eye in motion.

That Friendly Touch

The use of hand-drawn illustrations, borders, and backgrounds combine to give the design of *Tidings* a very down-home feel. "There's nothing wrong with looking personal," says Jensen. "In fact, I think that's the mark of a good newsletter. It should look like it was created by a micro-publisher rather than a slick advertising firm. Of course, you may win a lot of design awards for an overtly professional look, but you won't always reach your client's customers."

Creating a Feel

"If I was an artist or a botanist staying at Rancho La Puerta," says Deitter, "I would keep a journal or field notes of what I saw. This quick-sketch feeling is something I try to bring to the newsletter." For the Winter 1997 issue, Deitter brought back samples of local fauna, spread them out on her kitchen table, and sketched them (opposite page, middle and bottom). These whimsical yet detailed illustrations reconnect former guests with the garden beauty found everywhere at the spa.

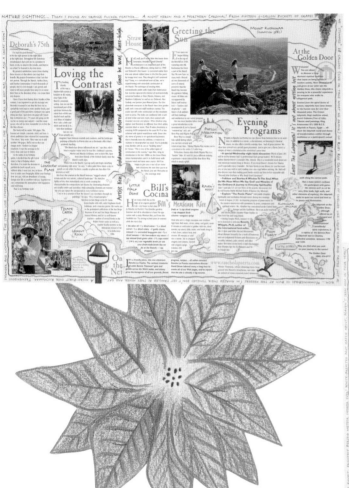

Island Escapes

The mission of parent publication Islands magazine is to describe the feel of island destinations to readers. The publication's subscriber base, however, needed particulars such as how to get to an exotic locale, where to stay upon arrival, and how much a trip costs. Such details, the publishers concluded, would require a change in Islands' highly successful format. The solution? Produce a newsletter.

TRIM SIZE is 8 1/2" x 11" (22 cm x 28 cm)

EIGHT-TO-SIXTEEN-PAGE, TWO-COLOR MONTHLY

Crane Scott Opaque Vellum Book 70 lb (105 gsm) TEXT STOCK

Adobe Garamond BODY FONT; sidebars in Futura Bold

CIRCULATION: 5,000

FEATURE COPY LENGTH: 2,500–3,000 words

LAYOUT PROGRAM: QuarkXPress

HARDWARE: Macintosh

EDITOR: Tony Gibbs. DESIGN: Patty Kelley. Both are members of the Islands Publishing Co. staff based in Santa Barbara, California.

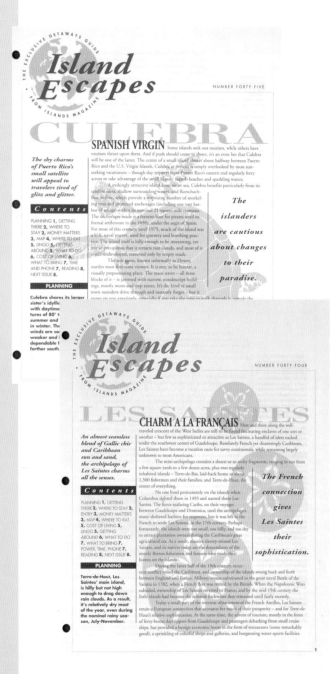

Island-hopping

Every traveler needs a good map and every issue of *Island Escapes* includes one—even though its creation is often an adventure in itself. "Source material is always a problem," says editor Tony Gibbs, who travels to most every destination covered in the newsletter. "Islands that are or were under British possession are well-charted, but islands in other territories often have no official maps." In these cases, Gibbs has to find less conventional forms of reference, such as illustrations from T-shirts or cocktail napkins, to supplement the work of his photographer.

Back home, Gibbs turns over his research to designer Patty Kelley and a freelance artist who combine these varied pieces of information to create a finely detailed pencil illustration. Once this contour map is complete, Kelley scans it and imports it into Adobe Illustrator to create the island's network of roads, trails, and landmarks.

Design You Can Rely On

For the inexperienced, travel to an obscure island can be downright scary. So, not only does the copy for *Island Escapes* have to be up-to-the-minute, the design has to instill a sense of trust, a feeling that everything found within the publication will prove true upon arrival.

To maintain subscriber confidence, Kelley sticks to her three-column template for each issue. Travel data fills the outside sidebar, which measures 2" (5 cm) in width. The center column, 4" (10 cm) wide, carries the feature story; the inside column, which measures 1" (3 cm) wide is set aside for captions and breakouts such as additional photos and copy boxes. The inside and outside columns use bold sans serif type that create a solid frame for the demure serif body copy in-between. The result is a sophisticated, almost scholarly look to the layout.

How Big Is My Photo?

"In most newsletters," says Kelley, "it makes sense to vary the size of photos to create variety. Because the images in *Island Escapes* are informational rather than decorative and deal with specific places such as a hotel or restaurant, it makes sense to keep them all the same size. That way, they carry equal weight in terms of importance for the reader."

Pretty Colors

Kelley works with an illustrator to create clip art for each issue. These pieces represent some unique aspect of the featured island. For instance, the issue on Catalina—the island famous for its roaming herds of buffalo—featured a bison. After the artwork is complete, Kelley digitizes it and imports it into QuarkXPress, where she screens it back behind black text. "I always choose very deep or rich colors," says Kelley, "so I screen my images back to 20 percent or even 15 percent so that you can still read the body text that overprints the illustration. If you're working with a lighter color, of course, you'll be able to go with a much higher percentage."

emerge from the haze.

A few minutes later, the signs of human development become visible, most of them clustered toward the east end, in the heights around the harbor of Avalon. And then you pick out the details of Catalina's most famous landmark, the magnificent cylindrical Casino. Bustling Avalon, larger of the island's two towns, holds nearly all the tourist facilities – restaurants, hotels, shops, rental apartments and homes, tour companies, and water sports operations – as well as most of the island's permanent population. In spite of regular influxes of tourists, the town has managed to retain a distinctive personality of its own, especially noticeable in the off-season months; it's a good-humored cross between amusement park and frontier village.

Residents know they depend on visitors for their economic survival – but they also recognize that the visitors will keep coming only if the island remains worth visiting. And though there are differences of opinion about how much development is permissible and what form it should take, most islanders love Catalina essentially the way it is.

Outside Avalon and the small village of Two Harbors, more than 80 percent of Catalina retains the sometimes stark, always dramatic beauty of natural California, the way it was before automobiles and asphalt. Part of the credit for this happy state goes to geographical isolation: For much of the island's history, those 20 miles of often windswept water between it and the mainland made development simply impractical.

After some 4,000 years of habitation by Native Americans, Santa Catalina was "discovered" and claimed by the Spanish in the 16th century. A land grant from the last

Most of the island is benignly controlled by a nonprofit foundation.

A GUIDE TO
LES SAINTES

LES SAINTES

WHERE TO EAT

Dining on Terre-de-Haut can be a splendid experience. Among the island's two dozen eating places are several that could hold their own nearly anywhere in the world, and even the underorganized establishments would be top-of-the-line on many Caribbean islands. But you want to pace yourself, as few American digestions are ready to assimilate a steady intake of serious cuisine.

Budget aside, we'd suggest you limit yourself to no more than one consequential meal a day, whether it's lunch or dinner. For the other you can snack on *accras* (see LINGO) at a creole restaurant or share a pizza or a plate of chilled smoked fish, a delicious and surprisingly filling Saintois specialty.

All the ferries restaurants have good wine lists, or you can drink beer, juice, or mineral water. (The tap water is quite safe but tastes rather flat.) In most cases the tip is included, but if your bill doesn't say *service compris*, just ask.

For a lighter meal that's also first-class, **LA SALADERIE** is well worth a visit. By Saintois standards – all of 12 tables, in a delightful shaded veranda right on the water, surrounded by tropical plantings. The menu offers nine different salads, from $7 to $12 – or create your own, priced per ingredient. We enjoyed every bite of our *poulet* ($10), composed of tomatoes, onions, bits of honed, just-cooked fresh fish, with olive oil

All Terre-de-Haut is at your feet from the top of Le Chameau.

and French bread on the side. Our dessert was the island's specialty, *tourment d'amour*, a delicately flavored almond-and-coconut pastry. It was pleasant enough, but not the love-tormented bombshell its name would suggest.

Another place for light meals is the **JARDIN CREOLE**, an upstairs bar and restaurant on the square where the ferries tie up. Rambling and clapboardy, it offers three eating areas, including the narrow outdoor porch from which you can survey the street below. It's a bustling, popular hangout that also serves breakfast, beginning at 8:30 A.M. For dinner there's usually a specialty, such as fish pie with a Roquefort dressing ($10), and three or four other main dishes. We had the *poisson fumé* platter ($14), consisting of three varieties of chilled smoked local fish, served with toast and butter and a tomato-and-lettuce salad. Filling and delicious. Another specialty that's well worth a try are the "salty" and "sweet" crepes: Our lime-and-sugar pancake had a wonderful sweet/sour/sugar-crunchy flavor.

albeit sometimes reluctantly. The smaller creole restaurants and some other businesses take neither credit cards nor travelers' checks (on which banks charge a hefty commission) – but many of them will accept U.S. dollars if you'll take your change in francs.

Your hotel will probably be able to change small-denomination travelers' checks, as will the Post Office. A branch of the Credit Agricole bank is tucked under the balcony of the Jardin Creole restaurant, down by the main ferry landing, but it's about the size of a shoebox and its hours seem sporadic in the extreme.

Our advice: Bring about $200 in francs, plus an equal amount in dollars or travelers' checks; and don't forget your *cartes de crédit* – especially Visa and MasterCard.

COST OF LIVING

Local beer	$2.40
Coke	$2.00
Coffee	$1.40
Postcard	$.50
Postage to U.S.	$1.20
Film (36 exp.)	$11.80

LINGO

French is very much the primary language on

WHERE TO STAY

With few exceptions, visitors' accommodations on Les Saintes are restricted to the island of Terre-de-Haut – which is probably where you want to spend most of your time, in any case. No major resort complexes exist here, but there are plenty of other choices. Besides the handful of small hotels and one villa complex, a number of apartments and rooms for rent also come and go. Our feeling, though, is that you're best advised to first sample the island's attractions while lapped in the relative luxury of a hotel or villa before you commit to an apartment.

If you're reluctant to make your accommodation arrangements in a foreign language, we can strongly recommend the services of **FRENCH CARIBBEAN INTERNATIONAL**, a small agency whose extremely helpful staff has personal experience of the places it represents, including those in this newsletter. Tel. (805) 967-9850; fax (805) 967-7798.

Located almost at the western extremity of the island, about two miles from town, the 29-room **HOTEL BOIS JOLI** is virtually a self-contained resort on a small scale. Its primary beach fronts on the island's main bay, not far from the excellent snorkeling around the yacht anchorage at the foot of Le Pain de Sucre. Immediately overlooking the beach, the hotel's large swimming pool abuts a terrace with chaise longues and the shaded bar area where breakfast is also served. On a second level is the hotel's good restaurant and lounge. About a quarter-mile away, over the island's narrow spine, is another beach, *plage Crawen*, accurately described as "clothing optional." (The phrase refers to total nudity, since mere toplessness is optional at all beaches – and around your hotel's pool, too.)

The Bois Joli's accommodations are either connected bungalows or individual rooms in a blocky, three-story pink building slightly removed from the restaurant. The rooms are small and the furnishings minimal, but views are good. Those described as "first class" have air-conditioning, a bath area with hot-water shower (though only cold water in the sink), and nice harbor views ($151 for a double in low season; $172 in high). The bungalows are newer and fancier, and (in our opinion) worth the extra charge of $71-$73 per night. In both cases, the Modified American Plan

(You can encounter a tropical rain shower at any time, though.) Temperatures don't vary greatly throughout the year – figure between 65° and 85°F – and the easterly trade wind makes air-conditioning unnecessary except on still, sunny days. You're in the hurricane belt, of course, so August and September are questionable times to visit. Our choice would be spring – April or May.

GETTING THERE

From the U.S. mainland, it's a three-stage flight at least. East Coast travelers can easily reach Terre-de-Haut in a single day, leaving JFK at 8 A.M. and arriving in Pointe-à-Pitre, Guadeloupe, a little after 2 P.M. (Low-season advance purchase weekdays - $418, R/T; high-season, $462, via American Airlines.)

A daily 5 P.M. Air Guadeloupe flight hops across to Les Saintes ($72 R/T) in about 15 minutes. You can make your reservation from the U.S. – tel. (590) 82-47-00 – but you'll have to pay for and pick up your ticket at Pointe-à-Pitre airport.

Coming from the Midwest or West Coast,

The greatest attraction of Les Saintes is the combination of classically Caribbean climate, hospitality, and geography with French cuisine and culture. The essence of these little islands exists outside the daytrippers' perimeter – on the delightful beaches of Terre-de-Haut, the pleasant trails of Terre-de-Bas, and in the town once the ferries and cruise ships have left.

The small Auberge Les Petits Saintes happily combines a hotel, restaurant, art gallery, and antique shop.

Island Escapes
(ISSN 1056-997X) is published monthly by Islands Publishing Co., 3886 State St., Santa Barbara, CA 93105. (805) 682-7177. Issue 16: May 1995. Annual subscription price $78. Second-class postage paid at Santa Barbara, CA. POSTMASTER: Send address changes to: *Island Escapes*, 3886 State St., Santa Barbara, CA 93105.

Editor's choice

AUBERGE LES PETITS SAINTES

You're unlikely to find a more resolutely unusual small inn than this 11-room establishment, also known as Les Anacardiers and formerly a private home, perched on a hillside overlooking the town and harbor. One of the Auberge's young owners is a painter whose colorful works adorn the walls, but the profusion of antiques (also for sale) in the main lounge area what will seize your attention, while your soul is soothed by eclectic taped music. Outside is a delightful terrace with swimming pool, and the auberge's justly renowned restaurant (see Where to Eat) is on the veranda. The atmosphere is warm and disarming – after a few hours you feel as if you're a house guest rather than a client. The small air-conditioned rooms are divided between the ground floor and upstairs, and though all have private toilets, four of them share two showers. We'd choose #2, which has its own shower and an entrance on a semiprivate veranda – a pleasant place to vegetate, overlooking the pool area. ($92 from mid-April to mid-December; $130 the rest of the year.) The room charge includes tax and service, as well as a simple but adequate continental breakfast consisting of fresh juice, a whole baguette with butter and homemade preserves, and a pot of superb coffee. Tel. 99-50-99; fax 99-54-51.

includes a buffet breakfast and a full dinner, use of the pool, beach, and water sports gear, as well as airport transfers and a van service to and from town several times a day. A coolly friendly, family-oriented establishment, the Bois Joli is fine if you're not the sort of person who plans to spend a lot of time in your room, and if the attractions of town and its eating places aren't a primary interest. (We think you're missing a lot if you restrict your Saintois dinners to a single establishment.) Tel. 99-50-38; fax 99-55-05.

If you're willing to prepare some of your own meals, **LE VILLAGE CREOLE**, a short walk from the east end of town, may be just the ticket. The 22 modern, compact, well-arranged apartments, two to a villa, are designed to accommodate four (in two small but air-conditioned bedrooms upstairs) plus two more, if required, on a folding bed in the all-purpose main room downstairs. There's an outdoor deck for lounging. The furnishings are simple but entirely adequate, and the kitchenette is exceptionally well equipped. Though our apartment had clearly been well used, it would be hard to imagine a better setup for a small family or one or two couples, whether they planned to cook or not. Thanks to cross-ventilation, the air-conditioning isn't really necessary until you close the bedroom doors. The apartments are cleaned daily, and the manager, Ghyslain Laps, not only speaks English but knows his island inside and out and will be delighted to help with arrangements. Waterfront apartments for two adults are $112 from mid-April to mid-December, $168 the rest of the year, except for Christmas-New Year's and Carnival (mid-February to mid-March), when a surcharge applies. Garden units are $20 to $40 less. For two couples, the waterfront units are $152 and $228. Tel. 99-53-83; fax 99-55-55.

you'll probably have to make an overnight stop on the outward leg of the trip. Even though you arrive in Pointe-à-Pitre late at night, it's a more sensible layover than from San Juan, and you can either spend the day sightseeing Guadeloupe or take the 8 A.M. (except Sunday) Air Guadeloupe flight. (From Los Angeles, $722 or $767, R/T; from Chicago, $586 or 630, R/T.)

You can also ride a high-speed ferry that leaves Point-à-Pitre at 8 A.M. and returns from Terre-de-Haut at 4 P.M. (1 hour; $32 R/T), but it can be bouncy in the short open-water stretch between islands.

ENTRY

Passport: Yes.
Visa: No.
Tip: You must clear customs in Pointe-à-Pitre, but if you're clearly a tourist and don't seem to speak French, you'll probably be waved through the green, nothing-to-declare lane without inspection.

MONEY MATTERS

Currency is the French franc, which runs about 5F = US$1.00. On Terre-de-Haut, most tourist-oriented shops and eating places accept plastic,

g a l l e r y

F o o t p r i n t s

Footprints is published by Adventure 16, a Southern California-based outfitter devoted to equipping, training, and guiding outdoor enthusiasts.

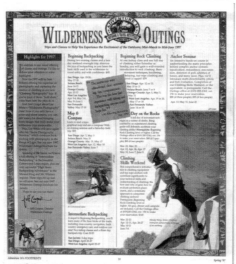

TRIM SIZE is 11"x 12" (28 cm x 30 cm)
SIXTEEN-PAGE QUARTERLY
CIRCULATION: 75,000
EDITOR: Peter Jensen. DESIGN: Marjorie Taylor.
 Both are freelancers based in San Diego, California.

Everything about *Footprints* says "outdoors," from the action photos to the intriguing woodcut-style banners and icons. *Footprints* runs on newsprint, which isn't as friendly to color as a glossy or matte-finish paper. However, Adventure 16 designers make the most of this format by using color sparingly. Overuse of color would seem dull. Here, colored icons and rules mixed with a few background screens add just the right amount of spice to already stunning outdoor images.

T h e A r t o f E a t i n g

Edward Behr's publication The Art of Eating *proves that every meal can be an exquisite experience.*

TRIM SIZE is 8 1/2" X 11" (22 cm x 28 cm)
TWENTY-PAGE QUARTERLY
Sabon BODY FONT
CIRCULATION: 2,500
EDITOR AND WRITER: Edward Behr. DESIGN: Keith Chamberlin of
 Saint Johnsbury, Vermont, and Edward Behr of Peacham, Vermont.

The Los Angeles Times calls *The Art of Eating* "thoughtful and graceful." Both these adjectives certainly apply to Edward Behr's design. This publication embodies the art of simplicity, proving that elegant design is just as appealing as cutting-edge design. Behr's clean, two-column layout emphasizes well-written copy. Sophisticated black-and-white photography creates interest. Notice the subtle use of dingbats—as essential to this publication as the proper presentation of a gourmet meal.

The Southern California Gardener

The informative Southern California Gardener *comes to readers three-hole punched so that they can save seasonal tips, advice, and reminiscences on gardening along the Pacific Coast from year to year.*

TRIM SIZE is 8 1/2" x 11" (22 cm x 28 cm)
TWENTY-EIGHT-PAGE BIMONTHLY
Centaur BODY FONT
CIRCULATION: 8,000
EDITOR: Lili Singer, who, along with CO-PUBLISHER: Phyllis Benenson, is based in Van Nuys, California. ART DIRECTOR: Siobhan Stofka, Siobhan Stofka Design, located in Los Angeles.

Color illustrations make this handy notebook a real piece of art. Covers for *The Southern California Gardener* are especially striking, setting the tone for each issue. The two-column layout allows for text to flow smoothly throughout, even in the more complicated "Planting Guide" section where information on annuals, perennials, and edibles is separated by two-point rules.

Passages

Magellan's World is a club for travelers, the benefits of which include a subscription to Passages. *Features include travel, health, adventures, discoveries, and new products.*

TRIM SIZE is 8 1/2"x 11" (22 cm x 28 cm)
EIGHT-PAGE QUARTERLY
Adobe Garamond BODY FONT
CIRCULATION: 5,000
EDITOR: William Callahan of Magellan's World. DESIGN: Dean Puccinelli of Balint & Reinecke. Both are based in Santa Barbara, California.

Old World maps, icons, and treatments serve as pleasing backgrounds for this businesslike publication. The three-column format and relatively small (ten-point) Garamond type allow designer Dean Puccinelli to include more text than most newsletters. However, notice that he is careful to keep the leading open for easy reading. Photos run relatively small but still pack punch as they are well-cropped and sharp.

S o u t h T e x a s C o l l e g e o f L a w 1 9 9 6 A n n u a l R e p o r t

*The only private law school in Houston, Texas, South Texas
College of Law has trained lawyers to hold positions of leadership since 1923.*

TRIM SIZE is 10 1/2" x 8" (27 cm x 20 cm)
FORTY-EIGHT-PAGE ANNUAL
BODY FONTS INCLUDE Adobe Garamond, Gill Sans, and Triplex
CIRCULATION: 10,000
DESIGN: Geer Design, artist Mark Geer based in Houston, Texas.

This annual report details the college's initiative to bring together technology and the
practice of law. By using the Internet as a massive resource, virtually creating an on-line
courtroom, students can jump-start their careers into the twenty-first century. Futurism
combined with the sophistication of the legal profession are portrayed through Mark
Geer's vibrant design.

The cover is a good example of this symbiosis. It features an embossed image of a wall
plate for a telephone jack, in this context representing modem outlet. Inked on top are
tiny orange arrows running in opposite directions in horizontal columns. this arrange-
ment evokes the power of information exchange. Throughout the report, digitally-
enhanced photos reproduced with fluorescent inks show how the study and practice of
law will benefit from existing and emerging technologies.

W i n d o w o n W h e e l e r

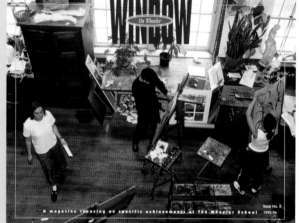

*Founded by artist Mary C. Wheeler in 1889, The Wheeler School is a college preparatory school for nursery
through twelfth-grade students. Curriculum focuses on art as a means to a more well-rounded education and
view of life. Student Jennifer Aisenberg explains the mission of the school in this quote found in the pages of the
publication: "Since the age of five, I've seen works of art adorning the walls of Wheeler hallways that seem equal
to anything at the Museum of Modern Art. And now, doing these projects myself, I feel almost superhuman."*

TRIM SIZE is 11" x 8 1/2" (28 cm x 22 cm)
FORTY-FOUR-PAGE ANNUAL
Galliard BODY FONT, horizontally scaled to 90 percent
CIRCULATION: 5,000
EDITOR: Laurie Flynn. DESIGN: Keating & Associates/Hess Design with the Wheeler School
 Art Department. The Wheeler School is located in Providence, Rhode Island.
 Keating & Associates/Hess Design is based in South Natick, Massachusetts.

The most impressive element of *Window on Wheeler* is the courageous design decision to allow
student work to stand on its own. This gate-fold, featuring three pages from the oeuvres of
young Wheeler artists, is proof that kids can do anything, even self-portraiture, just as well as
adults—that in fact, the sky is the limit. The layout of these images is held together by a
repetitive frame with a thin (half-point) rule. This is featured throughout and represents
Wheeler's "Window."

Note the pleasing compositions of photos from page to page. On the left-hand page, images
are arranged along diagonals. On the center page, images follow a more circular path and are
placed near the outlines of the frame. The right-hand page puts the weight of images on the
top and bottom of the page. This change in rhythm attracts attention and draws the eye from
page to page.

Malofilm Communications
1996 Annual Report

Malofilm Communications is involved in all aspects of the entertainment industry. From live action, multimedia, and animation production to acquisitions and distribution, they do it all.

TRIM SIZE is 9" x 11" (23 cm x 28 cm)
THIRTY-SIX-PAGE ANNUAL
Trad Gothic BODY FONT
CIRCULATION: 6,100
DESIGN: Belanger Legault Communications Design Ltd. based in Montreal, Quebec, Canada.

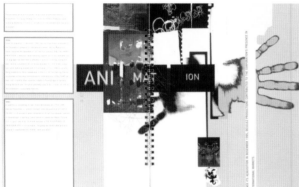

With major acquisitions and numerous projects in the production pipeline, Malofilm is a company on the move. Belanger Legault Communications' design captures both this progressive feel and the excitement of the moving image with a jazzy layout. The "in production" look comes, in part, from the irregular and rough treatment of images, as if they were pieces of film rescued from the cutting-room floor. Also note that negative images are used often. The six-column layout is played with, sometimes becoming one wide column, sometimes running horizontally instead of vertically. This effect gives the look of film running through a projector.

Jacor Communications Inc.
1996 Annual Report

From the annual: "Including announced pending acquisitions, Jacor owns, operates, represents or provides programming for approximately 130 radio stations in 28 broadcast areas. . . . In addition, Jacor's E.F.M. subsidiary syndicates programming, including Rush Limbaugh and Dr. Dean Edell, to approximately 800 stations throughout the country."

TRIM SIZE is 6 1/2" x 11" (17 cm x 28 cm)
FIFTY-PAGE ANNUAL
BODY FONTS include Garamond and News Gothic
CIRCULATION: 15,000
DESIGN: Petrick Design of Chicago, Illinois.

Titled *Imagine,* Jacor's annual report comes in a black sleeve with a small cut-out window that frames the word "enigamI" printed on the report within. When the report is removed from the sleeve, the reader finds a ten-page vellum fold-out. "enigamI" becomes "Imagine" and a string of very interesting lyrics are revealed across the accordion-like pages. Text from news reports are mingled with phrases from popular songs, creating an almost improvisational poem— and exactly what listeners hear when they flip through a radio dial.

Underneath the text is a stream of screened-back colors forming the image of a recycling radio wave. This intriguing fold-out leads the reader into a clean, concise, two-color report.

ntries, "I learned ... myself, such that ld products... log drains as ... hemicals we buy ... showed me how ... negar unclogged ... ly safe for the ... conomical."

ence Fair is an ... ored by local ... munity

ding Nissan.

of the event, ld in the South ... years.

Mary Williams, ... r for Nissan, ... Nissan has par-

the streetscapes as he displayed how electricity is generated and distributed – including electric vehicles. I always walk away from this event with a handful of new ideas sparked by these kids and their projects."

goods & services

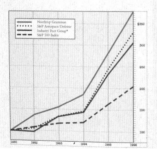

business operations. Success requires that we maintain excellent relationships with customers, suppliers, employees, and other stakeholders.

The adjacent chart portrays the measurement of shareholder value creation. Performance to the right of the vertical center line indicates success at earning cost of capital—the minimum level of return necessary to compensate shareholders for investing their money in the company. A position above the horizontal center-line indicates effective asset utilization. Our goal is to continue to perform at the highest level in the blue quadrant while growing revenues.

Shareholder value is the primary component in determining incentive compensation for Northrop Grumman officers and key managers. Ongoing employee educational programs ensure that a unified focus on value creation permeates the entire company. As a result, employees are devising and executing such value-building actions as disposing of excess assets, speeding cycle times, and eliminating unnecessary activities.

The comparative returns chart below clearly shows the success of our efforts in value creation as compared to our industry peer groups and the Standard and Poor's 500.

end figure in our history, and we reduced our debt by $1 billion.

Kent Kresa
Chairman of the Board,
President, and
Chief Executive Officer

Your management team is excited about the future of Northrop Grumman. We are in a growth mode. Many of our programs are at the beginning of their production life cycles. Our products are performing well in service, and have drawn praise from our customers. We were successful in winning many new programs in 1996 and we are off to a good start in 1997 capturing new and follow-on business in our primary markets.

We continue to take the actions necessary to streamline our operations, eliminate excess facilities and equipment, and strengthen the company's position to compete in the defense and commercial aerospace and information systems market-places of the twenty-first century.

Over the past three years, we have successfully brought together four separate enterprises—Northrop, Grumman, Vought Aircraft, and Westinghouse's defense and electronics business—to form a seamless team. Our business imperative of "Perform, Win, and Grow" is intrinsic to the management philosophy of all our operating elements, and we continue to employ the fundamental principles of integrated product and process teams throughout the company to achieve the competitive technology, management, and financial advantages necessary to ensure a bright future.

With the acquisition of the defense and electronics business of Westinghouse Electric Corporation last March, we have transformed the company from a producer of military air-planes to a defense electronics firm with a stable military air-craft business and expanding commercial aerostructures and marine, space, and information systems businesses.

Saturn Turns Ten

en years ago, no one would have believed it. An American company could come along and build a small car at an affordable price that would rival the imports in quality.

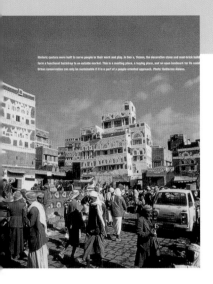

Historic quarters were built to serve people in their work and play. In Sna'a, Yemen, the decorative stone and mud-brick buildings form a functional backdrop to an outside market. This is a meeting place, a buying place, and an open landmark for its residents. Urban conservation can only be sustainable if it is a part of a people-oriented approach. Photo: Guillermo Aldana.

No matter the social status, no matter the purpose, excuse, or inclination, nothing can stop us from shopping. We buy goods that support our daily needs, that display our social status, that entertain and comfort us. Many even spend a great deal of their workday buying goods and equipment for their workplaces.

Nothing can stop us from shopping. We buy goods that support our daily needs, that display our social status, that entertain and comfort us.

With an ever-increasing sea of choices, it is often hard for companies providing goods or needed services to rise above this melee of buying. Nowadays it is not enough to have the best product or to create something truly useful and worthwhile. For customers to even know it exists, a product must be marketed in constantly evolving ways.

Branding a product—to create for it an identity that is immediately recognizable as the most hip, the most exclusive, the most reliable, or the most unusual—is all important. One of the best ways to develop or enhance a brand is through the design of a strong newsletter or annual report. As opposed to a Website, the value of printed material is the ability to immediately convey substantiality. Great design can build this by portraying not only the product but the feel of the product. As you will see in the pages that follow, design and illustration combine to explain how a manufacturer feels about a product and what it can do. Design shows that a grease-stained aircraft hangar is actually high art, that a piece of computer hardware is really a playful tool, and that box of cereal can remind us of the victories of life.

Design, in other words . . . sells.

adaptec

ADAPTEC, INCORPORATED
691 SOUTH MILPITAS BOULEVARD
MILPITAS, CALIFORNIA 95035
(408) 945-8600
http://www.adaptec.com

CAHAN & ASSOCIATES 818 BRANNAN STREET SUITE
300, SAN FRANCISCO, CA 94103 PH: (415) 621 0915
FAX:(415) 621 7642 © CAHAN & ASSOCIATES

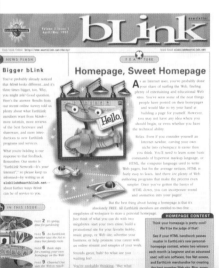

Observation

4

equipment

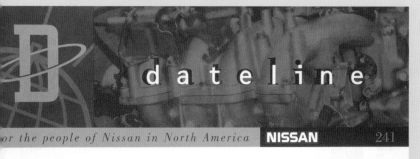

dateline

or the people of Nissan in North America **NISSAN** 241

Infiniti Indy Power Takes Five Top 20 Finishes

To sports enthusiasts and automotive manufacturers around the world, the Indianapolis 500 represents

This year a large crowd, including a group of Infiniti dealers, DOMs, and service writers were on hand to witness the Infiniti Indy engine make its successful debut at the Indy 500 – only 15 months after the project officially began. After 200 laps around the historic 2.5-mile Indianapolis Motor Speedway, five of the top 20 finishers were powered by the Infiniti Q45-based, 4.0-liter, 32 valve V8 racing engine.

A total of six Infiniti Indy-powered cars qualified for the event, piloted by an experienced drivers list that included Mike Groff, Roberto Guerrero, Lyn St. James, Johnny Unser, Dr. Jack Miller and Dennis Vitolo.

For only the second time in its 81-year history, the start of the race was delayed for two days due to rain – with the event

Running as high as ninth place at one point in the race, Infiniti Indy driver Lyn St. James' #90 Hemelgarn Racing Infiniti Dallara receives attention in the pit.

Go with your gut. That's the slogan of Cahan & Associates, a San Francisco-based design firm that created the quirky and highly successful 1996 annual report for Adaptec, a manufacturer that specializes in computer products that move digital information at high speeds. In this case, the client wanted to brand a new identity. Of course, Adaptec wanted to show that it builds products that "move the data that moves the world." Also needed was something a bit beyond the ordinary. Users were to think of the products as more than just pieces of equipment—as tools for enhancing, creating, and furthering any type of digital endeavor.

You know you've got a great design concept when the parts come together with relative ease—your favorite choice is often the right choice. The designers highlighted in this chapter adhere to this simple yet elusive law of design.

The solution? Create a publication that anyone can identify with—a child's primer with all its bold colors, feisty characters, and simplistic text.

When interviewing Bill Cahan about this ingenious choice, he explained that when the idea came up, every one of his designers immediately knew it was right because . . . it felt right. Because it felt right, all the elements of the design process fit perfectly, as if the project itself appreciated the idea. (Hint: you know you've got a great design concept when the parts come together with relative ease.) Cahan added that one of the most rewarding aspects of production was the confidence to work from the gut, that the favorite choice is often the right choice.

In our this chapter, all the designers have adhere to this simple yet elusive law of design. We hope you enjoy their unexpected approaches.

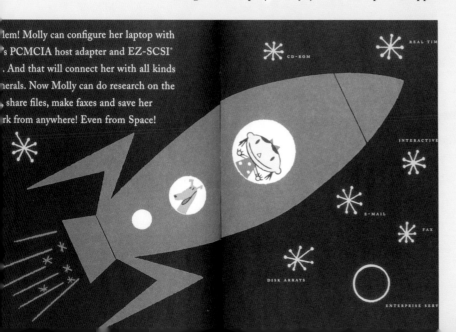

lem! Molly can configure her laptop with
's PCMCIA host adapter and EZ-SCSI°
. And that will connect her with all kinds
nerals. Now Molly can do research on the
, share files, make faxes and save her
rk from anywhere! Even from Space!

REAL TIM
CD-ROM
INTERACTIVE
E-MAIL
FAX
DISK ARRAYS
ENTERPRISE SERV

Northrop Grumman Corporation

1996 Annual Report

For thirty years, Northrop produced high-quality annual reports featuring black-and-white photographs. In 1996, the company focused on its move from aircraft prime contractor to defense electronics manufacturer. To maintain its dignified manner, present aerospace equipment as art, and portray a new feeling of diversification, Northrop Grumman relied on the talents of Douglas Oliver and his Santa Monica-based design studio.

TRIM SIZE is 8" x 11" (20 cm x 28 cm)

EIGHTY-EIGHT-PAGE, SIX-COLOR ANNUAL

Confetti Black, COVER STOCK; Proterra Shale, Stucco, Oyster 70 lb (105 gsm)TEXT STOCK; Duotones printed on Mead Signature Gloss 100 lb (150 gsm) TEXT STOCK

Bembo BODY FONT

CIRCULATION: 87,000

LAYOUT PROGRAM: QuarkXPress

HARDWARE: Macintosh

DESIGN: Douglas Oliver, Douglas Oliver Design Office, Santa Monica, California.

Northrop Grumman Corporation

1996 Annual Report

Just Let It Happen

Cover design is the most important aspect of any quality annual report. However, the process of creating a great cover often is attributed more to serendipity than technique. Designer Douglas Oliver found this cover while touring a naval facility for Northrop in Annapolis. He was intrigued by the many computer printouts tacked to walls and strewn across desktops. When he spied a sonar test on unique circular graph paper, he knew he had his art.

Box It Up

To help portray the new, diversified nature of Northrop Grumman's business, Oliver decided to compartmentalize. He treated each section as a stand-alone, mirroring the way the company began approaching its many new sectors. One of the most powerful departments in this annual report is a twelve-page photo essay of black-and-white images, each showcasing a piece of equipment in dramatic light. Oliver explains that the showcase serves several purposes: first, it provides a sophisticated feel, akin to fine art; second, the use of black-and-white rather than color gives the report the air of a documentary film, which, as Oliver points out, lends credibility—a sense that everything included rings true; and third, the gallery does not feel overdone to stockholders. Black-and-white, although usually as expensive to produce as color, seems a fiscally responsible choice.

About Those Charts

Oliver created reader-friendly charts. For instance, a graph on page two (opposite page, top) shows how dramatically an investment of US$100 in Northrop Grumman common stock rose in five years. "When a company has something this powerful to say, they want to put it up front," explains Oliver. However, he is quick to add that charts have to be straightforward. "I've never been excited by gimmicks in charts or ones that are too involved. You can use design to cleverly disguise poor numbers, but, in the long run, you're really not hiding anything. I think it's better to create charts that deliver a simple message quickly."

Paper

One of the first elements that both designer and client agreed upon was the choice of paper. "We wanted a textbook feel to the book. We also decided early on that, budget-wise, it was not compelling to sprinkle the entire book with photos. An uncoated stock meant we could enhance the sophisticated feel by adding colored line art." Each compartment boasts a different shade of paper, but each choice comes from the same family.

At NORTHROP GRUMMAN, a principal business objective is to achieve superior growth in shareholder value. In 1993, we initiated a shareholder value measurement process based upon cash flow return on investment principles. This process is integral to our strategy formation and execution, and guides daily business operations. Success requires that we maintain excellent relationships with customers, suppliers, employees, and other stakeholders.

The adjacent chart portrays the measurement of shareholder value creation. Performance to the right of the vertical center line indicates success at earning cost of capital—the minimum level of return necessary to compensate shareholders for investing their money in the company. A position above the horizontal center-line indicates effective asset utilization. Our goal is to continue to perform at the highest level in the blue quadrant while growing revenues.

Shareholder value is the primary component in determining incentive compensation for Northrop Grumman officers and key managers. Ongoing employee educational programs ensure that a unified focus on value creation permeates the entire company. As a result, employees are devising and executing such value-building actions as disposing of excess assets, speeding cycle times, and eliminating unnecessary activities.

The comparative returns chart below clearly shows the success of our efforts in value creation as compared to our industry peer groups and the Standard and Poors 500.

[fig. 1 – SHAREHOLDER
VALUE CREATION]

A January 1991 investment of $100 in Northrop Grumman common stock was worth $379 in December 1996. Total return assumes reinvestment of dividends.

* Industry Peer Group includes Boeing, General Dynamics, Lockheed Martin, McDonnell Douglas, Raytheon, and United Technologies.

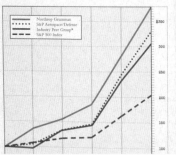

	Northrop Grumman
	S&P Aerospace/Defense Industry Peer Group*
	S&P 500 Index

$350
300
250
200
150
100

Fellow Shareholders

1996 WAS A VERY SUCCESSFUL AND EVENTFUL YEAR
We achieved record sales of $8.1 billion and record op
million. The company's business backlog stood at $12.
end figure in our history, and we reduced our debt by

KENT KRESA
Chairman of the Board,
President, and
Chief Executive Officer

Your management team is
Northrop Grumman. We
our programs are at the be
cycles. Our products are p
drawn praise from our cus
winning many new progra
good start in 1997 capturing new and follow-on business in
our primary markets.

We continue to take the actions necessary to streamline our operations, eliminate excess facilities and equipment, and strengthen the company's position to compete in the defense and commercial aerospace and information systems market-places of the twenty-first century.

Over the past three years, we have successfully brought together four separate enterprises—Northrop, Grumman, Vought Aircraft, and Westinghouse's defense and electronics business—to form a seamless team. Our business imperative of "Perform, Win, and Grow" is intrinsic to the management philosophy of all our operating elements, and we continue to employ the fundamental principles of integrated product and process teams throughout the company to achieve the competitive technology, management, and financial advantages necessary to ensure a bright future.

With the acquisition of the defense and electronics business of Westinghouse Electric Corporation last March, we have transformed the company from a producer of military air-planes to a defense electronics firm with a stable military air-craft business and expanding commercial aerostructures and marine, space, and information systems businesses.

	Northrop Grumman
	S&P Aerospace/Defense Industry Peer Group*
	S&P 500 Index

Northrop Grumman Corporation

A Little Character, Please

"We only use five typefaces here and have a tendency to focus on the ones with a low x-height and tall ascenders in the lowercase. Faces with this configuration just look more classic, more elegant. Bembo is the face we chose for Northrop because it has a complete family of old-style figures and a good-looking companion italic. The choice of your type is a major one, and that's why we work with so few. Within a face there are a whole family of options that can be used together to create a typographic system for your book. This should create a set of visual cues for the reader that lures him through," says Oliver.

To Keep It Simple, You Need a Lot of Patience

Oliver wanted to depict the width and depth of the company at a glance. To achieve this he created a chart (below) that boasts all the intrigue of a periodic table. Early concepts for this spread included a mock-futuristic battlefield on which each of the many combat systems would be shown in action. As Oliver explains, this became an abyss of work and didn't seem to meet the mission statement. Instead, he decided to stick with detailed silhouettes that literally jump off the page. Although this may appear to be one of the easier spreads to put together, its layout kept changing until print time—proving that achieving simplicity can be a complicated process.

TRIM SIZE is 14" x 8 1/2" (36 cm x 22 cm)

FOUR-PAGE, TWO-COLOR, BIWEEKLY

Evergreen 70 lb (105 gsm) TEXT STOCK

Times Roman BODY FONT

CIRCULATION: 3,200

FEATURE COPY LENGTH: 450 words

LAYOUT PROGRAM: QuarkXPress

HARDWARE: Macintosh

EDITOR: Kristin Gallagher, located in Tustin, California.

DESIGN: Randy Nickel, Nickel Advertising Design, located in Dana Point, California. Internal Communications, Nissan, Rick Christopher, based at the national headquarters in Gardena, California.

d a t e l i n e N i s s a n

dateline Nissan *keeps employees up-to-date on internal events, activities, and initiatives.*

Pick a Template, Any Template— Then Stick with It

Five years ago designer Randy Nickel was hired to redesign *dateline Nissan*. Working in conjunction with freelance editor, Kristin Gallagher, Nickel's goal was to create diversity from issue-to-issue through graphic elements, as opposed to constantly redoing his template. Says Nickels, "I've learned that you can really push too hard to create a new look. You have to listen to that old phrase—keep it simple, stupid. If you keep the layout consistent, same type from issue to issue, you allow your graphics to make a difference." And that, after all, is what they're there for.

Different Is Good

dateline Nissan's template is three columns, plus two very thin outside columns used for wacky trivia and oddball quotes. Gallagher explains that originally these quotes had something to do with Nissan or at least with cars and were included to keep reader interest. The response from employees was overwhelming—most workers state that the quotes are the first item they read when they pick up the publication. Says Gallagher, "Our selection of quotes just got more funky and off-the-wall. Now they have nothing to do with articles; they're just there to keep people entertained."

Notice (page 57) that these outside columns are also used for photo bleeds.

Nissan Foundation Celebrates Year-Five

True to its heritage, the Nissan Foundation commemorated its fifth anniversary by rewarding five non-profit organizations with grants totaling $250,000. The grants, which far exceeded the organizations' requests, were presented at an awards ceremony held

Recipients of the anniversary grants included The Accelerated School, the Youth Intervention Program, A Place Called Home, Puente Learning Center and Para Los Niños. The five organizations were selected to receive Foundation grants based on their innovative programs that are proving to generate positive results in the South Central Los Angeles Community.

"Thanks to the Nissan Foundation's support, our Crisis Nursery has successfully prevented abuse and neglect in over 99 percent of participants during its first three-and-a-half year of service," says Miki Jordan, executive director and CEO of Para Los Niños. "The Crisis Nursery must keep its doors open to families during times of crisis to ensure the safety of children."

The Nissan Foundation was established in 1992 as a five-year, $5 million endowment following the civil unrest in South Central Los

Infiniti Indy Power Takes Five Top 20 Finishes

To sports enthusiasts and automotive manufacturers around the world, the Indianapolis 500 represents

This year a large crowd, including a group of Infiniti dealers, DOMs, and service writers were on hand to witness the Infiniti Indy engine make its successful debut at the Indy 500 – only 15 months after the project officially began. After 200 laps around the historic 2.5-mile Indianapolis Motor Speedway, five of the top 20 finishers were powered by the Infiniti Q45-based, 4.0-liter, 32 valve V8 racing engine.

A total of six Infiniti Indy-powered cars qualified for the event, piloted by an experienced drivers list that included Mike Groff, Roberto Guerrero, Lyn St. James, Johnny Unser, Dr. Jack Miller and Dennis Vitolo.

For only the second time in its 81-year history, the start of the race was delayed for two days due to rain – with the event

Running as high as ninth place at one point in the race, Infiniti Indy driver Lyn St. James' #90 Hemelgarn Racing Infiniti Dallara receives attention in the pit.

dateline Nissan

Since the budget is fairly tight, Nickel creates most of the illustrations himself. Although he doesn't think of himself as an illustrator, his kooky creations are refreshing. Take a look at this fun picture of a rather nerdy young fellow surrounded by zipping atoms. This graphic accompanies an article about a science fair judged by a Nissan employee. Part of the appeal comes from the fact that it's a rough, simple sketch. However, refining it a tad in the computer with the additions of tinted highlights and a colored background makes it jump off the page.

Steal from the Big Guys

Nickel wanted the newsletter to look like a magazine, at least, at first glance. So, he set up his flag as a grid. The D for "dateline"—with its ring that represents employees coming together—always butts up against a frame with a changing background. Behind the lowercase word "dateline" is a new image every issue.

Table of Contents: Don't Box Them In

Tired of seeing tables of contents in a box? Here's a fun alternative. Nickel runs his "Inside this Issue" along the bottom of the page with icons representing the various stories (opposite page, bottom).

A succe
Kanri ope
Sacramen
PDC-wid
NMC's P.
The Genb
took place
of 1996 a
NML's Sa
Japan. In
NMC trai
Genba Ka
PDC supe
operations
parts distr
Genba
shop floor
philosoph
boost PD(
as well as

Women buy more athletic shoes per year than men do, but men spend 34% more per pair.

IQS Rankings Strengthen Brand Image

There is plenty of excitement around Nissan about the 1997 J.D. Power and Associates Initial Quality Study (IQS) results, and rightly so. The findings of this independent research group make a powerful statement to consumers about the quality of Infiniti and Nissan vehicles – a statement that can translate directly into increased sales.

Visions is a publication for Saturn owners, employees, retailers, and their families.

TRIM SIZE is 11" x 17" (28 cm x 43 cm)

EIGHT-PAGE QUARTERLY; FOUR-COLOR outside,
 TWO-COLOR inside

Sabon BODY FONT

CIRCULATION: one million+

LAYOUT PROGRAM: QuarkXPress

HARDWARE: Macintosh

EDITOR: Juanita Kukla. DESIGN: Hal Riney & Partners,
 San Francisco, California.

Preview Features

The cover of *Visions* (left) lets readers know what's inside by placing, just above the flag, a brief description and portions of graphics from feature articles. This design technique subtly suggests: "We've got a whopper newsletter here, and some of the things to look for are . . ."

Designer Drop Caps

Susan Holmgren of Saturn's Corporate/Manufacturing Communications says an artist was commissioned to design "a whole alphabet with a Saturn look." The *Visions* flag spells the newsletter name with letters from this parts-tools-gauges, etc. creation. The drop caps that head each article keep the look—a Saturn look, a consistent look.

A Little Fun with Art

Artists are commissioned to design graphics for *Visions*. Their assignment is to keep the upbeat look of Saturn's brochures, to come up with work that is, as Holmgren describes, "cartoony, playful." This fun look follows the idea that Saturn customers shouldn't be just satisfied, they should be enthusiastic.

Note the graphic that takes up one-third of the back page of Winter 1995 *Visions* (opposite page, top). The expressions of members of a rowing crew present the idea that their work—say, they're really working together as builders or sellers of Saturn or they're really out for a spin in a Saturn—is just plain fun. They row with tools of the Saturn trade rather than oars.

Another large graphic shows cheerful-looking figures who appear to be on an assembly line. They are a retailer and a worker who team up by raising high a giant wrench. Thus the Saturn spirit is kept in place here and throughout *Visions*.

Now that you have developed a reputation for knowing a cool thing when you drive one, chances

acuSounder

Acuson corporation is a leading manufacturer and service provider of high-performance medical diagnostic ultrasound systems and digital image management products. The Human Resources department publishes acuSounder to keep its worldwide base of employees in touch. Its mission is to provide general news about the company, focusing on the people involved.

TRIM SIZE is 8 1/2" x 11" (22 cm x 28 cm)

EIGHT-PAGE, TWO-COLOR PUBLICATION PRINTED
11 TIMES YEARLY

Simpson Coronado 80 lb (120 gsm) TEXT STOCK

BODY FONTS INCLUDE Garamond 3, Frutiger

CIRCULATION: 2,500

FEATURE COPY LENGTH: 500 words

LAYOUT PROGRAM: QuarkXPress

HARDWARE: Macintosh

EDITOR: Mary Thorsby, freelance. ART DIRECTOR: Joshua Chen of Chen Design Associates. DESIGNERS: Joshua Chen and Gary Blum. PUBLISHER: the Human Resources department of Acuson Corporation. All are based in the San Francisco Bay area of California.

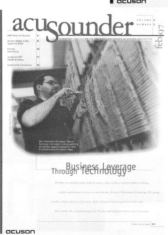

It Doesn't Take Much

Designer Joshua Chen's work on the current redesign of *acuSounder* began with a slight change to the flag. Formerly *acuSounder* was spelled out entirely in lower case. The client decided that the S should be a cap, yet Chen felt this would appear intrusive. He developed a compromise by dropping the cap as if it were a lowercase descender. This pleased the client and gave the flag a sophisticated punch.

Don't Give It All Away

Next, Chen addressed the cover as a whole. The former template placed the cover story on the actual cover, making the design cramped and unattractive. Chen worked with editor Mary Thorsby to create a magazine-type feel. Chen encouraged Thorsby to write the opening more as a teaser so that only a paragraph appears on the cover. Laid out with an interesting image, this entices the reader to turn the page and get into the body of the newsletter.

Show Some Teeth

As explained above, the goal of *acuSounder* is to provide general news about the company. Although elements of the design are clean and straightforward (note the subtle use of rules that create a slightly technical feel), the overall impression is one of abundance and content. Acuson employees enjoy many aspects of their work. Chen uses cropped images of people to focus attention on the faces of Acuson employees. Note how many images he uses of people and how each is cropped to focus on their best asset—a smile.

Build It Up

Chen likes maps because they are filled with texture—one of his favorite design elements. Says Chen, "Texture brings so much more to the page. I create texture by building up layers which give a sense of perspective; layers allow elements in the foreground to play off elements in the background."

The April '97 cover (opposite page, top left) is a great example of texture. Notice how the placement of elements make them appear to float one on top of the other. The map seems to recede into the background, while the headline (which looks like the rumpled, slightly burned edges of a treasure map) appears to float on the same level as the copy. This illusion is created in part by the use of a feathered border on the map and by the use of light-colored borders around the two pictures. The reader's eye is further tricked by the ingenious use of carefully chosen images. See how the photograph of Kanji characters follows the curve of the map, thus the map seems to recede into the distance. The photo of the pottery vessel follows this curve as well; however, it follows in a subtle manner. Combining these elements enhances the sense of depth.

Magazine cover 1 (April 97)

acu**sounder**

VOLUME **5**
NUMBER **4**

A MONTHLY PUBLICATION FOR EMPLOYEES AND FRIENDS OF ACUSON CORPORATION

apr 97

ACUSON'S ADVENTURES IN ASIA PACIFIC AND LATIN AMERICA

Whether you visit Tokyo or Thailand, or Sydney or Sao Paulo, you'll find Acuson systems in constant use in hospitals and clinics across the Asia Pacific and Latin America regions. That's because Acuson employees and distributors are out spreading the word, conducting demonstrations, building relationships and sealing deals to provide these regions with the latest in ultrasound technology.

This month the *acuSounder* highlights Acuson's activities in Asia Pacific and Latin America, and the people who make it all possible.

Cover story on page **4-5**

acuson

Magazine inside page (May 97)

cover story

NORTH AMERICA SERVICE GATHERS TO CATCH THE MOMENTUM

Ray Cales

Ask anyone in Acuson's North America Service group to describe 1996, and they'll sum up the year in two words—challenge and success. While the group had plenty to celebrate as they gathered in Scottsdale, Ariz., last month, they spent a significant amount of time discussing how they can make even greater contributions to Acuson's bottom line.

"I don't think anyone needs to be reminded what a year it's been," conference host **Ray Cales** acknowledged at the kick-off session. "For all of us at Acuson, it's been a major transition. Without all of you, Acuson would not have been able to overcome the challenges we faced last year. You *do* make a difference."

Cales, who was recently named North America Service Manager, invited several Acuson executives to share a few thoughts with the group. The speakers complimented the Service team on successfully meeting all the challenges associated with introducing the Sequoia and Aspen products last year while maintaining an exceptionally high level of service on Acuson's other products.

Lowell Morgan

Jim Fetterman, Vice President, Customer Services Group, and **Ronn Heath**, Director, Product Support and Field Service, recognized that the Field faced several internal and external challenges during 1996—especially in the area of selling service contracts.

"Selling service contracts is my biggest concern," says CE **Lowell Morgan**, who covers the Washington, D.C., and southern Maryland areas. "We have a lot of competitors out there, so it was good for us to hear Acuson's new plans and strategies in this area."

Cynthia Smith

Mark Miller and **Tim Chaney**, Directors of Sales for General Imaging and Cardiology, respectively, shared good news about new product sales, noting that the introduction of Sequoia helped strengthen Acuson's leadership position in the ultrasound market. In fact, several customers who were planning to purchase other systems changed their minds when they learned about Sequoia.

The group heard updates from several other Mountain View leaders, including a few words from Remote Access Product Support Engineer **Wendy Kunkel** and Ultrasound Help Desk Manager **Michael Hardin** about how their teams are helping to solve customer problems via the telephone and remote access, thereby reducing the number of times CEs must travel to customer sites. (Look for more on these groups in a future *acuSounder*.)

Western Bar-B-Que Round Up

What better way to kick off several days of brainstorming than with a good ole' western Bar-B-Que?

All the Acuson trailblazers received official Acuson cowboy hats and beverage holsters at the bar-b-que.

This Acuson posse includes Pat Miler (HQ), Dee Lillis (New Jersey), Amy Whitehead and Kenda Snyder (Atlanta) and Sarah Hudson and Deborah Moody (San Jose).

Don Van Dievold (HQ, far right) moseys up to the vittles line.

Tim Chaney (HQ) and Dee Lillis (New Jersey).

Magazine cover 2 (June 97)

acu**sounder**

VOLUME **5**
NUMBER **6**

A MONTHLY PUBLICATION FOR EMPLOYEES AND FRIENDS OF ACUSON CORPORATION

jun 97

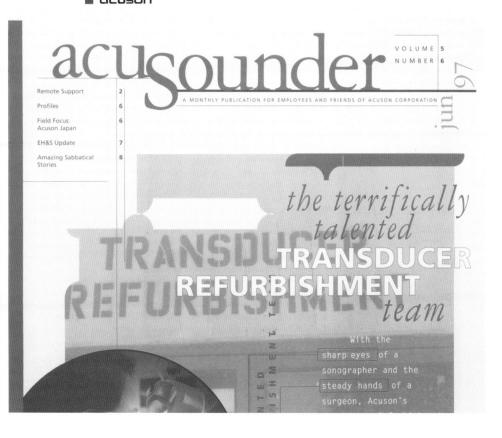

the terrifically talented TRANSDUCER REFURBISHMENT *team*

With the sharp eyes of a sonographer and the steady hands of a surgeon, Acuson's

ABC&D—All About Being Connected to Data:

1996 Annual Report

From the annual: "Adaptec makes products that move information faster, so people can work, build, and create more productively . . . Adaptec moves the data that moves the world."

TRIM SIZE is 8 3/4" x 10 1/4" (23 cm x 28 cm)

58-PAGE, FOUR-COLOR ANNUAL

Cougar Vellum TEXT STOCK

Caslon BODY FONT

CIRCULATION: 65,000

LAYOUT PROGRAM: QuarkXPress

HARDWARE: Macintosh

EDITORS: Lindsay Beaman and Kevin Roberson. ART DIRECTOR: Bill Cahan of Cahan & Associates, located in San Francisco, California. DESIGN: Kevin Roberson, also of Cahan & Associates.

Understand Your Client and You'll Find a Theme

When owner/designer Bill Cahan and his associates sat down to brainstorm the design of Adaptec's 1996 annual, they knew two things—the technology that Adaptec works with to build products is becoming more and more complex and that Adaptec products allow customers to move data quickly. "We tossed out a lot of ideas," says Cahan, "but most of them were pretty esoteric. What we wanted to say was that although the systems behind Adaptec products are complex, the message is simple—Adaptec moves the data that moves the world."

Half-joking, someone suggested turning the annual into a children's book. Of course, this brilliantly simple concept stuck. Based on the look of children's primer books, Adaptec's report explains the complex functions of UltraSCSI PCI cards and PCMCIA host adapters in language we can all understand—the phraseology of "Dick and Jane." In classic beginning-reader fashion, the story of Adaptec follows the antics of Molly, Wally, and dog Data. Wally has a hard time scanning big photo files and backing up his hard drive. Molly, on the other hand, can "multitask" with the help of Adaptec tools! And Data, "being a smarter than average dog"—an adaptation of the slogan used by U.S. cartoon icon Yogi Bear—uses Adaptec host adapters and network interface cards to "beat the bandwidth bottleneck."

Go Traditional... If You Can Find a Printer

Once this jolly design concept was given the go-ahead, "everything," said designer Kevin Roberson, "pretty much fell into place." The book was quickly broken down into three chapters—"Chapter One: A Small Office," "Chapter Two: The Enterprise," and "Chapter Three: The Mobile User"—each with a little moral ending. The tricky thing about pulling off it was finding the right illustrator. Roberson decided to go with Richard McQuire, a fine artist with little experience in designing for annuals but possessing a unique style.

Roberson explained to McQuire that he wanted the characters to be primitive, drawn with heavy lines and block colors. To achieve this, McQuire built his images the old-fashioned way with rubyliths (an acetate film that serves as a mask for particular areas) for color separation by hand rather than computer. "It actually was very ironic. We wanted to hearken back to traditional techniques for over-printing, so our illustrator created four different layouts—one for each color—and all to talk about technology. The really funny thing about it was that our printer didn't know what to do with our rubyliths. Since everything is digital now they had to set up a whole system for taking our color to film," says Roberson.

JOHN G. ADLER
Chairman of the Board

F. GRANT SAVIERS
President and Chief Executive Officer

Having Fun

Cahan is particularly proud that Adaptec management received so much positive response from the book. When CNBC produced a four-minute segment on Adaptec, part of the story was dedicated to the captivating design of the annual report. "The response was huge," says Cahan, "which proved to us that it pays off to go with your instincts, even if that means going out on a limb with something significantly different." All the free publicity of course pleased Chairman John G. Adler and President/C.E.O. F. Grant Saviers, whose atypical portraits appear here.

Those Little Extras

This report is bound exactly like a children's book, hardcover and all. Endsheets are decorated with rockets, teddy bears, and pictures of Data the dog. The front endsheet has a graphic for a "this book belongs to . . ." bookplate.

See Wally hard at work.
He tries to scan big photo files.
He tries to move video files
to his backup drives.

Poor Wally. Wally thinks his new
processor makes him work faster.
He does not know that the data
link between his PC, peripherals,
and the network is more critical.

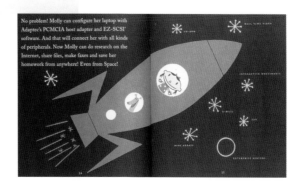

No problem! Molly can configure her laptop with Adaptec's PCMCIA host adapter and EZ-SCSI software. And that will connect her with all kinds of peripherals. Now Molly can do research on the Internet, share files, make faxes and save her homework from anywhere! Even from Space!

JPM

careers

Volume 12 Number 1 1997

CONSERVATION

The GCI Newsletter

Publications that cover the how-to's of a business or industry are typically rather dry. These poor war horses, which have to pack an overwhelming amount of facts into a page count that is limited by budgetary concerns, are often downright unreadable.

For our section on "Career" publications, we have searched for exceptions to this rule. The following diverse selection of newsletters/journals and annual reports share one design element in common—an eye for white space.

Nothing is more tiring for the reader or, in fact, more overwhelming than lack of white space.

Publications that persist in cramming both copy and illustrations up to the trim find that no one actually reads their stories. Although there is a great deal of information conveyed in the Getty Conservation Institute's newsletter, *Conservation*, its out-of-the-ordinary shape (11 5/8" or 29 cm square) ensures that there is ample room for negative space. Notice how the areas of non-activity lend sophistication to the design and intrigue to the text in this and other featured publications.

The following diverse selection of newsletters/journals and annual reports share one design element in common—an eye for white space

INTERACTIVE INVESTOR RELATIONS

Accessing international analysts
One investor conference company makes it easier for corporations to get the attention of busy investors and financial watchers

Reaching analysts online just got easier — thanks to one enterprising investor conference company.

New York City-based The Wall Street Forum (**www.wallstreetforum.com**) is the first conference outfit to make broadcasting presentations to investors online possible.

At the first conference uploaded on the Internet, 85 analysts from Europe, Canada and around the country logged in, says Gerald Scott, CEO of the Forum. That's on top of the more than 750 who attended the January conference physically. At the second conference in March, the number of virtual attenders more than doubled to about 200.

The service has been a boon to lesser-known companies, like Wallace Computer Service, that traditionally have had a tougher time getting analysts to listen to their investment story.

"If you're McDonald's, or some company with a big name, it's fairly easy to get investor interest — people are willing to take a look at your numbers," says Brad Samson, director of IR and public relations at Lisle, Ill.-based Wallace. "But when you're more of an industrial business-to-business company like we are, even though we're almost $1 billion in size, people may not take the time to find out about you."

The challenge for smaller companies, Samson adds, is to get investors to give you a hearing. Unless they're specifically interested in a company, analysts and institutional investors won't take the time to physically attend the conferences.

"To me, one of the best parts of the Internet feed opportunity is that people who might be slightly interested in you, can dial in just like you flip to a movie on HBO that you're not sure you're going to like and you don't want to spend the money to rent," Samson says.

How it works
The Forum usually draws about 100 companies to present at the conference. Most companies have capitalizations of more than $100 million. The number of analysts attending: about 800 on average.

The cost to a company making a presentation at the conference is $3,300. The Internet link-up is an extra service Samson believes will give the Forum an edge over the competition (i.e., brokerage firms and larger conference outfits).

Each presentation lasts 30 minutes followed by a 15-minute Q&A session. Analysts attending the conference via the Internet actually see and hear exactly what conference attendees do. Viewers need basic computer equipment: A 486 system with 3 RAM, speakers, Web access and a modem of at least 14.4 bps.

Once analysts choose a session to attend, they're given an electronic form on which they provide their names, firm, city and state. The form also provides space to list questions directed at a speaker. The form can be e-mailed at any point during a presentation, and Forum staff simply voice any questions listed.

On the left two-thirds of their PC screens, they view the same slide show the company uses at the conference. To make this work, The Forum collects the slides a few weeks before the conference and loads them online.

The right third of the screen shows a live digital photograph of the CEOs or CFOs who are presenting.

To ensure that things go smoothly on the technical side, The Wall Street Forum keeps a demo presentation up on its Web site so analysts can test their software and make sure it's working before the actual conference. The Forum also makes it possible for analysts to

CARN: Corporate
Annual Report Newsletter

For corporations producing annual reports, CARN is a godsend. Dedicated to examining every aspect of annual report production, this Lawrence Ragan Communications publication provides insight for executives, designers, and editors on new trends in editorial themes, cutting-edge layout, and financials representation.

TRIM SIZE is 8 1/2" x 11" (22 cm x 28 cm)

SIXTEEN-PAGE, THREE-COLOR MONTHLY

60 lb (90 gsm) White Offset STOCK

Minion BODY FONT

CIRCULATION: 800

FEATURE COPY LENGTH: 1,000 words

LAYOUT PROGRAM: Adobe PageMaker

HARDWARE: PC

EDITOR IN CHIEF: Cecile Sorra. ART DIRECTOR: Lucy O'Sullivan. Both are staff members of CARN, a division of Lawrence Ragan Communications Inc. in Chicago, Illinois.

Little Things

When designer Lucy O'Sullivan set out to redesign *CARN*, she knew it wouldn't take much to update this already classic newsletter. To help readers find their way through the publication she added an additional color and expanded the depth of the border at the top of each page so that it could carry the title of each section. To accommodate more copy without unsightly line breaks, O'Sullivan broadened columns by a few points. She also moved the table of contents from the inside to the front.

Come Together

Lawrence Ragan produces sixteen publications per year, the majority of which are top sellers. However, Interactive Investor Relations, a sister publication of *CARN*, did not live up to the company's expectations. "Instead of scrapping the newsletter," explains editor Cecile Sorra, "we decided to include it as an insert in *CARN*." "Interactive Investor Relations," which covers online interactive investor relation packages (such as annual reports), complements the content of *CARN*. It is bound into the middle of the newsletter and is set apart by a very business-oriented look. For this publication, O'Sullivan sticks to two columns and simple pull quotes to spice up the copy. She also adds a one-point rule to frame each page and a different but related pastel color for the headline and illustration backgrounds.

The overall advantage? Reader appreciation. Subscribers feel they are getting more editorial bang for their buck.

Charting It Out

No designer likes to create charts, but if you set up a template and stick with it, it won't be such a nightmare. The annual report "report card" that appears on the back of each issue (opposite page, top right) gives readers a quick and easy reference for what works in an annual report and what doesn't. However, cutting copy to fit is a tedious task for Sorra, who edits directly in Adobe PageMaker on O'Sullivan's template.

Says Sorra, "The 'Report Card' is definitely my biggest challenge because I have to justify, in just two sentences, why an annual has received a particular grade on a particular aspect of design or editorial. And those two sentences have to be absolutely straightforward; otherwise readers will question my grade."

Size Matters

O'Sullivan has the production of *CARN* down to a science. Her three-column template is so streamlined that her biggest concern each month is how she's going to size photos. Typically O'Sullivan begins her production work by creating a rough layout. She carefully measures her art and then sizes it for scanning; that way she can confidently work on copy layout while art is being digitized. Note that she likes to keep her images about the same size. Of course, this avoids complaints from competing companies that the newsletter covers, but it also gives the design a uniform, almost museum-catalog look and feel—definitely a sophisticated (and time-saving) option.

Report Card

Company	Nordson Corp. 28601 Clemens Rd. Westlake, OH 44145-1119 (industrial mfr.)	Molex Inc. 2222 Wellington Ct. Lisle, IL 60532 (connector mfr.)	Fair, Isaac & Company, Inc. 120 N. Redwood Dr. San Rafael, CA 94903 (financial software developers)	Tredegar Indus- tries 1100 Boulders Parkway Richmond, VA 23225 (plastic/aluminum products)	Genentech, Inc. 460 Pt. San Bruno Blvd. S. San Francisco, CA 94080-4990 (biotechnology)
Appearance Refers to the immediate visual impression.	B- There's no innovation, almost boring. But it's simple, straightforward. While not an attention getter, info is clearly segmented and easy to obtain.	C- Would have been an "A" — striking pics, well-conceived flow. But AR's binding fell apart! Don't underestimate the import of a good printer.	A- AR actually looks a little silly with all the shots of grinning managers. Book idea/look doesn't convey co.'s bright position in industry.	B Pics effective in showing what co. produces. But some pages get a little busy, diluting overall communication of AR's design.	A Cover is fun, showing CD-ROM of latest approved drug stuffed in blue jeans pocket. Plays on theme, "Genes At Work."
Readability Grades the final effect of the combination of design and content. (For example, can the reader find and digest material quickly?)	B AR is adept at providing product overview on break-outs of key strategies and performance. But pics are staid and not communicative.	A Like the completeness of financial highlights. Info is readily segmented in logical, geographic order, tying together AR's global theme.	A Italicized headlines get lost on page. Purple and blue print is light and serves no readability purpose. Good info gets lost.	A- There are lots of charts throughout that daringly track co.'s performance at a glance. Most demonstrate an impressive business operation.	B+ Because of technical nature of co., AR is packed with info. Some pages suffer from overload; but others provide good snapshots.
Chairman's Letter Does it explain last year and tell what the company aims to do in the next year(s)?	B Bit windy. Has candid explanations of year's performance, but leaves out definitive strategy for '97. Ex: How will acquisitions boost co.'s strength in market?	A Letter is translated into 5 languages. Impressive coz it makes sense to do thematically and strategically. Good perspective and detail that doesn't bog down prose.	A- Phew! A 6-pager. Probably could have cut it back by 1/3. But we applaud the effort to educate reader on co.'s service — and market.	B Succinct. That's normally good, but letter should elaborate a little more. Ex: "We see many threats." What are the threats? How will co. deal with them?	C+ Too many technical terms. Surely it can translate in lay terms. Also, strategies are in reverse order: improve finances should list first.
Text Does it deal efficiently with important issues?	A Presents balanced look at ups and downs (and whys) in geographic regions. Highlights workforce while imparting key business strategy.	B+ Well-scripted blend of marketing and perspective. But would have liked to see more detail on strategy for some of the co.'s trouble spots.	B+ AR makes sure readers know what services co. provides and demand for them. But we still need some discussion of co.'s performance.	B- This report relies a lot on the graphs to tell the story. But reader doesn't know how sales of some divisions may have inflated some numbers.	B- Lawsuits seem to plague company, largely because of patent issues. Text mentions all of them. But reader is left to guess at impact.
Discussion of Financials Does the report weasel, hide behind ponderous locutions, or otherwise make a reader struggle to decipher what is really happening?	B It's all here, but it doesn't provide some important details. Ex: Co.'s trying to reduce negative impact of inflation by raising productivity, but doesn't say how it will do that.	B Readable prose, but info needs to be segmented, not lumped under general subheds. Also need more info on how over-budget start-up plant was and how co. is responding.	C+ Financial section does better job than middle of book of breaking out info sections. But it's a tough read. Can barely make out info it's trying to impart.	B+ Finally have some explanations for the graphs in the middle of the book. It's a largely complete picture that should have appeared in earlier pages.	B+ This discussion is straightforward, giving reader a better idea of co.'s challenges than any other part of the book.
Stock On the basis of this report alone, would we buy the stock?	Yes While there are some holes in the report's disclosure, it provides sufficient evidence that co. is healthy and will continue to be so.	Yes AR is convincing in its message and outline of co.'s growth around the world. There's a good amount of perspective.	Yes If you can muddle through the text, you'll find that co. is poised for rapid growth.	No Get the sense that co. is hiding some serious info because much of the real story doesn't appear until financial discussion.	No Not convinced that co. has clear strategy to pull out of the many problems it has. AR needs to do better job of pulling relevant info together.

16 CARN • May 1997

CARN bases its decision to buy stock in a company on the annual report's effectiveness in communicating a firm's message and direction, not necessarily on its health, or not-so-healthy condition.

INTERACTIVE INVESTOR RELATIONS

Accessing international analysts

One investor conference company makes it easier for corporations to get the attention of busy investors and financial watchers

Reaching analysts online just got easier — thanks to one enterprising investor conference company.

New York City-based The Wall Street Forum (www.wallstreetforum.com) is the first conference outfit to make broadcasting presentations to investors online possible.

At the first conference uploaded on the Internet, 85 analysts from Europe, Canada and around the country logged in, says Gerald Scott, CEO of the Forum. That's on top of the more than 750 who attended the January conference physically. At the second conference in March, the number of virtual attenders more than doubled to about 200.

The service has been a boon to lesser-known companies, like Wallace Computer Service, that traditionally have had a tougher time getting analysts to listen to their investment story.

"If you're McDonald's, or some company with a big name, it's fairly easy to get investor interest — people are willing to take a look at your numbers," says Brad Samson, director of IR and public relations at Lisle, Ill.-based Wallace. "But when you're more of an industrial business-to-business company like we are, even though we're almost $1 billion in size, people may not take the time to find out about you."

The challenge for smaller companies, Samson adds, is to get big investors to give you a hearing. Unless they're specifically interested in a company, analysts and institutional investors won't take the time to physically attend the conferences.

"To me, one of the best parts of the Internet feed opportunity is that people who might be slightly interested in you, can dial in just like you flip to a movie on HBO that you're not sure you're going to like and you don't want to spend the money to rent," Samson says.

How it works

The Forum usually draws about 100 companies to present at the conference. Most companies have capitalizations of more than $100 million. The number of analysts attending: about 800 on average.

The cost to a company making a presentation at the conference is $3,300. The Internet link-up is an extra service Samson believes will give the Forum an edge over the competition (i.e., brokerage firms and larger conference outfits).

Each presentation lasts 30 minutes followed by a 15-minute Q&A session. Analysts attending the conference via the Internet actually see and hear exactly what conference attendees do. Viewers need basic computer equipment: A 486 system with 3 RAM, speakers, Web access and a modem of at least 14.4 bps.

Once analysts choose a session to attend, they're given an electronic form on which they provide their names, firm, city and state. The form also provides space to list questions directed at a speaker. The form can be e-mailed at any point during a presentation, and Forum staff simply voice any questions listed.

On the left two-thirds of their PC screens, they view the same slide show the company uses at the conference. To make this work, The Forum collects the slides a few weeks before the conference and loads them online.

The right third of the screen shows a live digital photograph of the CEOs or CFOs who are presenting.

To ensure that things go smoothly on the technical side, The Wall Street Forum keeps a demo presentation up on its Web site so analysts can test their software and make sure it's working before the actual conference. The Forum also makes it possible for analysts to

Technology trends for the IR professional

Graphically Speaking

Part I of II

Who cares?

Which companies appear to care about the report and its design? Our take on the first batch of 1996 ARs

By Jack Summerford
Contributing Editor

These exceptionally executed spreads for Herman Miller's annual report show why the AR and its designers care.

This column really began more than 15 years ago, when I placed my name on every annual report list I could find. The result was several hundred reports delivered over a period of just a few weeks and a somewhat irritated postman.

I divided the harvest into three categories — actually they were stacks. Stack A included those annual reports to corporations that, by my judgment, obviously cared about the document and wanted it to project that care through good design. They also had a message to communicate, and they succeeded in relaying the message visually.

Stack B consisted of reports from companies that also cared but — because of a lack of resources or imagination or trust in a good design firm, or all three — just didn't pull it off. It's called mediocrity.

Stack C was the stack from graphic hell, the Land of Nobody Cares. You know the kind, the 10-K wraps, or similar types, the kind that if it did have photography or illustration, it was of the poorest quality. And, the typography ... we won't discuss the typography.

The third stack was the tallest. I mean it was really the tallest. If my memory is accurate, this stack of reports represented of two-thirds of all the reports in my "study."

The size and status of a company seemed to have no bearing on whether a particular report ended up in the tall stack, or the shorter stacks for that matter. Some of Wall Street's finest were included in Stack C. Their numbers may have been great, but they were graphically bankrupt.

So, the final result was something like this:
• Stack A (those companies that cared about the design of their report, tried and succeeded): about 10 percent
• Stack B (those that cared but failed): about 25 percent
• Stack C (those companies that failed and didn't care): about 65 percent

Admittedly, all this grading and judging is subjective. But that doesn't mean we can't have standards of excellence. In addition to satisfying the obvious requirements of good communication, such as readability, logical numerical display, and maybe a good photograph of the CEO, there are two main elements essential to a well-designed annual report.

First and most important, the report should have an idea. A concept. A theme. This is the vehicle that carries the company's message.

Second, that vehicle needs good fuel. The ingredients of that fuel are copy, typography, photography and/or illustration charts and graphs, paper stock and printing. These not only need to be of the best quality, but also need to be appropriate to the idea or message.

That's about it. Two very broad steps to great annual reports. Those are the elements I use to gauge an annual report's success. That is how I determine if a report ends up in Stack A.

Grab the easy chair

Now that brings us to the new crop. The 1997 crop of 1996 reports. What will the harvest reflect?

Unfortunately, as we go to press with this issue, our timing is bad for annual reports. In about a week and a half we should have a very good sampling of the new reports. Right now, we are limited to a few early birds and, of course, the off-year reports — those companies whose fiscal years end in June, September or an even more exotic month.

Among that group, there are a few standouts that have caught our attention. The report for Herman Miller (855 E. Main Ave., P.O. Box 302, Zeeland, MI 49464-0302) is almost always a favorite. The report consistently has a concept or big idea

TRC Companies' use of the compass and travel journal to demonstrate the company's global reach is not original. But the AR designers tastefully pull the theme through.

behind it, an idea that furthers the institutional image of the company while clearly taking care of annual report business.

This year's report did not disappoint. The report took a then-and-now approach to celebrating 40 years of business (1956-1996). In fact, they say that right on the cover. "Forty years ago Herman Miller stood for something. We still do." Add that line to a nice black-and-white photo of probably the most recognizable chair in the world — the Charles Eames Lounge Chair designed in 1956 — and you are off and running with a good idea.

The inside pages feature spreads that compare the company in 1956 with the company in 1996. One of the first such comparisons shows a group photo of employ-

ees in 1956. On the right page is 1996's group employee photo. Well actually, the 1996 employee group photo takes up the next five pages.

On another spread, the left page carries a photo of a 1956 telephone with the company's four-digit phone number, 2161, under the photo. On the right page is a picture of the company's Web site with the corporate home page address: http://www.hermanmiller.com. (2161 vs. http://www.hermanmiller. I haven't quite decided whether that is a positive change.)

This then-and-now format works equally well when comparing 1956 product lines with 1996. It also carries well into the financial highlights, which

continued on next page

Conservation

The Getty Conservation Institute publishes Conservation to keep trained professionals informed about its work. The publication is also designed for anyone who appreciates the work of preserving cultural heritage. Conservation covers the preservation of not only fine art and architecture but also sites of archaeological importance such as the 3.6-million-year-old hominid footprints, preserved in volcanic ash, discovered by Mary Leakey in the late 1970s.

TRIM SIZE is 11 5/8" (29 cm) square

TWENTY-FOUR-PAGE, TWO-COLOR PUBLICATION PRINTED THREE TIMES YEARLY

Evergreen 70 lb (105 gsm) BOOK STOCK

Ehrhardt BODY FONT

CIRCULATION: 8,500

LAYOUT PROGRAM: QuarkXPress

HARDWARE: Macintosh

EDITOR: Jeffrey Levin of the Getty Conservation Institute, based in Los Angeles. DESIGN: Joe Molloy of Mondo Typo Inc. located in West Los Angeles, California.

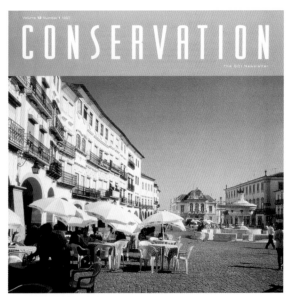

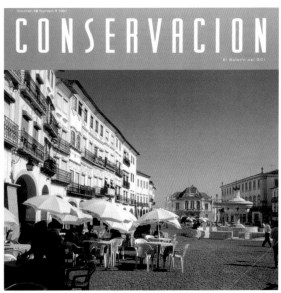

Design Evolution—It's a Good Thing

Like many newsletters that have flourished for a number of years (Conservation is more than ten years old), the Getty Conservation Institute's publication has seen several design incarnations. The latest included a move to a large, square format that catches the reader's eye—especially at conferences and meetings—and provides room for photos and copy to breathe. Editor Jeffrey Levin acknowledges that a few librarians have a bit of a hard time archiving the impressive work due to its unusual size but this minor challenge is definitely offset by positive reviews from subscribers.

Besides the format change, Levin regularly instigated other incremental improvements. For instance, to improve readability the template has changed from two columns to three, and, in one section, four much narrower columns. The body font has switched from Garamond to Ehrhardt, a Monotype font that designer Joe Molloy feels is particularly readable due to a slightly heavier weight and taller x-height.

Odd Size—Good Idea? Bad Idea?

For Molloy the large, square layout is a dream for positioning photos. "A square set-up is ideal because it accommodates both horizontal and vertical images." However, when it comes to actual production, the format is a challenge. As Molloy points out, even with a 17" (43 cm) monitor he can't zoom in very far without losing some portion of a spread. Also, it's impossible to print full size on a laser printer; Molloy outputs his pages at ninety percent on tabloid-sized paper for proofing.

You Must Have a System

Designers are never surprised by oddball problems; few, however, often deal with type in another language. Since each issue of Conservation is produced in English and Spanish, Molloy created a system for fitting Spanish type without changing his English layout. Says Molloy, "I design the English version about a week ahead of the Spanish version, so all the images and headlines are laid out and created. To keep from having to redesign my headline type, I try to create graphic pictures that will work for both languages." For instance, on lovely spread with the title, "Face to Face with Landmarks" (the opposite page, middle), Molloy explains that his intriguing setup (Both "faces" butt against each other vertically; with the top word in black and the bottom in white, so they look like the reflection in a mirror) luckily worked perfectly in Spanish as well, appearing as "Cara a Cara."

Make the Most of Great Photos

Here's an inviting spread that depicts this publication's photojournalistic style. Note the lovely use of the full-page photo on the left balanced by two photos that are sized to fit in the outside column of the right-hand page. Molloy's template allows for longer-than-average photo captions.

Conserving Historic Centers More'than Meets the Eye'

FACE TO FACE WITH LANDMARKS

CARA A CARA CON EL PATRIMONIO

IN ACCORDANCE WITH THE GCI'S CONCERN FOR THE ENVIRONMENT THIS NEWSLETTER IS PRINTED ON RECYCLED PAPER

THE GETTY
CONSERVATION
INSTITUTE

1200 Getty Center Drive, Suite 700
Los Angeles, CA 90049-1684 USA
Telephone: 310 440-7325
Fax: 310 440-7702
Web site address:
http://www.getty.edu/gci

Journal of

Property Management

Since 1935, the Journal of Property Management *has been dedicated to providing educational and trend stories to professionals in the field of property management.*

TRIM SIZE is 8 1/8" x 10 7/8" (21 cm x 28 cm)
NINETY-TWO-PAGE, FOUR-COLOR BIMONTHLY
Marva 80 lb (220 gsm) COVER STOCK; Delta Bright 50 lb
 (75 gsm) BODY STOCK
Adobe Garamond BODY FONT
CIRCULATION: 23,500
FEATURE COPY LENGTH: 2,500 words
LAYOUT PROGRAM: QuarkXPress
HARDWARE: PC
EXECUTIVE EDITOR: Mariwyn Evans. DESIGN MANAGER:
 Flint Weinberg. DESIGN: Michael Sonnenfeld. All are
 staff members of the Institute of Real Estate
 Management located in Chicago, Illinois.

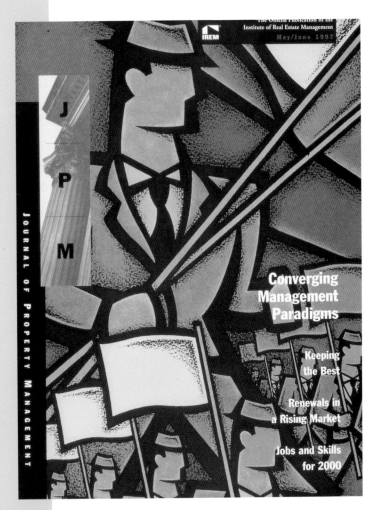

Modern Image
Since its redesign in 1995, the *Journal* has made continual steps toward offering a clean, easy-to-read format to its readers. The template has developed to include ample use of white space, bold sans serif headlines, and icons to set off departments and features.

Choose the Best; Leave the Rest
One of *JPM*'s chief assets is strong cover design. Artist Flint Weinberg explains that covers are usually custom created for each issue by freelance photographers or illustrators. For dealing with out-of-house artists, editor Mariwyn Evans offers the following rule of thumb; "Most freelancers fall into one of two categories: they can either take our idea and simply produce it or they can take our idea and bring some of their own creative personality to the project. If you can," she says, "try to work with artists in the latter category."

Icons Are Our Friends
Each department in *JPM* features its own straightforward photo icon; for example, a fountain pen for the "President's Letter" and a photo of the Capitol Building in Washington for the "Legislative Update" (opposite page, top). What makes these fun is adding a duotone effect and clever cropping.

Evans notes that many of the departmental icons were taken by photographers on assignment. After computing the costs, Evans found it was cheaper to pay for original shots rather than pay royalties on stock images each issue.

Give 'Em a Theme
Every month the *Journal* focuses on a different theme. The design challenge is to come up with headlines and type that work for a series of linked stories, representing the overview. An excellent example appears here for a series about property redevelopment (opposite page, middle). Within this theme, the following three articles appear: "Boardrooms to Bedrooms," "Mills to Desks, Gurneys to Beds," and "Too Old to Be a Mall Anymore?"

Although other fonts are incorporated, note that each headline includes Franklin Gothic Condensed as a basic building block for creating a design based on type. The combination and reuse of blue and brown key the headlines into the overall look. In addition, each story opens with a iconographical portrait of a cityscape that horizontally gradates from black and white to color, a subtle feature that further reinforces the connection between stories.

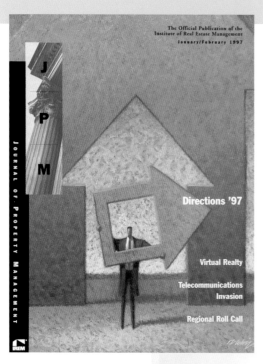
Military Housing Needs You

Jo Anne Corbitt, CPM

Jo Anne Corbitt, CPM®, CPM

Megan's Law Unclear

IAQ Standard Overkill?

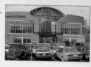

What's Old...Is New Again

Boardrooms
to
Bedrooms

by Jane Adler

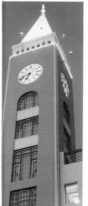

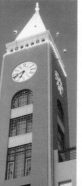

Clock Tower, 616 Second St., San Francisco

Matching Space to Need

A Municipal Helping Hand

What's Old...Is New Again

Mills to **Desks,**
Gurneys to **Beds**

by Kent Harrell Wadsworth

Textiles to New Liberties

What's Old...Is New Again

Too
Old
to Be a Mall Any More?

by Marleys Evans

Refit the Property

Change from the **Inside Out**

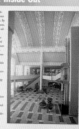

Chicago Volunteer Legal Services

1996 Annual Report

Attorney and paralegals from the Chicago Volunteer Legal Services work to ensure equal access to basic legal rights and responsibilities for the working poor throughout Chicago and its suburbs.

TRIM SIZE is 5 1/2" x 8 5/8" (14 cm x 23 cm)
SIXTY-TWO-PAGE PLUS cover, dust-jacketed, TWO-COLOR-PLUS-THREE-SPOT-COLOR ANNUAL REPORT, with three spot colors on pages 1–28 and two spot colors on pages 29–62
Cheltenham Condensed BODY FONT
CIRCULATION: 5,000
LAYOUT PROGRAM: QuarkXPress
HARDWARE: Macintosh
WRITER: M. Lee Witte and Margaret Benson. DESIGN: Tim Bruce of Froeter Design Company in Chicago, Illinois. PHOTOGRAPHER: Tony Armour.

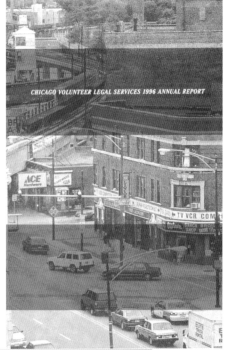

Wave Your Flag

Well, the headline "flag" doesn't exactly wave, but the jacket for this annual report is certainly an attention-getter. Bruce tinted this black and white photo of a Chicago neighborhood in red and blue to create the American-flag Stars and Stripes.

Bruce explains the decision to include a jacket, "I wanted to wrap the report up, like a flag, while also showing a working neighborhood in Chicago."

Conventional Theme

Because the Democratic National Convention was held in their city, the memory of 1996 has a very patriotic feel for Chicagoans. In preparation for the festivities, many parts of the city underwent much needed clean-up, which also led to a sense of pride. So, what better time, thought designer Tim Bruce, to make democracy a theme for the Chicago Volunteer Legal Services annual report?

Note the use of bold blue and red colors on glossy white paper as a reinforcement of this theme. To maintain a sense of community or neighborhood involvement, Bruce handbrushed this lettering and colored the words in the computer. "I wanted to have that handmade quality, like the handbills or homemade political posters you see on the street," says Bruce.

Total Immersion

Just like a documentary film crew, Bruce and photographer Tony Amour went to clients' homes to get the real stories behind their cases and the legal services that made such an impact on their lives. Citizen Augie Santana had been to court eighteen times trying to obtain visitation rights before he found the Chicago Volunteer Legal Services. With the help of attorney John Van Harken, a settlement is pending.

Says Bruce, "There was little structure to our photo shoots, we just sort of let things happen. When we met Augie, he brought out his case files and showed us a note he had written to the courts and a photo of his daughter that he keeps on his dashboard of his car. His ex-brother in-law actually had to smuggle it out to him."

In keeping with Santana's honest and open telling of his predicament, the layout of his photos (opposite page) is straightforward. Bruce allows images to make full impact by giving them room and, where needed, white space. Note the unusual use of white space in the lower left-hand quadrant of the second spread. It feels like a reflection of Santana's feelings: lost and empty.

CVLS & Corporations

MOTION BY Augie FOR Visitation

I Augie Santana Father oF Cynthia Santana
Has Been Paying child support and has no
Visitation rights what so ever
would like to have the rights to see
my child

1,878
MEMBERS
11,445
CLIENTS

A GLORIOUS CELEBRATION OF DEMOCRACY

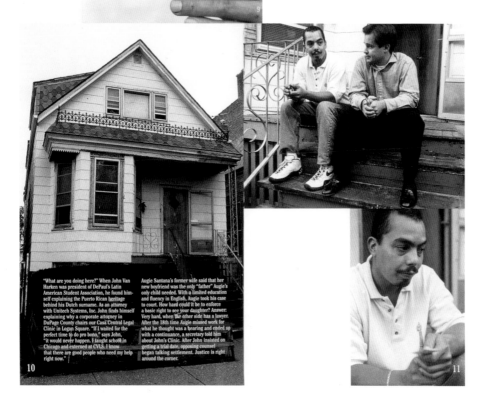

"What are you doing here?" When John Van Harken was president of DePaul's Latin American Student Association, he found himself explaining the Puerto Rican heritage behind his Dutch surname. As an attorney with Unitech Systems, Inc. John finds himself explaining why a corporate attorney in DuPage County chairs our Casa Central Legal Clinic in Logan Square. "If I waited for the perfect time to do pro bono," says John, "it would never happen. I taught school in Chicago and externed at CVLS. I know that there are good people who need my help right now."

Augie Santana's former wife said that her new boyfriend was the only "father" Augie's only child needed. With a limited education and fluency in English, Augie took his case to court. How hard could it be to enforce a basic right to see your daughter? Answer: Very hard, when the other side has a lawyer. After the 18th time Augie missed work for what he thought was a hearing and ended up with a continuance, a secretary told him about John's Clinic. After John insisted on getting a trial date, opposing counsel began talking settlement. Justice is right around the corner.

C/H/A/P/T/E/R

6

goods

Publications that showcase goods have to tap into something special. They have to make a customer giddy with anticipation, unswervingly loyal, or simply out-and-out happy to contribute, through their purchase, to the growth of the product itself. House organs for manufacturers have to keep employees just as inspired; in effect, they are designed to remind every salesperson, executive, and factory worker that both their company and their product are winners. And they have to do all this with absolute honesty.

Under the honesty-is-the-best policy edict, is the clever and genuine newsprint report for the Portland Brewing Company. When artist Adam McIsaac and his partners from The Felt Hat sat down

House organs must remind every salesperson, executive, and factory worker that both their company and their product are winners.

with their client, they quickly understood that it had been a less than impressive year for the company. Unfortunately the micro-brewing industry had taken a downturn due to market oversaturation. Although Portland Brewing execs had gallantly rebounded, their end-of-year numbers would not reflect their efforts. Instead of trying to hide this irritating turn with fancy graphics and trumped-up charts, the designers suggested that Portland Brewing put their cards on the table and tell the real story to their investors. Not only did this approach win hearts and ultimately dollars for the client, it led to a charming, humorous design that is truly unforgettable.

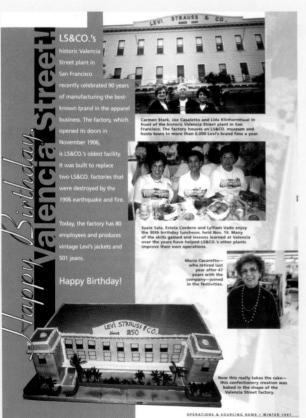

Happy Birthday, Valencia Street!

LS&CO.'s historic Valencia Street plant in San Francisco recently celebrated 90 years of manufacturing the best-known brand in the apparel business. The factory, which opened its doors in November 1906, is LS&CO.'s oldest facility. It was built to replace two LS&CO. factories that were destroyed by the 1906 earthquake and fire.

Today, the factory has 80 employees and produces vintage Levi's jackets and 501 jeans.

Happy Birthday!

Carmen Stark, Joe Casaletto and Lida Klinhornhual in front of the historic Valencia Street plant in San Francisco. The factory houses an LS&CO. museum and hosts tours to more than 6,000 Levi's brand fans a year.

Susie Sala, Estela Cordero and Lylliam Vado enjoy the 90th birthday luncheon, held Nov. 19. Many of the skills gained and lessons learned at Valencia over the years have helped LS&CO.'s other plants improve their own operations.

Maria Casaretto—who retired last year after 47 years with the company—joined in the festivities.

Now this really takes the cake—this confectionery creation was baked in the shape of the Valencia Street factory.

OPERATIONS & SOURCING NEWS • WINTER 1997

Portland Brewing Company

1996 Annual Report

This popular craft brewer also runs two successful restaurants . . . make that "brewpub and eateries."

TWENTY-EIGHT-PAGE, TWO-COLOR TABLOID ANNUAL

NEWSPRINT STOCK

Monotype Grotesk BODY FONT

LAYOUT PROGRAM: QuarkXPress

HARDWARE: Macintosh

DESIGN AND EDITORIAL: The Felt Hat, located in
 Portland, Oregon.

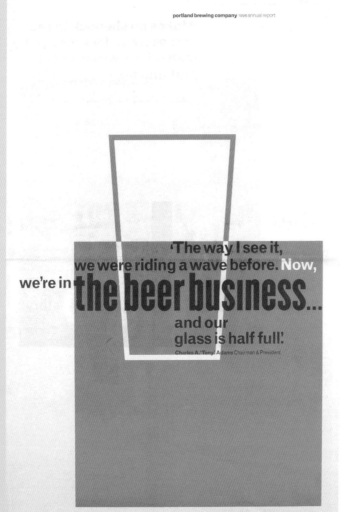

The Truth Doesn't Always Hurt

Due to oversaturation of the marketplace, the microbrewing industry suffered in 1996. Literally up to their ears in suds, every company reported losses. Even though the popular Oregon-based Portland Brewing Company made a comeback in the fourth quarter, it was not enough to offset losses and show a profit for the year, an obvious disappointment to the shareholders.

When designer Adam McIsaac and his partners in The Felt Hat met with executives to discuss their annual report, he found them less than enthusiastic about the project. "They were pretty depressed," says McIsaac. "But they told me two interesting things. Last year was bad, but the prospects for the next year were good. They were already out of the storm. So we suggested that they say just that, that the company carry on a frank discussion through the annual report to shareholders concerning the condition of the industry, how that related to the company, and how they were fighting back."

This "honesty-is-the-best-policy" approach resulted in a marvelously unique publication. To keep costs down, McIsaac and his partners built a layout for the tabloid format to be run in two colors on newsprint. Both copy and illustrations are uncharacteristically appealing in their frank, but humorous, take on the facts. Here's an example from the opening spread (opposite page, middle): "It takes no Sherlock to see that '96 was a less rosy year than others we've had...the market changed on us . . . the demand we were chasing dropped off. The result was Economics 101." Illustrations show ninety-nine bottles of beer (a hint at over-saturation) and pint glasses that are meant to appear half full rather than half empty (homage to the company's optimism).

The happy ending to this design story is that the shareholders were so proud of their company's brave publishing move that they honored the owners with a standing ovation at the shareholders' meeting, even offering to do whatever it might take to put the company back on its feet.

Ye Old Type

Type selection in this report honors the Bauhaus school of Germany (definitely a great art and beer culture). Here McIsaac gives a little historical perspective. "Germans were using sans serif typefaces extensively during the final years of the Weimar Republic (the forms, which the Germans called Grotesk, first appeared during the Industrial Revolution). The use of these letters—and of red and black—refers to the European craft tradition. The absence of capital letters in the text and the asymmetric compositions are pure Tschichold (who taught at the Bauhaus)."

Set the Pace

"It's harder to manage the flow of design in a simple book like this," explains McIsaac. "So we relied on the genius of our copywriter. He is a bit of a stand-up comedian—with a very specific way of speaking that is mirrored in his writing—so we actually had him perform the copy and record it. We listened to this over and over to help set the pacing and syncopation of the layout."

this was the year our flanders street pub was transformed into the second of our full-service restaurants and a fine big place to try true brews and listen to live blues.

mall **flanders**

in 1965, there was but one small craft brewer in the united states. by '84, there were four. by '94, nearly 600. and by mid-'97 somewhere around 1,100. that's a boom for you, and one—in this part of the country especially—that looked like it would live forever. but there were quirks.

proliferation's prickly path.

...duct

it takes no sherlock to see that '96 was a less rosy year than others we've had at portland brewing. just take a look at the highlights and this straight-up report.

the short ‹ **why** › story?

well, the market changed on us. while we were ramping up production (along with every other craft brewer), the demand we were chasing suddenly dropped off. the result was from economics 101: supply outpaced demand. conditions changed so fast that, even though we course-corrected, we still turned in a bum fourth quarter. and showed a loss for the year.

we're not whining, mind you. what happened happened and we're dealing with it. matter of fact, as you'll see when we describe **context** (e.g. how other brewers are faring), we're dealing pretty well. our **true brews**—*mactarnahan's amber ale, oregon honey beer, wheat berry brew, haystack black,* our new *zigzag lager,* and the seasonals—are great. our installed capacity is up to 135,000 barrels of full ale production, our processes and controls have improved a bunch, and we work in a great brewhouse.
we like our prospects a lot. but we wanted you to know going in why we sound a little more deliberate this time.

The World of Kashi

A story is told on every package of Kashi cereal—the genesis of the product, for example. The mission of The World of Kashi *is to tell stories about how consumers and Kashi employees make the cereal part of their healthy lifestyle. The publication also includes fun trivia such as the fact that "Jerry Seinfeld stocks Kashi Medley in his cupboard on the 'Seinfeld' T.V. show."*

TRIM SIZE is 8 1/2" x 11" (22 cm x 28 cm)

FOUR-PAGE, FOUR-COLOR NEWSLETTER

Recycled Evergreen Glossy BOOK STOCK

CIRCULATION: 250,000

FEATURE COPY LENGTH: 200 words

LAYOUT PROGRAM: QuarkXPress

HARDWARE: Macintosh Power PC

EDITOR: Karen Moyer, Public Relations, Kashi Company, La Jolla, California. ART DIRECTOR: Roxanne Barnes, Roxanne Barnes Creative Services, San Diego, California. 3-D ILLUSTRATOR: Pak Sing Chan, San Diego, California.

Come Together

Kashi's product message and newsletter design are intertwined. As the newsletter copy explains, Kashi is "a synthesis of 'kashruth' or kosher and 'Kushi', the last name of the founders of macrobiotics (a whole foods way of eating/living)." Happily for the company's marketing pros, Kashi also means energy food in Japan, happy food in China, and pure food in Hebrew. The world over, Kashi's "Seven Whole Grains and Sesame" mixture is known as a natural wonder.

Thus the cover of the premiere issue of *The World of Kashi* (left) features a plate decorated with a map of a large part of the world. A fork and a spoon lead the reader to think "the world of Kashi" and to open a box, pour a bowl of cereal, and spoon away. Inside, both copy and images reflect the multi-cultural viewpoint and market base of the company.

Is It Real or Is It Digital?

If you can't find an illustration or photograph for your perfect cover, go ahead and make it. Editor Karen Moyer explains that, although the premiere issue cover looks like it was photographed, it was actually created on the desktop. Says Moyer, "We received a call from a woman who wanted to know where we purchased the plate pictured on the front, as her daughter, who's in the Peace Corps, collects world-theme items. I had to break the news to her that the world plate existed only on computer—designed by our graphic artist."

Don't Forget Your Copy Machine

Adding a little texture to design doesn't mean hours of extra work. Designer Roxanne Barnes enlarged an actual postcard—pictures and postmark—mailed from Kashi, China, on a photocopier, then scanned this into her computer. "The rough texture," she says, "gives an earthy feel. It's like traveling the world," the world of Kashi, that is.

Photos Should Stress Theme

According to Moyer, *The World of Kashi* tells a story on every page. She says, "We want to show the folksy, honest, real people behind this company." The premier issue shows employees in colorful clothing, including Kashi T-shirts, who ran in the 1993 Chicago marathon.

White Space Creates Focus

Lots of white space on each page of the Kashi newsletter directs the reader to notice vibrant colors. For instance, the colorful product packages and page edge make the newsletter seem charged—adding to the theme of good health obtained from good nutrition.

thousands of entry forms, newspaper ads, posters and t-shirts.

Some of the larger events we sponsor are the March of Dimes "Walk America," the Susan G. Komen Breast Cancer Foundation's "Race for The Cure," the Heart Walks put on by the American Heart Association, the Alzheimer Association "Memory Walks," the Portland and New York City

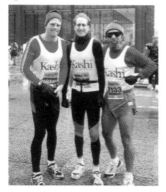

Kashi Employees at Chicago Marathon '93

Marathons, Pittsburgh's Great Race 10K and the San Francisco Bay to Breakers 10K.

WHAT IS KASHI?
FROM SEVEN WHOLE GRAINS AND SESAME SPROUTED...

■ **Kashi Breakfast Pilaf** Something different for a change! A delicious blend of Seven Whole Grains and Sesame, that's the perfect change of pace for breakfast, lunch or dinner. It's packed with nutrients to give you staying power. Cooks in 25 minutes. Recipes from basic breakfasts to extravagant entrees included.

■ **Puffed Kashi** America's favorite diet cereal. Whole grain goodness with more nutrition per bowl than any other puffed cereal — with only 70 calories and less than 1g of fat per serving. No sugar or salt. And this tasty, multigrain puff even stays crunchy in milk.

■ **Kashi Medley** Seven cereals in one! Kids love Kashi Medley because the taste says sweet, adults love it because the ingredients say healthy. Sweetened with fruit juice and honey, Medley's combination of Seven Whole Grains and Sesame flakes, O's, nuggets, Puffed Kashi, corn flakes, no fat added granola, plus apples and raisins makes a great breakfast or snack.

■ **Kashi Vegetarian Pizzas** A sign of the times. Greek Gourmet (spinach, tomatoes and feta cheese), Spicy Southwest (vegetarian refried beans, jalapeños, corn, two cheeses and black olives) and Cheese & Sauce. Gourmet frozen pizzas with a hand

made crust featuring five types of grain. All about 200 calories per serving (and 8-11 grams of fiber). Truly guilt free indulgence. At natural and specialty food stores.

■ **Spa Kashi Salads** Nine different specialty grain salads made from a combination of Kashi Pilaf, garden fresh vegetables, herbs and spices. Created for some of the world's finest health spas and resorts in styles to suit every taste: Brazilian Black Bean, Spicy Chinese, Pesto and Wild Holiday, to name a few. Fat-free and low fat vegetarian varieties. No preservatives. Now available by the pound at supermarket service delis in Southern California. Soon to be offered nationwide.

New

■ **Honey Puffed Kashi** Now Puffed Kashi's unique blend of Seven Whole Grains and Sesame is honey roasted into a crisp, sweet breakfast or snack. You won't think twice about indulging in Honey Puffed Kashi. Sweetened with desert wildflower honey instead of refined sugar. No added oils or sodium. Has 78% less fat than Breadshop's Puffs n' Honey and 41% fewer sugars per serving than Kellogg's Smacks.

■ **Kashi Gourmet Quality Vegetarian Entrees** Look for new vegetarian entrees made from Kashi, Seven Whole Grains and Sesame Pilaf, including *Kashi and Lentils Paprikash, Kashi Parmesan, Kashi Ratatouille, Kashi Waterzoni* and *Kashi Mexicana*.

During ten years of cooking with Kashi, Co-founder Gayle Tauber has created five fabulous entrees. These gourmet vegetarian dishes use only the freshest ingredients and are seasoned to perfection. Sold in grocery, specialty and natural food store "heat and serve" deli departments and featured on the menus in restaurants and other food service establishments.

KASHI DOWN UNDER AND OVER YONDER

Throw some Kashi on the bar-be! Well, not exactly, but Kashi products will soon be available in Australia thanks to our new relationship with a major importer/distributor in Aussieland.

Kashi products are also exported to the United Kingdom, France, Germany, Israel, Canada and Japan with plans to expand sales into other countries. For two years now, Kashi Company has exhibited in the U.S. Pavilion at ANUGA, the world's largest international food show, which draws exhibitors and visitors from nearly 100 countries, in Cologne, Germany. As whole grain eating is a way of life for many cultures, the interest in Kashi's Seven Whole Grains and Sesame products generated from this show has been incredible. So look for Kashi the next time you're globe-trotting.

MAD ABOUT KASHI
Making it big on the air waves

It seems Paul and Jamie on the hit T.V. program, "Mad About You," are also crazy about Puffed Kashi. On one show, they give it to their dog, Murray, as a treat. And on another, Paul pulls Puffed Kashi from the cupboard, shook it, and complained that "his" box of cereal was empty.

Professed cereal fanatic and comedian Jerry Seinfeld stocks Kashi Medley in his cupboard on the "Seinfeld" T.V. show. Look for the pink and blue Medley box in his kitchen. It's usually the fourth cereal from the right, on the open shelf.

"The Renegade" T.V. show recently filmed an episode in La Jolla, right in front of Kashi Company's offices. For two years we talked with Lorenzo Lamas, who plays lead character Reno, and found out that he loves our cereals. Needless to say, we gave him a care package of Kashi products.

AND ON THE BIG SCREEN

Did you see the movie, "Point of No Return"? In one scene, Bridget Fonda's character is grocery shopping in an L.A. market. While she's piling her cart full of food, she grabs a few Kashi Pizzas from the freezer case.

Also, look for Kashi products to be featured in the upcoming Martin Scorsese film, "Search and Destroy" (due out in 1995).

Tulia Greenwald

KASHI KIDS

Kids often take time to write and tell us how much they love our cereals. In fact, Kashi Medley recently won first place in a "No-sugar Cereal Tasting Contest" held by second graders at Beverly Vista School in Beverly Hills, CA. Part of a "Health Champions" program which teaches comprehensive health education to students in grades K-8, Ms. Kassel's second grade class sampled seven different no-sugar cereals, then voted on their favorite. And Kashi Medley won! Here is one of the drawings depicting the event.

KASHI JUST DOES IT

Kashi Company was one of the first food manufacturers to aggressively develop the sports marketing niche. At hundreds of events across the country ranging from runs, walks and triathlons to aerobics, skiing competitions and health fairs, participants receive samples of

Kashi products and coupons. For each event, the Kashi logo is printed on thousands of entry forms, newspaper ads, posters and t-shirts.

Some of the larger events we sponsor are the March of Dimes "Walk America," the Susan G. Komen Breast Cancer Foundation's "Race for The Cure," the Heart Walks put on by the American Heart Association, the Alzheimer Association "Memory Walks," the Portland and New York City

Kashi Employees at Chicago Marathon '93

Marathons, Pittsburgh's Great Race 10K and the San Francisco Bay to Breakers 10K.

Recently, we have expanded our product sampling at art festivals and cultural events in major cities, including the Long Island Jewish Arts Festival and the La Quinta Arts Festival in Palm Springs. Let us know what's going on in your city. Write us with the names and dates of annual festivals, athletic, health and cultural events which attract nutrition-minded people.

KASHI FLYING HIGH

Numerous airlines are serving Kashi products on their in-flight meals. American offers Kashi Pilaf on their special meals menu. Kashi Pilaf was chosen by American Airlines in an effort to upgrade its vegetarian fare by offering a variety of non-traditional choices, among them a greater selection of grains. And, if you fly Delta or Continental and request a special breakfast meal, you'll get Kashi Medley. So, ask for Kashi when you fly.

Operations &
Sourcing News

TRIM SIZE is 8 1/2"x 11" (22 cm x 28 cm)

TWENTY-PAGE, THREE-COLOR QUARTERLY

Simpson Evergreen TEXT STOCK

BODY FONTS INCLUDE Bembo, Caecilia, and Ribbon 131

CIRCULATION: 4,500

FEATURE COPY LENGTH: 750 words

LAYOUT PROGRAM: QuarkXPress

HARDWARE: Macintosh

EDITOR: Linda Butler of Levi's headquarters. DESIGN:
 Joshua Chen of Chen Design Associates. Both are based
 in San Francisco, California.

Operations and Sourcing is the division of Levi Strauss & Co. that manufacturers garments for sale in the United States. Operations & Sourcing News keeps this worldwide base of employees up-to-date on new policies, systems, and their company's cutting-edge approach to customer satisfaction.

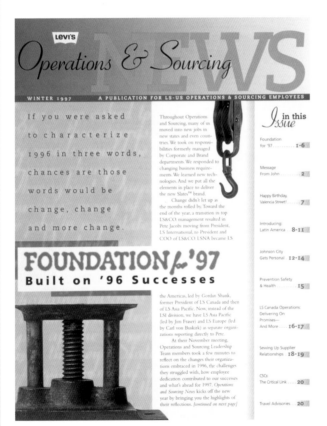

Dealing with Images

As with most newsletters, designer Joshua Chen doesn't always get professional quality photos from the field. Many of the images he works with are snapshots or, worse yet, Polaroids. "I have to do a lot of cleanup work on images in Adobe Photoshop," says Chen. "For one picture that showed a group of three people standing together, I actually had to extend their bodies so that they didn't look chopped off at the neck. Now, that may sound like a lot of work, but, if you know what you're doing, it's actually easier than asking for a re-take or trying to find another image. Our time frame doesn't allow for that sort of thing."

Chen also mixes up the types of frames he uses. As he points out, square black and white pictures get boring fast. He often blurs the edges of photos or turns them into duotones or tritones to create interest. These extras are meant to help the reader focus on a particular area of the image.

To Grid or Not to Grid?

When Chen sits down to design a newsletter he doesn't spend much time sketching it out. "I find that it's best to jump on the computer fairly early and not get too hung up on thumbnails. The computer is just so much more accurate. Plus, because *Operations & Sourcing News* was a redesign, I was able to import text from a previous issue for good word counts—a much better system than working blind," Chen says.

The template for *Operations & Sourcing News* is an eight-column grid Chen uses as a guide. "I do base the publication on a grid, but I'm not locked to it. The grid runs through the publication, but it doesn't scream out at you. Instead I tend to design each article specifically, more like a magazine. It's a lot more work this way but it ensures that each issue is fresh and different."

It All Stacks Up

Chen often stacks type in headlines because he likes the geometric shapes the combinations of fonts create. However, he is careful to use complementary typefaces in combination. "Basically you want to give the reader the impression that these faces are meant to be together. Still, don't feel this is a hard-and-fast rule. Always feel free to experiment."

In the "Happy Birthday, Valencia Street" spread (opposite page, middle left), notice how the "y" descenders in this headline perfectly frame the word "Valencia." When stacking, be doubly sure that words are legible.

White Space

"I try to create variety from feature to feature—to give the reader a different feel. For instance, the 'Happy Birthday, Valencia Street!' page is very active. The next spread, an article called 'Latin America: A Lesson in Leadership,' is very open and sparse."

Johnson City Gets Personal...
Personal Pair, That Is

TOP 10 REASONS FOR JOHNSON CITY'S IMPROVEMENTS

Introducing: Latin America

*Message From Joe Maccarrone
Vice President
Latin America Customer
Fulfillment Region*

Latin America: A Lesson In Leadership

Happy Birthday, Valencia Street!

LS&CO.'s historic Valencia Street plant in San Francisco recently celebrated 90 years of manufacturing the best-known brand in the apparel business. The factory, which opened its doors in November 1906, is LS&CO.'s oldest facility. It was built to replace two LS&CO. factories that were destroyed by the 1906 earthquake and fire.

Today, the factory has 80 employees and produces vintage Levi's jackets and 501 jeans.

Happy Birthday!

Carmen Stark, Joe Casaletto and Lida Klinhormhual in front of the historic Valencia Street plant in San Francisco. The factory houses as LS&CO. museum and hosts tours to more than 6,000 Levi's brand fans a year.

Susie Sala, Estela Cordero and Lylliam Vado enjoy the 90th birthday luncheon, held Nov. 19. Many of the skills gained and lessons learned at Valencia over the years have helped LS&CO.'s other plants improve their own operations.

Maria Casaretto—who retired last year after 47 years with the company—joined in the festivities.

Now this really takes the cake— this confectionery creation was baked in the shape of the Valencia Street factory.

OPERATIONS & SOURCING NEWS • WINTER 1997

LS-US. The team's vision: continuous improvement, world-class leader in product customers and consumers." To the team is working on an of Levi's jeans compared to such as fit, strength and ined with consumer need to improve.

years.

have a lot of

Sewing Up
Supplier Relationships

The U.S. Supplier Relationship Planning team had its hands full in 1996, finalizing five relationship plans. The suppliers: Burlington Menswear, International Garment Processors, Tee Jays, Denim Processors and JSC Container. That brings the total number of U.S. plans to 15, with four more in progress.

EARLY SUCCESSES

SIMPLICITY AND PREPARATION

NEXT STEPS

Work Council Helps Guide Relationships

OPERATIONS & SOURCING NEWS • WINTER 1997

bLink

EarthLink Network, one of the world's premier Internet service providers, developed its monthly bLink newsletter as a printed guide for new Internet users. bLink serves as both a teaching tool and an entertainment guide to the Web. Says editor Mike Brown, "New media generates a lot of fear. Print does not. The newsletter is a safety blanket for new users, something they can keep beside their computer when they're online."

TRIM SIZE is 8 3/8" x 10 7/8" (22 cm x 26 cm)

TWENTY-PAGE, FOUR-COLOR COVER AND TWO-COLOR CONTENTS BIMONTHLY

60 lb (90 gsm) Husky offset Smooth TEXT STOCK

Garamond BODY FONT

CIRCULATION: 300,000

FEATURE COPY LENGTH: 900 words

LAYOUT PROGRAM: QuarkXPress

HARDWARE: Macintosh

EDITOR: Mike Brown. ART DIRECTOR: Teri Osato. Both are staff members of Pasadena, California-based EarthLink Network.

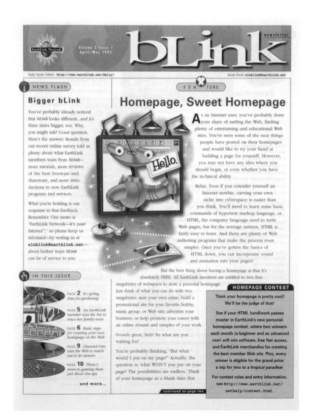

To bLink or Bunk?
The *bLink* flag was designed digitally and went through some twenty different variations before it was approved. "We had to try dozens of different fonts because the word '*bLink*' kept reading like 'bunk,'" remembers Osato, with a laugh. "Finally we settled on Garamond Book and made the 'L' a cap."

Newsletters; Baby Magazines
There are thousands of elements that go into the production of a magazine: making sure that scans stay with the correct articles, that service bureaus have necessary fonts, and that all four negatives from a particular advertisement actually make it to the printer. Keeping all those elements in order takes massive amounts of organizational knowhow. New publishers can jump right in and tackle all this at once or they can get in shape by printing a newsletter first.

bLink is an example of a newsletter that plans to be a magazine. With each issue the *bLink* team adds another four or so pages, and every few months a new element—like a bump up in quality from two- to four-color.

Words and Pictures
Sometimes an illustrated flag just isn't enough. *bLink* department flags (opposite page, bottom) feature both a short phrase and a unique icon. Says Osato, "Some people are comfortable with words, others are more visual. Hopefully, our mastheads attract both types of people."

Notice how small *bLink* department flags are relative to the rest of the page. They're definitely big enough to read but don't take away precious real estate from body copy—something a newsletter definitely can't afford.

Cyan, Cyan, Cyan
"Dealing with duotones can be really tricky," says Osato. "Photos hold up well, but illustrations tend to get muddy." To combat this, Osato has her artists develop their designs in Adobe Illustrator and Photoshop and save them in cyan and black, which adds depth to the drawings and also eases reproduction.

Illustrations are then imported into QuarkXPress. When she takes her digital file to the printer, she includes a PMS sample from a Pantone color book along with her dummy layout. This way there is no question about the exact color she wants to replace the cyan.

bLink newsletter (left)

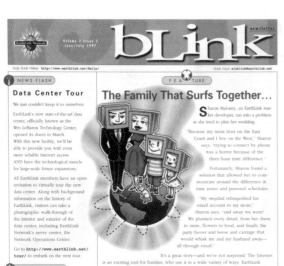

Volume 2 Issue 2 — June/July 1997

Daily bLink Online: **http://www.earthlink.net/daily/** bLink Email: **elnblink@earthlink.net**

NEWS FLASH

Data Center Tour

We just couldn't keep it to ourselves.

EarthLink's new state-of-the-art data center, officially known as the Wes LeBaron Technology Center, opened its doors in March. With this new facility, we'll be able to provide you with even more reliable Internet access AND have the technological muscle for large-scale future expansions.

All EarthLink members have an open invitation to virtually tour the new data center. Along with background information on the history of EarthLink, visitors can take a photographic walk-through of the interior and exterior of the data center, including EarthLink Network's nerve center, the Network Operations Center.

Go to **http://www.earthlink.net/tour/** to embark on the next tour.

IN THIS ISSUE...

FEATURE

The Family That Surfs Together...

Sharon Maloney, an EarthLink market developer, ran into a problem as she tried to plan her wedding.

"Because my mom lives on the East Coast and I live on the West," Sharon says, "trying to connect by phone was a horror because of the three-hour time difference."

Fortunately, Sharon found a solution that allowed her to communicate around the difference in time zones and personal schedules.

"My stepdad relinquished his email account to my mom," Sharon says, "and away we went! We planned every detail, from her dress to mine, flowers to food, and finally the party favors and horse and carriage that would whisk me and my husband away—all through email."

It's a great story—and we're not surprised. The Internet is an exciting tool for families, who use it in a wide variety of ways. EarthLink employees, many of whom spend much of their workday online, offer some great examples of how people who understand the Net put it to use at home.

Facilities manager Ken Washburn, for example, uses the Net to stay in touch with his father.

"My dad is in his late 60s," Ken says. "He lives in Maine, and his health is not that good—so he doesn't get around as much as he would like. A little more than a year ago, he got on the Internet and we started communicating back and forth with email...It is so easy that I find I write to him roughly 10 times more than I used to.

"I credit the Internet and email with making the bond between my father and myself stronger."

But email isn't the only way families can benefit from the Net—not by a long shot.

"My daughter, Alexa, is 11 and uses the Internet all the time," says EarthLink vice president of sales Julie Mantis. "Most recently, she created a science fair project that showed the effects of using toothpaste to reduce plaque.

continued on page two

bLink newsletter (right)

Volume 2 Issue 4 — October/November 1997

bLink Online: **http://www.earthlink.net/blink/** bLink Email: **elnblink@earthlink.net**

NEWS FLASH

EarthLink Wins Best ISP Award

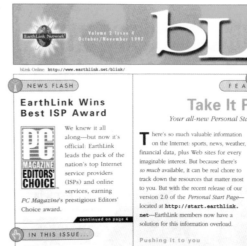

We knew it all along—but now it's official: EarthLink leads the pack of the nation's top Internet service providers (ISPs) and online services, earning *PC Magazine*'s prestigious Editors' Choice award.

continued on page 4

IN THIS ISSUE...

FEATURE

Take It Personally

Your all-new Personal Start Page℠ puts you in control

There's so much valuable information on the Internet: sports, news, weather, financial data, plus Web sites for every imaginable interest. But because there's *so much* available, it can be real chore to track down the resources that matter most to you. But with the recent release of our version 2.0 of the *Personal Start Page*—located at **http://start.earthlink.net**—EarthLink members now have a solution for this information overload.

Pushing it to you

You don't have to scour the Web for the "pushing" all the information you want to one easy-to-access location: your *Personal Start Page*. The term "push" refers to how Internet content is proactively delivered to your computer, eliminating the need for you to go out and search for it yourself. And because you can specify which news sources and topics interest you most, it's like subscribing to your dream list of newspapers and magazines and having the best articles from each delivered to your desktop every day—free of charge.

UNDER CONSTRUCTION

Organization In-Site

How to organize single- or multiple-page Web sites

Homepage vs. Web Site

If you just made your first homepage, it probably only needed to be a single page with some text, a graphic or two, and several links to favorite sites, all fitting easily onto the computer screen. Though the original HTML may have been difficult for you, the challenges mount as your site grows. And when you add to it, you'll need to decide whether this one-page homepage still works or whether you need to plan a Web site.

You *can* simply add any new material to your single page, so that visitors need to

```
<A HREF="#origin">
My Origin</A><BR>
<A HREF="#job">
My Job</A><BR>
<A HREF="#hobbies">
My Hobbies</A><BR>
<A HREF="#girlfriend">
My Girlfriend</A><BR>
```

The tags above may look familiar if you've used links before—except that there are no URLs after the **HREF** attributes. Instead, bLink links to "anchor names" located further down on the same page. Anchor names always follow the **#** sign in

MEMBERS PROFILE

Finding a New Life Online

An EarthLink Internet account is more than just a toy. If you still need convincing, read how two EarthLink members are using the Internet to help others—and themselves.

...fter he was involved in a serious car [accid]ent, EarthLink [mem]ber Eddie [Ho]lder (**mlholder@** [eart]**hlink.net**) [thou]ght his life was [over.] Instead, the [Inter]net helped him [find] a whole new [life. H]ere is Eddie's [story] as he related it to us [throu]gh email:

Internet is more than a great

A Thermometer, a Bedpan, an[d] a Homepag[e]

As a nursing student at Pasadena C[ity] College in Pasadena, California, EarthLink member Robe[rt] Bowman was getting impatient th[at] his school wasn't making

g a l l e r y

C h o i c e s

Instead of creating a traditional brochure boasting the accomplishments of Essex Two, this design office decided to make a statement. With the publication of newsletter Choices, *Essex Two explains how it interprets the art of communication and how this relates to "the traditional values of character and individual achievement."*

TRIM SIZE is 9" x 6" (23 cm x 15 cm); gate unfolds to 9" x 18" (23 cm x 45 cm)
SIX-PAGE, FOUR-COLOR QUARTERLY
CIRCULATION: 2,500
DESIGN AND EDITORIAL by Essex Two, based in Chicago, Illinois.

Each issue of *Choices* deals with one compelling theme such as "Perception," "Commitment," or "Change." Each cover relates directly to the short essay inside. For instance, a story about Christopher Columbus and how he used a parlor trick involving an egg to prove to his naysayers that he was an original thinker features the object of his game.

OBSERVATION · THE COLUMBUS IDEA

The ideas of Christopher Columbus were more monumental than any of his discoveries. Most of us born just before World War II as well as the baby boomer generation born just after, were taught that "in 1492 Columbus sailed the ocean blue." This was also the time when the notion that Columbus may not have discovered the New World was being presented. In fact, many suggest that it's ludicrous to credit any individual with the discovery of a continent already inhabited by an entire culture.

Political correctness aside, it is not important who discovered what when. What is important is why. Why did Columbus go? Why did he spend most of his life either in pursuit of funds to test his idea or living with the consequences of his discovery? Most of the questions were explained by Columbus himself upon his first return to Spain from America.

The news of his return preceded Columbus by several days. Smaller, faster ships met him at sea, provided supplies and returned to Spain with word of his arrival. When he arrived on shore, he still had to cover a tedious distance over land before he could present himself and his discoveries to his benefactor, the Queen.

There was an enormous I-told-you-so that the Queen had for almost everyone in the royal court, including the King.

This gave the Queen more than enough time to prepare an elaborate homecoming celebration. No detail was overlooked. The finest foods and wines were delivered. The castle and the grounds were prepared as though a visit from the Pope himself was expected.

This all needed to be done for a variety of reasons. There was an enormous I-told-you-so that the Queen had for almost everyone in the royal court, including the King, and it needed to be said without actually saying the words. This level of celebration said it loud and clear.

People and egos being what they are, as Columbus' time as well as today, nobody liked to have an I-told-you-so hanging over their heads. To dilute the Queen's triumph, several of the ministers who spoke against the Columbus exploration started a rumor. They said that while what Columbus did was significant, in a way it was inevitable that someone would have bumped into the New World eventually, even if by acci-

dent. By the time of the dinner in the great hall, everyone was feeling quite smug and self-satisfied, to the point that several ministers were openly hostile and sarcastic toward Columbus.

He was again alone with his ideas without support. As the dinner went on, the Queen, almost in desperation, asked Columbus to respond to these comments. He was seated at the head table next to the Queen with over thirty ministers and bureaucrats all around him. He stood up and called for the chef. When he appeared, hot and sweaty from the kitchen, Columbus asked him to bring everyone in the room a raw egg.

When everyone had an egg, Columbus said, "I can make my egg stand upright using the small end. Can any of you?"

A combination of laughter and ridicule escaped from each participant, something like bad-smelling gas. Columbus' face changed from the warm, round countenance of an intellectual cherub to that of a slave driver as he said, "Do it, if you can!" Without a sound they all attempted the challenge.

After only a few minutes, no one at the dinner was able to complete the task

"Of course you can now do what has already been done, but only after someone has shown you how."

and had quit in frustration. With new-found courage, those ministers who had started the rumors said in protest that it could not be done and that Columbus was trying to avoid their assessment of his accomplishment as a lucky accident.

Columbus cleared the space in front of him on the dinner table. He reached for the salt and poured out a small mound, no bigger than a button. He placed the small end of his egg in the mound of salt and it stood up. He then blew away the mound of salt, and the egg still stood.

The ministers began to protest. "This is just like the discovery of the New World. Now, we can all do the trick!"

Columbus stopped everyone with a look. "Of course you can now do what has already been done, but only after someone has shown you how."

Some good ideas survive obstacles. Many do not. Successful new products and services prosper because of the entrepreneurial spirit in senior managers who recognize that ideas are America's products, and that we have a penchant, an aptitude, a talent for innovation and creativity. Original thinking starts with original thinkers.

Urban Shopping Centers Inc.
1996 Annual Report

From the annual report: "Urban Shopping Centers Inc. is a self-administered real estate investment trust (REIT) in the business of owning, acquiring, managing, leasing, developing, and redeveloping super-regional and regional high-end shopping malls throughout the United States."

TRIM SIZE is 8 1/2" x 11" (22 cm x 28 cm)
FORTY-PAGE, TWO-COLOR-PLUS-SPOT-COLOR
SABON BODY FONT
CIRCULATION: 17,000
DESIGN: Essex Two, located in Chicago, Illinois.

Spreads at the opening of this annual report feature inviting black-and-white portraits. There's Sarah Dodd, store coordinator for the Pottery Barn in Urban's Old Orchard Center, hugging a dramatic vase; Jim Norman and Dottie Berger, Hillsborough County Florida county commissioners donning hard-hats and swinging shovels at the Brandon TownCenter; and Jeffrey Winograd, area supervisor for Lettuce Entertainment Restaurants, at Foodlife in Water Tower Place, toasting the reader. Each photo serves as a background for intriguing sidebar copy run in white (or black if it covers a white area of the photo) and a large, salmon-colored headline. The activity in the photos and the dramatic typography draws readers into the dense one-column text on the right-hand page.

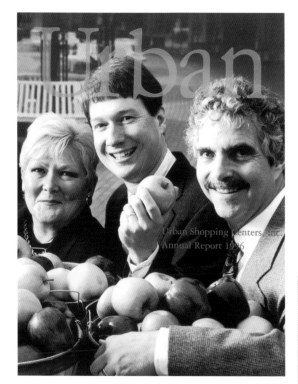

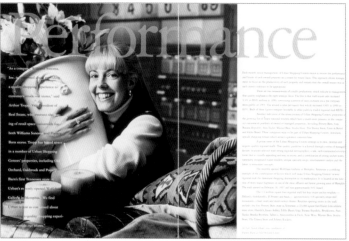

S c r e e n A c t o r

Screen Actor, *the official publication of the Screen Actors Guild, provides members with news on Guild activities and benefits, along with entertainment industry trends.*

TRIM SIZE is 8 1/2" x 11" (22 cm x 28 cm)
EIGHT-PAGE, FOUR-COLOR BIMONTHLY
Garamond 3 BODY FONT
CIRCULATION: 90,000
EDITOR: Greg Krizman of the Los Angeles-based Screen Actors Guild.
 DESIGN: The Ingle Group located in Inglewood, California.

Screen Actor has a simple, classy design. The drop shadow behind "Actor" in the flag brings real life to the serif font. One of the most pleasing features of the design is the ample amount of white space. This gives the photos some breathing room—which is particularly fun, considering that everyone likes to look at stars, even other stars.

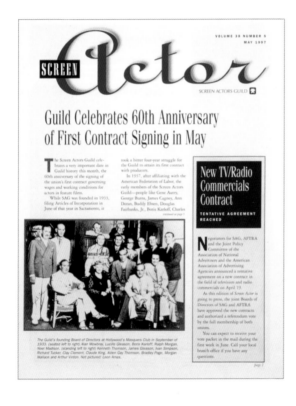

Contrails

Devoted to the transportation needs of corporate leaders from the world, Bombardier publishes Contrails *to showcase the benefits and diverse use of their business jets.*

TRIM SIZE is 8 1/2" x 11" (22 cm x 28 cm)
TWENTY-FOUR PAGE, FOUR-COLOR QUARTERLY
Perpetua BODY FONT
CIRCULATION: 10,000
EDITOR: Steve Phillips, at Bombardier headquarters based in Montreal, Canada. ART DIRECTORS: Sonia Greteman, The Greteman Group located in Wichita, Kansas.

This design is as bold and diverse as the line of corporate aircraft it represents. The color palette is rich and headlines are large and straightforward. Business jets, silhouetted in Adobe Photoshop, add excitement and beauty to the pages. A particularly stunning spread is this one for a feature titled "East Meets West." Notice how all the elements feel like the Far East and yet have an international touch. The headline font, with letters butted up against each other, remind us of Kanji figures. The layout, which stretches across the page, seems patriotic, like a flag.

g a l l e r y

H.J. Heinz Co. 1996 Annual Report

The company that produces the world's most famous ketchup specializes in more than just condiments. It also creates foods for infants and pets as well as specialty foods for weight control.

TRIM SIZE is 8 1/2" x 11" (22 cm x 28 cm)
SEVENTY-TWO PAGES
WRITERS: Eleanor Foa Dienstag, of Eleanor Foa Associates, Jack Kennedy of Ketchum PR. DESIGN: RKC! (Robinson Kurtin Communications! Inc.)
 located in New York, New York.

Akin to the saying, "never act with an animal, because it will steal the show," is the simple fact that engaging photos of babies always catch the eye. The Heinz annual report makes the most of fun toddler shots—on the cover and on this appealing spread that opens the section on Infant Foods—by running them extra large.

Type appears in a sans serif with a PMS gray. Combined with ample leading, this makes for easy reading and a designerly look. Note that paragraphs are separated by a box dingbat instead of an indent, another tasteful addition.

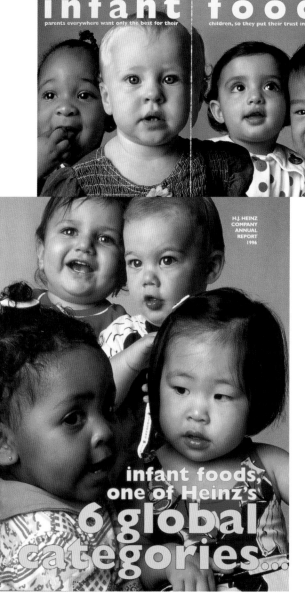

FOODSERVICE. Consumers today
pleasure of eating out. That is goo
adds up to more than $2 billion, c
vice is now Heinz's number-one

 every food d
 one-third in
 6% in the U
 and Asia. ■

to the foodservice market and nu
range of items — including ketch
sauces, baked goods and tomato p
 ■ In the United States, the comm
twice as fast as the retail sector. Heinz's foodservice

The Callaway GrapeVine

This publication tells of recent and upcoming events at the Callaway Vineyard & Winery, announces the introduction of new wines, and offers some great recipes to accompany particular selections.

TRIM SIZE IS 8 1/2" x 11" (22 cm x 28 cm)
SIX PAGES, BLACK PLUS THREE SPOT COLORS
Adobe Garamond BODY FONT
CIRCULATION: 40,000
EDITOR: Bev Stureman, Callaway Vineyard & Winery. DESIGN: Anne Howell of Maurice Printers. Both are based in Temecula, California.

Editorial content for *The Callaway GrapeVine* expresses the vineyard's commitment to community, environmental issues, and living well. Design emphasizes this mission through the use of colored photos with feathered borders. These images show happy people enjoying the great outdoors at Callaway. The feathered treatment softens the images, recreating the feel of pleasant memories.

This illustration of a baby owl by Mike Smith of the Callaway Wineshop accompanies a short story about an owl rescue in the vineyard. The simple inclusion of both illustration and story allow the reader to connect with the vineyard's mission: to feel good about the owners and workers and, thereby, their product. It's a nice touch to use an illustration by a staff member; it's a feel-good addition for the reader.

Big Blue Box

Big Blue Box *really is a big blue box sent to subscribers who work in the kids' market.*

TRIM SIZE IS 8 1/2" x 11" (22 cm x 28 cm); box measures 12" (30 cm) on all sides
ONE HUNDRED-PAGE, FOUR-COLOR QUARTERLY
CIRCULATION: Varies
EDITOR: Sue Edelman, staffer at Big Blue Dot. DESIGN: Big Blue Dot, A Studio of Corey & Company Inc. located in Watertown, Massachusetts.

Big Blue Box isn't a newsletter or a magazine. In fact, it doesn't fit neatly into any publication category. So, we thought, all the more reason to include it, as its trendy, interactive, budget-wise design makes it too good to leave out.

Inside the box is a corrugated orange-and-lime-green binder containing more than a hundred pages of editorial about the hottest goodies the market has to offer. Better yet, the box also contains samples of products that relate to current kids' trends. Big Blue Dot created the binder, box, and video that are included and also publishes a one-page tabloid-size newsletter called Big Blue Box Between Boxes Bulletin.

Highlights of design? Simplicity, no-fear color usage, a retro feel, and an unbeatable printing price (the binder pages are actually photocopied).

N o v e l l u s 1 9 9 6 A n n u a l R e p o r t

Novellus is a leader in the semiconductor and chemical vapor deposition industries. In other words, Novellus is making a big impact in the high-tech manufacturing business of Silicon Valley.

TRIM SIZE is 8 1/2" x 11" (22 cm x 28 cm), ANNUAL REPORT
THIRTY-SIX PAGES
BODY FONTS include Sabon and Franklin Gothic
CIRCULATION: 30,000
DESIGN: Larsen Design Office Inc. located in Minneapolis, Minnesota.

One of the most striking elements of this sleek design is a four-page gatefold that visually tracks the company's growth, quarter-by-quarter, for 1996. This intriguing chart has a high-tech feel but is easy to read. To help tie the work, the brilliant orange of the cover is used throughout for backgrounds, subheads, and rules. Photos of equipment in surrealistic ultraviolet light add a futuristic touch.

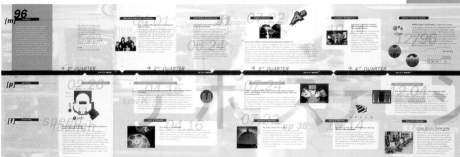

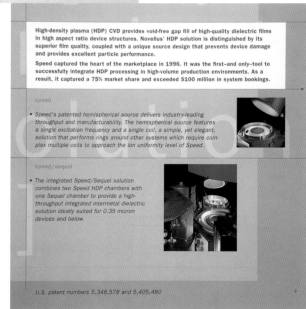

Stant Corporation
1996 Annual Report

From the Annual Report: "Stant Corporation is a leading designer, manufacturer and distributor of a broad range of automotive parts and tools. It is one of the world's largest manufacturers of automotive windshield wiping systems, windshield wiper blades and refills, closure caps and engine thermostats and a leading North American manufacturer of a variety of other automotive products including grease guns, hose clamps, automotive heaters and automotive tools."

SIZE: 7 1/4" x 10 1/8"
FIFTY-TWO PAGE ANNUAL REPORT
Frutiger BODY FONT
CIRCULATION: 12,500
WRITER: Tom Margetts. DESIGN: SamataMason Inc. based in Dundee,
 Illinois. CREATIVE DIRECTOR: Dave Mason. Design, Dave Mason,
 Pamela Lee. PHOTOGRAPHERS: Victor John Penner, Ray Fitzgerald.
 ILLUSTRATORS: Joe Baran, Pamela Lee. TYPOGRAPHER: Pamela Lee.

Imagine the perfect car. It could come in any form, but typically it will have sleek, classic lines, shiny chrome, and a clean, inviting interior. Designer Dave Mason must have had these details in mind when he created this annual report, because it boasts the same stunning stylistic impressions. There is a sexy black cover with two words in striking type—"Stant" and "1996" embossed in a small rectangular box that looks exactly like an odometer. In fact, the "6" at the end of "1996" is rolling up, followed by the number "7."

The contents include slick metallic inks, a glossy paper that feels like a new paint job, and distinctively "engineered" type. This fascinating three-dimensional, sans serif face, reminds the reader of blueprints or computer wireframe figures depicting some amazing new auto of the future—the perfect touch for a company that creates reliable products that even a beautiful car can't drive off the lot without. Also note the exquisite product lighting achieved by the photographer Victor John Penner. These black-and-white photos make grease guns look like Tiffany gems.

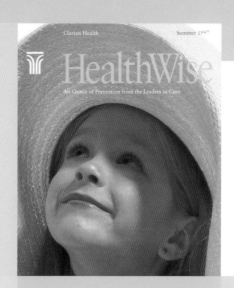

building awareness

What do women want?

It's not an easy matter to visually explain the science behind the process of aging, a new system for open-heart surgery, or the philosophy of an Eastern religion. To do this well, the designer must assume that a majority of the publication's readers, whether investors or laypersons, possess only limited knowledge of the topic. However, the artwork that lays the foundation for the text must not be juvenile; it must also attract the knowledgeable scientist, doctor, or philosopher.

Laypersons possess only limited knowledge of the topic. However, the artwork that lays the foundation for the text must not be juvenile; it must also attract the knowledgeable scientist, doctor, or philosopher.

Portraying the physical or the metaphysical is definitely an art in itself. In a very real sense design must walk a tightrope between hard facts and entertainment. It must also pull the reader in through stages. For instance, many of the publications in our "Building Awareness" section tend to provide information in an inverted pyramid, a writing style used in newspapers to explain the most important details first. Graphics and pull-quotes that take up a large portion of page space provide the layperson with enough basic info to grasp the concept. Dense information is provided in tightly written, typically smaller blocks of text.

Another intriguing design challenge for the artists featured in this section is imagery itself. How do you make surgery, test-tubes, and aggregates appealing? How do you make dense, highly allegorical ancient texts understandable? Turn the page and you will find some brilliant solutions.

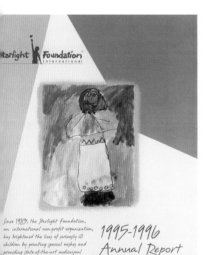

Since 1983, the Starlight Foundation, an international non-profit organization, has brightened the lives of seriously ill children by granting special wishes and providing state-of-the-art audiovisual entertainment to hospitalized children.

1995-1996 Annual Report

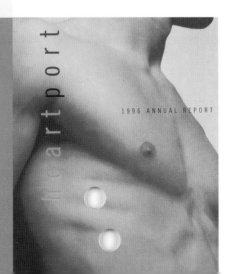

1996 ANNUAL REPORT

heartport

sciences

Volume 24
Number 4

Remember that cool science project you created as a kid? Whether your miniature volcano blew up or your rocket never flew, you still got a thrill out of the sheer fantastic nature of science. Your curiosity was piqued and your willingness to investigate the world around you was enhanced. The designs in our "Sciences" chapter bring this sense of childhood awe back to the reader.

Notice how the collage-like design of *Sydney's Koala Club News* becomes a feast for the inquisitive. Its frenetic, clustered energy makes you want to investigate every part of the text all at once—and, like a child, drink it all up at once. The annual report for CalMat features unique tools of the mining trade along with topographic charts used as backgrounds. Flipping through this beauty is enough to make anyone consider changing profession in order to truly explore the riches of Mother Earth.

You will find that the magic in this chapter is often spelled out best in visuals rather than words.

You will find that the magic in this chapter is often spelled best in visuals rather than words because visuals are the common denominator: the language all understand.

Staying the Course

Sydney's Koala Club News

Joining the children's membership category of the Zoological Society of San Diego means receiving Sydney's Koala Club News *as a benefit. The newsletter generates interest in the events, exhibits, and research of the San Diego Zoo and Wild Animal Park and educates children about animals, plants, and the environment. The liveliness of the newsletter makes learning fun.*

TRIM SIZE is 8 1/2" x 11" (22 cm x 28 cm)

SIX-PAGE, THREE-COLOR BIMONTHLY

70 lb (105 gsm) White Endeavour Velvet Recycled TEXT STOCK

Random Typographics BODY FONT

CIRCULATION: 135,000, mailed to members of the Zoological Society of San Diego children's membership category, ages three to fifteen

FEATURE COPY LENGTH: Main feature: 600–800 words; secondary feature: 500–600 words

LAYOUT PROGRAMS: QuarkXPress, Adobe Illustrator, and Adobe Photoshop

EDITOR: Karen E. Worley, Zoological Society of San Diego. DESIGN: Warner Design Associates Inc., San Diego, California.

Kids Love Color

Bright colors and new looks appeal to kids. Each issue of *Sydney's Koala Club News* is bright, almost neon, in appearance. The color scheme changes with each issue.

Make Everything Count

Everything about a well-designed newsletter works toward a central idea. Unless clutter is the result, all available space should be used to keep a theme going. In *Sydney's Koala Club News*, for example, even the cover's border promotes learning about animals and plants. What appears to be a line of bits of stems and leaves—eucalyptus, of course—surrounds the page. The border meets the flag, cornering with a sketch of a busily eating koala at the upper left and, to achieve an artful not-square balance, showing another sketch of a koala just below the upper-right corner. The bottom of the border is broken with names and pictures of animals to be searched for inside.

Regular Features Create Interest

Consider including regular features in newsletters—even ones not just for kids. Each issue of *Sydney's Koala Club News* features kids' questions in "Ask Mother Meerkat" (opposite page, right). In the July/August 1997 issue, a nine-year-old reader asks, "What is a meerkat's most keen sense?" Mother Meerkat answers and gives an example of the incredible vision of three meerkats who live in the Children's Zoo. Thus we have another instance of keeping to purpose. This example follows the goal of the newsletter contributing to members' knowledge of exhibits at the San Diego Zoo and the Wild Animal Park.

Keep Those Kids Busy

Making this newsletter interactive is the foremost design concept of editor Karen Worley, and *Sydney's Koala Club News* does seem to move about as fast as most kids. It presents a variety of information in a format that ranges from small to large photos and graphics, a template that varies in width and direction, and type styles that vary from feature to feature (one feature on field notes, for example, is printed as if copied from handwritten journals made during field research.)

Always Keep Audience in Mind

Designer Richard Warner says, "One thing that makes *Sydney's Koala Club* effective is that we're really clear on who the issues are for. We design with audience strictly in mind. Often a designer, especially those new to the field, will change the plan to suit the designer's taste. The designer falls into the trap of designing for himself or herself."

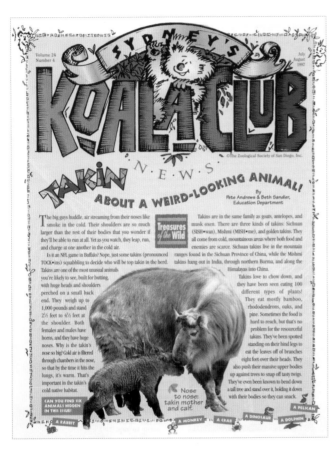

KOALA CLUB NEWS

Volume 24 Number 4

July/August 1997

©The Zoological Society of San Diego, Inc.

TAKIN' ABOUT A WEIRD-LOOKING ANIMAL!

By Pete Andrews & Beth Sandler, Education Department

Treasures of the Wild

The big guys huddle, air streaming from their noses like smoke in the cold. Their shoulders are so much larger than the rest of their bodies that you wonder if they'll be able to run at all. Yet as you watch, they leap, run, and charge at one another in the cold air.

Is it an NHL game in Buffalo? Nope, just some takins (pronounced TOCK•ins) squabbling to decide who will be top takin in the herd. Takins are one of the most unusual animals you're likely to see, built for butting, with huge heads and shoulders perched on a small back end. They weigh up to 1,000 pounds and stand 2½ feet to 4½ feet at the shoulder. Both females and males have horns, and they have huge noses. Why is the takin's nose so big? Cold air is filtered through chambers in the nose, so that by the time it hits the lungs, it's warm. That's important in the takin's cold native habitat.

Takins are in the same family as goats, antelopes, and musk oxen. There are three kinds of takins: Sichuan (SISH•wan), Mishmi (MISH•me), and golden takins. They all come from cold, mountainous areas where both food and enemies are scarce. Sichuan takins live in the mountain ranges found in the Sichuan Province of China, while the Mishmi takins hang out in India, through northern Burma, and along the Himalayas into China.

Takins love to chow down, and they have been seen eating 100 different types of plants! They eat mostly bamboo, rhododendrons, oaks, and pine. Sometimes the food is hard to reach, but that's no problem for the resourceful takins. They've been spotted standing on their hind legs to eat the leaves off of branches eight feet over their heads. They also push their massive upper bodies up against trees to snap off tasty twigs. They've even been known to bend down a tall tree and stand over it, holding it down with their bodies so they can snack.

Nose to nose: takin mother and calf.

CAN YOU FIND SIX ANIMALS HIDDEN IN THIS ISSUE!

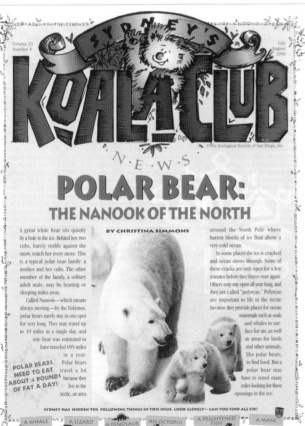

KOALA CLUB NEWS

Volume 23 Number 4

July/August 1996

©The Zoological Society of San Diego, Inc.

POLAR BEAR: THE NANOOK OF THE NORTH

BY CHRISTINA SIMMONS

A great white bear sits quietly by a hole in the ice. Behind her, two cubs, barely visible against the snow, watch her every move. This is a typical polar bear family: a mother and her cubs. The other member of the family, a solitary adult male, may be hunting or sleeping miles away.

Called Nanook—which means always moving—by the Eskimos, polar bears rarely stay in one spot for very long. They may travel up to 19 miles in a single day, and one bear was estimated to have traveled 695 miles in a year.

POLAR BEARS NEED TO EAT ABOUT 4 POUNDS OF FAT A DAY!

Polar bears travel a lot because they live in the Arctic, an area around the North Pole where barren blocks of ice float above a very cold ocean.

In some places the ice is cracked and ocean shows through. Some of these cracks are only open for a few minutes before they freeze over again. Others may stay open all year long, and they are called "polynyas." Polynyas are important to life in the Arctic because they provide places for ocean mammals such as seals and whales to surface for air, as well as areas for birds and other animals, like polar bears, to find food. But a polar bear may have to travel many miles looking for these openings in the ice.

SYDNEY HAS HIDDEN THE FOLLOWING THINGS IN THIS ISSUE. LOOK CLOSELY— CAN YOU FIND ALL SIX?

A WHALE A LIZARD A DINOSAUR AN OCTOPUS A FRIGHTENED FISH A MASK

Ask Mother Meerkat

DO BABY ANIMALS EVER GET BIRTH DEFECTS?

Elisabeth K. Burton, age 8½

Visit the Zoo's Sumatran orangutan exhibit at the Zoo and find Karen, the larger of the two youngsters. You'd never know that she was born with a hole in her heart. Her condition caused slow growth and weakness. After an operation that repaired her heart (her red hair hides the scar), she's the peppiest one in the group.

Bunyip the koala was born with scoliosis, a curvature of the spine. His condition can't be treated with surgery, and nobody knew if he'd live very long. But the keepers report that at age 6, Bunyip is pain-free and a happy camper. They'll always keep an extra-special watch on him, but they say that hopefully he'll have a "long happy koala life." Bunyip is currently on exhibit at the Wild Animal Park.

WHAT IS A MEERKAT'S MOST KEEN SENSE?

Isabel Tellez, age 9

Their vision is incredible. Moses, Ricky, or Timon (the Children's Zoo meerkats) stare overhead and sound an alarm long before we see the hawk. Also, everyone else who knows this meerkat trio laughingly says "don't forget their sense of hunger!" These little guys are truly voracious at dinnertime!

Send questions to: Mother Meerkat, Education Department, San Diego Zoo, P.O. Box 551, San Diego, CA 92112-0551. Unfortunately, we cannot print or answer all the letters we receive.

Geron

1996 Annual Report

TRIM SIZE is 7" x 11" (18 cm x 28 cm)

SIXTY-FOUR PAGES, FOUR-COLOR ANNUAL REPORT

80-lb (120 gsm) Endeavor TEXT STOCK; COVER: Lexan Mylar

BODY FONTS INCLUDE Rosewood, Trade Gothic

CIRCULATION: 10,000

LAYOUT PROGRAM: QuarkXPress

HARDWARE: MacIntosh

EDITOR: Carole Melis, a freelancer also from San Francisco.

ART DIRECTOR: Bill Cahan. DESIGN: Bob Dinetz, both of Cahan & Associates, located in San Francisco, California.

Geron *is dedicated to understanding the biological mechanisms "underlying age-related diseases, including cancer." Their efforts help make living better for the elderly.*

GERON 96

ANNUAL REPORT

Go For the Unexpected

Most annual reports covering the achievements and activities of science-related industries do so by focusing on sterile images. As Bill Cahan of Cahan & Associates says, "You usually just see ubiquitous photos of labs, lab coats, and test tubes." For Geron's first annual report, Cahan wanted to provide more. He not only wanted to help brand the company identity, he wanted to bring a human element to Geron's exploratory work.

To do this, Cahan made science more human by concentrating on juxtapositions such as the idea of "science" and the idea of "old age." For instance, the inside front cover (opposite page, top left) shows an enlarged image of young cells. Next to this is a picture of a seventy-year-old belly dancer in front of a portrait of her painted when she was twenty-five. Because the woman looks as good in old age as in her youth, the spread becomes a celebration of opposites.

Note that the juxtaposition is furthered by running the image of the young cells in color and the photo of the dancer in black and white.

If They Don't Get It—Why Do It?

The science behind the Geron approach to the inhibition of aging goes over 99 percent of the population's collective head. However, senior designer Bob Dinetz provides a visual explanation for the layperson (opposite page, middle right). His sketches, which explain the basics of Geron technology, are meant to imitate the wild scratches a professor might doodle on a napkin while trying to communicate the wonders of the natural world to a group of undergrads. They also look a great deal like the sketches in Dinetz's own journal.

Ideas From the Source

Note the use of grids for photos and captions. Dinetz explains that the idea for this template came from exploring Geron labs. "You find this pattern everywhere, from the holders for test tubes to the grid patterns for staining cells." In keeping with the personal touch of this report, the designers asked scientists to send photos of themselves in relaxed settings, possibly on vacation or playing in a park; thus the wide array of looks found here. Of course, photo quality was less than adequate, but Dinetz turned each into a compelling image through unusual cropping.

Presents Are Nice...

When the Geron annual report is mailed to potential stockholders it is accompanied by a smaller book (opposite page, bottom) titled *What Does Getting Old Mean to You?* Inside is an array of portraits accompanied by the subjects' answers to this question. At the back is a postage-paid return postcard for the reader to use to provide his or her view on what it means to get old. These responses are being collected for use in next year's report. Cahan explains that the publication of this little book has been amazingly helpful in terms of appeal and name recognition—hundreds of postcards now decorate the company's hallways.

And For the Observant

Page numbering for the Geron annual report begins with age "59" and ends with age "115."

GENOMICS & TELOMERASE
OF AGING INHIBITION

WHAT DOES GETTING OLD MEAN TO YOU?

When you bend down
you don't get up as fast.

Take one day
at a time sweetie.

CalMat 1996 Annual Report

The largest owner and producer of aggregates in California, CalMat supplies the sand and gravel used to build roads in the Sunbelt (California, Arizona, and New Mexico).

TRIM SIZE is 7 1/2" x 11" (19 cm x 28 cm)

FORTY-FOUR-PAGE ANNUAL REPORT with 5/4 COLORS on cover stock, 5/5 colors on Signature stock, and 2/2 colors on the Benefut stock

Signature Gloss 100 lb (270 gsm) COVER STOCK; TEXT STOCK: Signature Gloss 100 lb (150 gsm) Text and Benefut 70 lb. (105 gsm) Text Ivory, Squash, Kraft

Bodoni BODY FONT

CIRCULATION: 15,000

LAYOUT PROGRAM: QuarkXPress

HARDWARE: Macintosh

DESIGN: Douglas Oliver Design Office located in Santa Monica, California.

Limited Budget? Get Creative

The health of an industry definitely affects the design of a company's annual report. Every California business suffered during the recession of the early 1990s. The aggregate supply industry took one of the hardest hits. As testament to this, designer Douglas Oliver reports, "In 1994 my design budget had to be cut by 40 percent, which meant we couldn't afford photography." Happily, Oliver's solution ended up being an award-winner.

"If it was laid out as a one-lane wide road, CalMat's asphalt production would extend across the country and back two and a half times. So we built the book around the milestones you see on the highway—road signs." These signs boast intriguing catch phrases like "Road Construction Next 32,945 Miles" or "Cautious Optimism Ahead."

By 1996, Oliver's budget had increased enough to include photography again, but was still . . . challenging. Since the economy was definitely on an upswing and business was at last returning to normal, Oliver decided to say something about the staying power of the company itself, a company that could ride the storm and come out on top. "Management explained that they had done everything possible. That they were positioned and ready and now all they had to do was be patient. These comments led to the phrase, 'staying the course,' which became our theme for design."

Beauty in the Unexpected

By treating photos of old-fashioned surveyors' tools as art, Oliver achieves a sense of CalMat's tradition, longevity, and knowledge. Accompanying text explains the technology that has replaced these instruments. "I really went out on a limb with this one," says Oliver. "I knew that I couldn't show the client drawings or a mock-up of the look I was going for; it simply wouldn't have the impact of real photos. So I sprung for a couple days of studio shooting."

When Oliver went in for his first brainstorming meeting with his client, he was actually showing them his finished idea. Fortunately, management was impressed and immediately signed off. "You can't really do something like that unless you've worked with a client for a number of years. CalMat had a lot of trust in us. I knew exactly what they liked. Of course, that doesn't mean that I wasn't petrified when I walked in!"

Oh! Those Financials!

Says Oliver, "Designers have a lot of unwritten rules about the financial section—that you should never use one wide column because the reader's eyes will get tired and so on. Frankly, I think some of these rules are voodoo. What you should avoid is designing the report for you rather than the client. A chairman should be able to pick his book up and immediately recognize his company."

CalMat 1994 Annual Report

PAVEMENT NEVER ENDS

ROAD CONSTRUCTION NEXT 32,945 MILES

Over the next decade, California, Arizona and New Mexico are expected to repave about 33% of their state highway systems annually. That totals about 13,200 miles of roadway in California, 8,120 miles in Arizona, and 11,625 miles in New Mexico.

People are amazingly accurate, the PLUMB BOB allowed surveyors to arrive at a true horizontal plane in order to measure the distance between two points of different elevation. Today this task is often handled by an electronic device called the "total station," which offers the flexibility to measure true-foot distances as much as 2,000 feet distances.

Increased sales volumes and slightly higher average selling prices raised earnings in both our aggregates and ready mixed concrete operations.

The PHILADELPHIA ROD AND TARGET essentially, a ruler and half-cut — were two of the components used to determine the rise and fall of the ground surface in order to establish a true horizontal plane. Today the Global Positioning System performs this task much better.

THIS IS THE
FUTURE SITE OF THE
GERI AND RICHARD
BRAWERMAN
OUTPATIENT CENTER

C/H/A/P/T/E/R

8

health

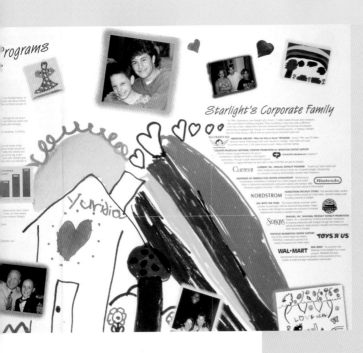

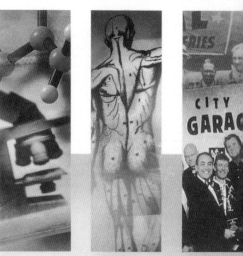

Like most achievements, the goal of good health is at once terribly difficult and infuriatingly simple. Good health requires regular exercise, good eating habits, and an optimistic mental outlook, all of which are difficult to acquire but, once established, relatively easy to maintain.

Yet, no matter how hard we struggle to keep up our health, we are often sideswiped by the unexpected: a traffic accident, a disease carried in our genes. That's when health must be maintained and enhanced through the complex practice of medicine.

Unlike the publications in the "science" chapter, design for health-related industries must appeal to the ambitious in nature, people who wish to care for their bodies in new and innovative ways.

This chapter honors both aspects by celebrating the health goals of the layperson and the miracles of the medical industry. Design in this case, much as in the previous chapter, must appeal to two categories of readers, the informed and the yet-to-be-informed. Unlike the publications in the "Sciences" chapter, design for health-related industries must often go one step further by appealing to the ambitious in nature, those who wish to care for their bodies in new and innovative ways.

For instance, the design of *Health Matters* intrigues both the certified exercise instructor and the avid amateur through an energetic combination of illustrations and photography. The illustrations symbolize the person we all want to be, while photos represent the goal achieved. The transition between the soon-to-be-healthy body and the healthy body is often shown through photographs that have been digitally manipulated.

A suggestion for artists in the health field is to remember that they are dealing with an audience in transition and that design should reflect that positive energy.

Red Peppers Turn Up the Heat on Workouts

THE METABOLIC EFFECTS OF CAPSAICIN, A SUBSTANCE known to most of us as hot red pepper, have received quite a bit of attention lately. It is easy to make a comparison between the hype over capsaicin and the unsubstantiated buzz of many years ago about grapefruit (someone manages to revive that one every few years). Thousands of people — women in particular — were puckering up to bushels of grapefruit, believing its so-called fat-burning properties would help them lose weight. The only thing lost was, perhaps, their ability to taste anything else!

Capsaicin also has received its share of claims. Unlike grapefruit, however, there is some evidence to suggest that capsaicin enhances both lipid and energy metabolism.

The body reacts to capsaicin in much the same way it does to caffeine, increasing plasma catecholamine levels through sympathetic activation of the central nervous system. But can it really make you burn more calories?

That's what researchers in Japan set out to determine. As is often the case, subjects were not exactly "average Joes." All were young, male, long-distance runners, and each was given a substantial meal with or without 10 grams (yes, that's a lot) of hot red pepper for breakfast. After resting for two-and-a-half hours, the men cycled on a stationary bike for one hour at approximately 60 percent VO$_2$ max. Those who were given the hot red pepper had significantly elevated respiratory quotient levels both at rest and during the cycling. Measurements of plasma epinephrine and norepinephrine levels indicated that the hot red pepper increased the men's ability to oxidize carbohydrate both at rest and during exercise.

These findings are less significant to those who want to lose weight than to those interested in increasing carbohydrate oxidation for exercise energy fuel. However, for athletes participating in prolonged exercise events, capsaicin is not an appropriate ergogenic aid since increased carbohydrate oxidation occurs at the expense of fat

City of Hope

1996 Annual Report

From the annual: "City of Hope, inspired and supported by a philanthropic volunteer movement, is dedicated to the prevention, treatment, and cure of cancer and other life-threatening diseases through innovative research and patient care."

TRIM SIZE is 8 1/2" x 11" (22 cm x 28 cm)

SIXTY-TWO PAGE, spiral-bound, SIX-COLOR ANNUAL REPORT

Classic Crest STOCK

Matrix BODY FONT

CIRCULATION: 20,000

LAYOUT PROGRAM: QuarkXPress

HARDWARE: Macintosh

DESIGN: Maggie van Oppen of Kimberly Baer Design Associates, located in Venice, California. PHOTOGRAPHER: Mark Robert Halper. ILLUSTRATOR: Richard Tuschman.

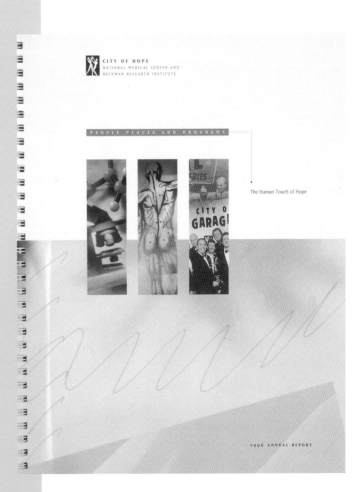

The Human Touch of Hope

Sure I'll Limit My Themes...But How?

Says project manager Michael Lejeune of Kimberly Baer Design Associates, "Annual report designers advise their clients to limit text to three or four key messages. That way design can constantly reinforce them through type choice, color illustrations, photos, everything. Because City of Hope is such a complex place, that's a difficult task. Not only does the center engage in many different health care activities, the annual report itself has to communicate to a diverse audience made up of insurance providers, doctors, research groups, benefactors, and so on."

To solve this conundrum, Lejeune worked with writer Dave Gurzenski, who pulled impressive stories from recent City of Hope publications. These stories led Gurzenski to develop four broad sections of interest—research, treatment, philanthropy, and contributors. Through the use of sidebars, each section focuses on three topics of interest—people, places, and programs—a slogan that City of Hope president, Charles M. Balch, M.D., brainstormed. The main body copy is a narrative describing current medical and research affairs.

Bind-In Texture

Building texture into design creates automatic interest for readers. One surefire way to grab a reader's attention is to bind in different-sized cuts of paper. In the City of Hope report, intriguing stories about donors appear on 3 1/2" x 9 3/16" (9 cm x 24 cm) cards (opposite page). Hiring one photographer ensured that images have a similar look. Note that bind-ins offer another money-saving alternative to collateral materials. They can be overrun and used in press or sales kits.

Fine Art

One of the most attractive features of this design is the use of photo collages. As Lejeune points out, "Collages allow you to create images of ideas, themes, and specific situations that are hard to capture in a traditional photograph. They also give a rich, free-form feeling to the design."

For this, the design firm hired photo artist Richard Tuschman, who provided very detailed first sketches showing how he intended to interrelate various objects. After receiving the go-ahead on a sketch, he worked with all media—photography, illustration, and found art—to create collages in Adobe Photoshop and Illustrator.

Lejeune explains that one of the most difficult photo illustrations was for the section on philanthropy. "Without focusing on money outright, we had to come up with a way to show the spirit of the people who donate to City of Hope." The solution was to use a dollar bill as a background texture, to fill in the famous central oval with sharing hands holding a rose of hope, and to surround this with group shots from fundraising events (opposite page, bottom).

HealthWise

HealthWise *is published by Clarian Health Partners Inc., a merger of the Methodist Health Group of Indiana and the University of Indiana's Medical School. Its purpose is to provide health information to patients and employees so that all can avoid hospitalization.*

TRIM SIZE is 5 1/2" x 11" (14 cm x 22 cm)

TWENTY-FOUR PAGE, FOUR-COLOR QUARTERLY

MEAD TEXT STOCK

SABON BODY FONT

CIRCULATION: 45,000

FEATURE COPY LENGTH: 500–1,200 words

LAYOUT PROGRAM: QuarkXPress

HARDWARE: Macintosh

EDITOR: Susan E. Spence of Clarian Health Partners, located in Indianapolis, Indiana. DESIGN: Essex Two, based in Chicago, Illinois.

The Power of Print

Hospitals are facing hard times. Consolidations are cutting overhead, thus making bed space a precious commodity. With the healthcare industry undergoing such radical change, it is more important than ever that healthcare providers teach people how to stay well. Education, it is believed, will help patients avoid lengthy hospital stays that ultimately overburden the system. To help Clarian Health Partners communicate advice for healthy living, design firm Essex Two created *HealthWise*.

Covers They Can't Resist

Each issue of *HealthWise* boasts a knock-out cover. The cover from the February 1994 issue (opposite page top right), with a face made up of pills, is especially eye-catching. Note that the illustration continues from front cover to back. This image is so strong that a close-up is actually re-used within the article, a definite money-saver.

That Friendly Touch

Another appealing feature of *HealthWise* is portraits. As the head of Essex Two, Joseph Michael Essex explains, these images help make healthcare a little more human. "*HealthWise* portraits are about relationships. You'll notice that each image has a person looking at you. That's very intentional as it creates a friendly bond between the reader and the industry. The images help defeat that adversarial feeling that a lot of us have toward hospitals."

Type That Speaks

Essex chose Sabon, a classic serif face, for the body copy as it feels familiar and comfortable to American readers. "Sabon is a variation on Times. It has a high x-height so it's still legible even in a small point size. It is an open face and very familiar to readers here who were taught to read using serif fonts. In Europe, the opposite is the case. Children learn to read with sans serif fonts."

Creating a Feel

"*HealthWise* has to sell first as a picture book and second as a communication tool for text. The pictures have to be a tease for the editorial. So, to create interest, we use both simple images that bleed off the page and complex collages that are created by hand."

Arrive Alive

You hold the keys to preventing traffic accidents

Here's the bad news:

- Motor vehicle crashes are the leading cause of death for people ages 5 to 27 years.

- A person is twice as likely to die from a car crash as from being murdered.

- Five Americans die every hour from a traffic crash.

Here's the good news:

Because most crashes are caused by human error, you can take action to keep you and your family from becoming one of these tragic statistics.

The portion of accidents caused by human error could be as high as 95 percent, according to the National Safety Council.

"In fact, calling them 'accidents' is really a misnomer," said Debbie Milas, marketing director, Governor's Council on Impaired and Dangerous Driving. "Rather than someone's brakes failing or a roadway caving in, most crashes are preventable and caused by things like inattention or failure to yield right of way."

Alcohol and other drugs play a role, too, and are involved in about 42 percent of all accidents nationwide.

"In Indiana, in 1994, the number of impaired driving accidents was lower than the national average, at 23 percent," Milas said.

"Inattention was the major contributing circumstance in 20 percent of accidents. What caused the inattention — talking on a cellular phone, reprimanding children, or just daydreaming — isn't documented," she added.

Safe Driving in the Workplace

Motor vehicle crashes are a big problem for employers as well. In addition to being the leading cause of death in the workplace, they are a huge cost. In 1993, traffic mishaps both off and on the job cost employers close to $54 billion in lost of worker availability and health-care costs. A public/private partnership called Network of Employers for Traffic Safety (NETS) was started in 1989 to encourage safe driving habits in the workplace.

NETS is a Methodist program funded by the Governor's Council on Impaired and Dangerous Driving. Locally, Methodist Hospital is working with Eli Lilly & Co., United Parcel Service and Ameritech to help other companies implement traffic safety programs in the workplace.

These companies have policies that require occupants of a company vehicle to wear seatbelts, and all provide specialized defensive driving training to employees who drive fleet vehicles.

Eli Lilly, for example, communicates traffic safety tips to its employees and their families. The 2,000-member sales force receives a newsletter every other month that focuses on a specific driving skill, such as controlling speed, handling intersections or avoiding rear-end collisions. Managers get a quarterly accident report that compares recent months with the last two years. And a monthly voicemail defensive driving message features voices of company executives and celebrities.

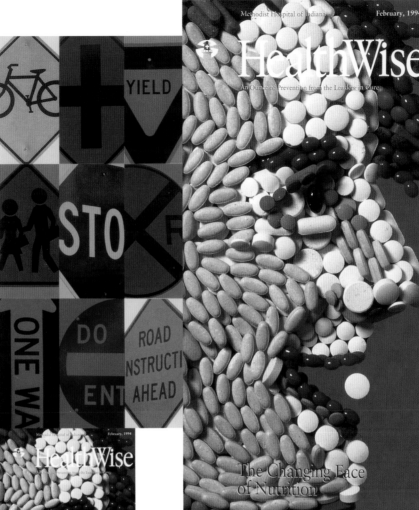

Fitness Matters

Published by the American Council on Exercise, a nonprofit organization dedicated to "promoting active, healthy lifestyles," Fitness Matters is distributed as a membership benefit to certified fitness instructors and fitness enthusiasts who have joined the organization's "Friends of ACE" public membership club.

TRIM SIZE is 8 1/2" x 11" (22 cm x 28 cm)

TWENTY-FOUR PAGE, FOUR-COLOR BIMONTHLY

Royal Impressions STOCK

Garamond Book Condensed BODY FONT

CIRCULATION: 42,000

FEATURE COPY LENGTH: 800–1200

LAYOUT PROGRAM: QuarkXPress

HARDWARE: Macintosh

EDITOR: Richard T. Cotton, M.A. CREATIVE DIRECTOR: Steve Lux. ART DIRECTOR: Karen McGuire. All are staff members of the American Council on Exercise, based in San Diego, California.

The Personality of Design

After a thorough survey of ACE membership, the editorial staff learned that their constituents wanted to store copies of *Fitness Matters* in binders rather than magazine boxes. The simple solution to this request was to three-hole punch the publication. However, this survey also led to the idea of breaking the publication into stand-alone, four-page pullouts, each with a title that keys to the newsletter's flag; i.e., "Research Matters," "Taste Matters," "Consumer Matters," etc. This way each section can be stored in a binder of its own.

An interesting thing about this layout is that each of the five sections has its own look and personality—yet each appears to be part of the whole. This is achieved by keeping the template virtually the same for each section but changing the color and style of illustrations.

Says art director Karen McGuire, "The ability to provide a different personality for each section, design-wise, comes from the material itself. The look of 'Consumer Matters' is related to technology—more graphs and charts— because the copy reads like that. The look of 'Info Matters' is lighter, more easygoing, because the text is lighter in tone."

Working Together

Editor Richard Cotton says that working on this publication is a real joy because editorial and design work hand-in-hand. "We always come up with design concepts together. No one stonewalls anyone else. If editorial is uncomfortable with something in design, the design team will figure out a way to make it work. If design needs a new headline to make a typographic element work, then editorial steps in and comes up with something new."

Nothing Ordinary Here

"I never like to use clip art as is," says McGuire. Note how she manipulated this image for an article called "A Shock to the System" in "Research Matters" (opposite page, bottom left). Taking a lead from the headline, McGuire took the image into Adobe Photoshop, posterized it, blended it with a lightning-bolt effect, and brought it down from full color to duotone. The result is a small piece of modern art that relates directly to the story's theme.

Another great example of photo manipulation is this cover shot of an indoor cyclist for an article on indoor group cycling (left). The original image was actually a perfectly sharp and clear studio shot. "However," says creative director Steve Lux, "We wanted the active feel of 'spinning'—how intense it is and the fact that it's an incredible workout. The static shot didn't have any of that energy." So Lux took the image into Photoshop and created an effect that simulates motion blur.

VOLUME 3 ISSUE 6
ACE FITNESSMATTERS

ACE body MATTERS™

Stress Buster

Energy Booster

by Mara Carrico

YOGA IS A PHILOSOPHY — not a religion — that originated in India more than 5,000 years ago. The repertoire of yoga is described in Sanskrit, the language of India's classical texts and scriptures as well as one of the oldest of the ancient Indo-European languages. Yoga, which means union, is a the whole person and life discipline, addressing ethical and moral standards as well as the care of the body, mind, emotions and spirit.

Hatha yoga is the physical component of this discipline. Commonly interpreted as "ha" meaning "sun" and "tha" meaning "moon," hatha also means "determined effort." Thus, hatha yoga is a method or discipline designed to bring balance to both body and mind through effort complemented by relaxation.

The repertoire of hatha yoga includes asana (Sanskrit for pose or posture) and pranayama (Sanskrit for the extension of one's life force) or breathing techniques. The postures are designed to move the spine through its full range of motion — extension, hyperextension, forward and lateral flexion. Other exercises involve torsion (twisting of the spine) and inversions (e.g., head and shoulder stands). Postures are performed while standing, seated, prone and supine.

There are numerous styles of hatha (see *Yoga Primer*, page 4), each with its own unique characteristics and benefits. There are, however, several key elements present in all hatha styles: developing steadiness and ease; creating balance through pose and counterpose; and being conscious of the breath. Being steady or stable in a posture while remaining at ease is a built-in safety feature of the practice. You always should feel stable while maintaining a sense of equanimity when attempting a challenging pose. Pose and counterpose is accomplished by including exercises that work opposing muscle groups. For example, a routine focused on forward flexion should include back-bending postures, and vice versa. As for breath, some styles place greater emphasis on breathing by including more pranayama techniques within an asana class.

The two programs outlined here include postures and breathing techniques drawn from several styles: Iyengar, Ashtanga, Viniyoga and Choudhury. The first set of breathing exercises and postures are designed to stimulate and strengthen the system,

continued on page 4

ACE info MATTERS

VOLUME 3 ISSUE 6
ACE FITNESSMATTERS

Spin It

SOME CALL IT TORTUROUS, OTHERS exhilarating. But there's no denying its popularity — some see indoor cycling as the biggest thing to hit the fitness industry since step aerobics. What sets these classes apart from the usual boredom of stationary cycling is the visual imagery provided by instructors. Participants are led on a "virtual" outdoor road race complete with hills, valleys, straight-aways and finish lines.

But before you reserve your spot (most classes are so popular that reservations are a must) and start composing your victory speech, there are a few questions to ask yourself, as well as a few precautions to take, to make your first ride a smooth and enjoyable one.

What Kind of Shape Am I In?

This question is crucial. Despite its heavy promotion as a workout for even the most uncoordinated, indoor cycling is by no means for everyone. The intensity levels of many classes are far beyond what most novices or part-time exercisers can achieve and maintain, particularly for 40 minutes or more (see sidebar, left).

It's easy to get caught up in an instructor's chant of "Faster RPMs!" and "Don't sit down!" even if your body is telling you otherwise. That's why it's so important that participants either be in very good cardiovascular condition, or have the discipline to monitor and adhere to their body's cries for moderation.

Get in Cycling Shape

Just because you may not be ready for a cycling class now doesn't mean you can't be in the very near future. Consider doing some cycling-specific training before you take your first indoor cycling class. Spend some time on a stationary bike, but make it interesting by creating your own "virtual" experience by "traveling" some of your favorite road trips in your mind as you listen to music. You can increase your endurance by interspersing periods of high-intensity cycling with more leisurely pedaling.

In just a few short weeks you'll be ready to sign up for your first indoor cycling class.

ACE Puts Cycling to the Test

A recent ACE-sponsored study examined how five participants of various fitness levels rated their levels of perceived exertion (using Borg's Rating of Perceived Exertion, a scale from 6 to 20) during a typical indoor cycling class. Most reported an exertion level in the high teens throughout much of the class. (Heart-rate measurements indicated that participants were exercising close to their maximum heart rate, which validates their perceptions.) This means that participants were exercising at a higher level of intensity than their bodies were accustomed to, despite being given instructions on how to modify their intensities to suit their personal fitness levels.

Get ready to consume plenty of fluids during this class.

Indoor Cycling Essentials

The following helpful tips can make your first cycling experience a positive one:

- Don't make the dreaded mistake of showing up in your usual boxers or running shorts — there's no better way to make your ride unbearable. Opt instead for bike shorts, preferably padded like most outdoor cyclists wear. While this won't eliminate the chaffing and discomfort altogether, it helps — a lot.
 - Your second most important item: a full water bottle. Get ready to consume plenty of fluids during this class.
 - Adjust the seat to the appropriate height. If the seat is too low, you won't be able to get enough leg extension on the downstroke. If it's too high, you'll be straining to reach and might injure yourself. Here's a good rule to follow: Your upstroke knee should never exceed hip level, while your downstroke knee should be about 85 percent straight. And don't grip the handlebars too tightly, as this will increase the tension in your neck and shoulders.
- Above all, concentrate on exercising at your own pace. Don't be intimidated by the high speeds and furious intensity of your cycling mates. Listen to your body and adjust the tension and speed accordingly, and don't be afraid to sit back and take a break when necessary.

A Shock to the System

RESULTS WITHOUT EFFORT. What could be more appealing? That's the concept behind a new generation of products (coming soon to late-night television) featuring electrical muscle stimulation (EMS). Originally used to help speed the rehabilitation process and to reduce atrophy in individuals confined to a bed, EMS is now being marketed through infomercials and home shopping networks as a means for healthy individuals to tone and strengthen their muscles and to lose fat.

When something sounds too good to be true it usually means that it is. In this case, while it is unrealistic for people to believe that they will transform their bodies by simply strapping on a few electrodes, there is a small measure of truth to the claims. Research presented at the American College of Sports Medicine conference earlier this year focused on the effects of EMS on 32 healthy, but sedentary, individuals.

Subjects were divided into a control group, which received no treatment, and a treatment group, which received approximately two dozen 30-minute treatments over a period of eight weeks. The rectus abdominis, the quadriceps and the gluteus maximus/hamstring muscles were targeted, with each group receiving 10 minutes of stimulation per session. Anthropometric measures, taken pre- and post-treatment, included body weight, body-fat percentage, girth measurements, isometric abdominal strength and dynamic hip strength. Results showed no significant differences in weight, body fat or girth measurements. Abdominal and hip strength, however, improved dramatically when compared to the control group.

According to lead researcher Julianne Abendroth-Smith of Utah State University, Logan, "EMS may strengthen muscles to a point, but probably will not help [individuals] lose weight, lose fat, or change their basic body dimensions."

EMS may strengthen muscles to a point, but probably will not help [individuals] lose weight...

Med. Sci. Sp. & Ex., Supplement, May 1997

ACE taste MATTERS™

VOLUME 3 ISSUE 6
ACE FITNESSMATTERS

Red Peppers Turn Up the Heat on Workouts

THE METABOLIC EFFECTS OF CAPSAICIN, A SUBSTANCE known to most of us as hot red pepper, have received quite a bit of attention lately. It is easy to make a comparison between the hype over capsaicin and the unsubstantiated buzz of many years ago about grapefruit (someone manages to revive that one every few years). Thousands of people — women in particular — were puckering up to bushels of grapefruit, believing its so-called fat-burning properties would help them lose weight. The only thing lost was, perhaps, their ability to taste anything else!

Capsaicin also has received its share of claims. Unlike grapefruit, however, there is some evidence to suggest that capsaicin enhances both lipid and energy metabolism.

The body reacts to capsaicin in much the same way it does to caffeine, increasing plasma catecholamine levels through sympathetic activation of the central nervous system. But can it really make you burn more calories?

That's what researchers in Japan set out to determine. As is often the case, subjects were not exactly "average Joes." All were young, male, long-distance runners, and each was given a substantial meal with or without 10 grams (yes, that's a lot) of hot red pepper for breakfast. After resting for two-and-a-half hours, the men cycled on a stationary bike for one hour at approximately 60 percent VO_2 max. Those who were given the hot red pepper had significantly elevated respiratory quotient levels both at rest and during the cycling. Measurements of plasma epinephrine and norepinephrine levels indicate that the hot red pepper increased the men's ability to oxidize carbohydrate both at rest and during exercise.

These findings are less significant to those who want to lose weight than to those interested in increasing carbohydrate oxidation for exercise energy fuel. However, for athletes participating in prolonged exercise events, capsaicin is not an appropriate ergogenic aid since increased carbohydrate oxidation occurs at the expense of fat oxidation. The authors write, "Hot red pepper ingestion before exercise could decrease endurance performance in athletes because hot red pepper can promote glycogen depletion in muscle and/or liver."

Med. Sci. Sp. & Ex., February 1997

Starlight Foundation International

1995–1996 Annual Report

The Starlight Foundation is best known for granting wishes to children with serious illnesses. However, as explained in its publications, this foundation is up to much more good than that. For instance, Starlight helps provide mobile entertainment units that roll over hospital beds and Starlight pediatric playrooms, places where children can find solace from an often sterile hospital environment.

TRIM SIZE is 25 1/2" x 19" (65 cm x 48 cm), folds down to 8 1/2" x 11" (22 cm x 28 cm)

TWELVE FOUR-COLOR FOLDED PANELS

Coated text 50 lb (75 gsm) TEXT STOCK

Eras BODY FONT

CIRCULATION: 6,000

LAYOUT PROGRAM: QuarkXPress

HARDWARE: Macintosh

1994–1995 annual report, CREATIVE DIRECTOR: Josanne DeNatale, Cognitive Marketing Inc., of Rochester, New York. ART DIRECTOR: Daniel Hoh, Daniel Hoh and Associates, Rochester, New York. 1995–1996 annual report, EDITOR: Deann Hechinger of the Starlight Children's Foundation, based in Los Angeles, California. DESIGN: Kim Ross of Kim Ross Creative.

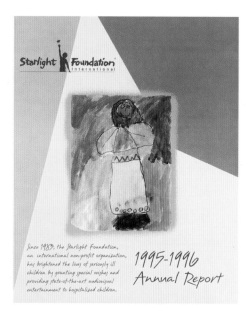

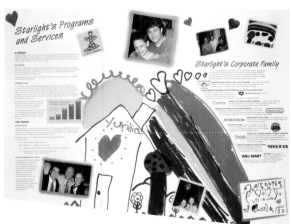

Annual Report—Be Playful But Stay on Budget

Josanne DeNatale, creative director at Cognitive Marketing, explains that when she gave Starlight's annual report assignment to Daniel Hoh, art director, she told him to throw caution to the wind. "I asked Dan to come up with a variety of sketches that were no holds barred," says DeNatale. "Of course, he came up with some pretty wild ideas, which met the client's parameters for looking more fun and child-oriented, but after talking to printers and running the numbers, they simply cost too much."

In the end, it was decided to go with one of Hoh's simplest yet most playful designs. "I got the idea from watching kids drawing on big pieces of paper on the floor," says Hoh of his report that opens in three folds to reveal a lovely poster-sized child's drawing and an array of wish granters and recipients (bottom left).

Note the angle cut at the bottom. This simple addition cost no more at the printer's, yet it adds a lot in terms of Hoh's original concept—to convey the creativity of childhood.

Puzzle Pieces

Although the idea of an annual report that unfolds for the reader is intriguing, creating it is a lot like putting together the pieces of an intricate puzzle (without the help of the box cover). Says Hoh, "It was definitely a challenge to organize the information so that it made sense as a reader opened it. I had to build a lot of small-scale mockups to get the layout of copy versus images correct."

By treating copy and photos as individual pieces of the puzzle, Hoh could move things around on his mockups until they all fit together in both a sequential and an esthetic manner.

TRIM SIZE is 8 3/8" x 10 2/3" (22 cm x 27 cm)

TWENTY-PAGE, FOUR-COLOR QUARTERLY

Gloss Coated 80lb (120 gsm) TEXT STOCK

Baskerville BODY FONT

CIRCULATION: 30,000

LAYOUT PROGRAM: QuarkXPress

HARDWARE: Macintosh

EDITOR: Deann Hechinger of the Starlight Children's
Foundation, based in Los Angeles, California.
CREATIVE DIRECTOR: Josanne DeNatale, Cognitive
Marketing Inc., of Rochester New York. ART
DIRECTOR: Daniel Hoh, Daniel Hoh and Associates,
Rochester, New York.

The Shining Star

"We wanted the design of The Shining Star *to resemble a photo album or a scrapbook so it would feel fun and warm," explains Starlight's marketing and communications coordinator, Deann Hechinger. "But we still wanted it to have an air of sophistication so that we could convey relevant information about the work we do to potential donors."*

Shining Star—a Balancing Act

To meet the foundation's guidelines, Creative Director Josanne DeNatale, Cognitive Marketing Inc., together with design firm Daniel Hoh and Associates, developed a format that incorporates hand-drawn and hand-written elements created by children the Foundation has helped. Entire thank-you letters are scanned and used as sidebars, while stickers and drawings are used as clip art. To provide a professional feel, Hoh keeps his leading tight and balances images with plenty of white space.

Star Tricks

To keep the newsletter easy to read, photos are placed adjacent to headlines, eliminating the need for most captions. He also avoids running a full page of text. As he points out, "People are time-compressed. They don't have time to read an entire article so you have to keep things light." Hoh's compartmentalized design allows readers to literally thumb through the publication and still digest a great deal of information.

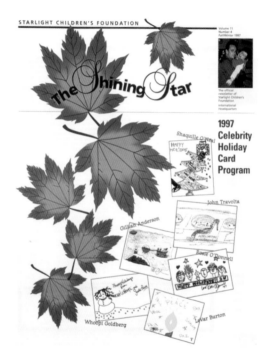

C/H/A/P/T/E/R

9

religion

AGAINST INTOLERANCE

"Every instance of hate or bigotry is one too many. We must continue ou
all forms of intolerance, and we must speak loudly as a community whe
This report indicates that ADL, and concerned Angelenos are making a r
important battle."

— Richard J. Riordan, Mayor of Los Angeles, speaking about the study of Anti-Semitic Incidents

AUDIT OF ANTI-SEMITIC INCIDENTS

Since 1979, ADL has recorded and tracked
reported incidents of anti-Semitic, vandalism as
well as assaults, threats and harassments directed
against Jews or Jewish institutions. This information
is an important resource for public officials and law
enforcement agencies and underscores the necessity
of ADL's vatique work.

*Regional Director David A. Lehrer, Los Angeles,
Mayor Richard Riordan, Multi-cultural Collaborator
Director Joe Hicks, Regional Board President George
E. Moss at the press conference announcing the
findings of the 1996 Audit.*

For the second straight year, the number of anti-
Semitic incidents occurring in the United States
declined. In 1996, the total number of incidents
reported to the ADL was 1726. This total represented a decrease of 125
incidents or 7%, from the 1995 total of 1843. In 1995 the total, in turn,
represented an 11% decline from 1994. This two-year drop was the first
multi-year decline in ten years.

California ranked third in the nation in the number of reported incidents (186)
behind New York and New Jersey. There were 128 reported incidents of assaults,
threats and harassment against Jews or Jewish institutions — down 27% from
1995. Incidents of vandalism also decreased state-wide in 1996 - 58
incidents were reported, down 35% from 1995. The total number of
reported incidents in Los Angeles County reflected the downward trend
— 92 reported incidents in 1996, down 45% from 1995. Noting the
decline, ADL Regional Director David A. Lehrer said "It tells us that the
combination of community concern, law enforcement action and
educational outreach is an effective approach that is reaping results in the
traditional arenas where anti-Semites are active."

HATE CRIMES TRAINING

In an effort to increase the law enforcement community's
knowledge and awareness of extremist group activity, as well
as to assist them in recognizing and investigating bias-
motivated crimes, the ADL has conducted extensive hate
crime training seminars. The ideology and activities of

national extremist groups such as the Ku Klux Klan, neo-Nazi Skinheads,
armed militias, and Christian Identity groups are examined, as well as hate
group activity on the Internet. In addition, the seminars address various
factors for identifying and defining a hate crime, constitutional issues in hate
crime enforcement, and the residual effect of hate crimes on communities.
Over the past year, law enforcement agencies in Los Angeles, Riverside and
Ventura Counties and Las Vegas have participated in such seminars.

ADL ATTACKED IN DAILY BRUIN

This past spring, UCLA's student newspaper, the *Daily
Bruin*, printed an anonymous attack on the Anti-
Defamation League that consisted of unsubstantiated
accusations and gross distortions. Entitled "Anti-
Defamation League Infringes on Civil Liberties," the
writer of the piece was permitted by the *Bruin* to shield
his/her identity "due to possible repercussions." As a result,
the paper seemed to be signaling its tacit approval of the writer's position and
his/her fear of reprisal. Recognizing the error of its ways, the *Bruin* ran an
unprecedented apology. "Principles of fear," it editorialized, "require those
who make specific accusations against a particular individual or organization to
stand behind those accusations, and not hide behind a cloak of anonymity.
Moreover, anonymity deprives readers of information necessary to determine if
the allegations made are credible." In addition to its apology, the newspaper
also published an article by the ADL refuting the charges and detailing the
League's demonstrated record of support for civil rights and liberties.

CSUN GIVES PLATFORM TO DAVID DUKE

One of the nation's most prominent racists, David Duke, accepted an
invitation to debate the issue of affirmative action at California State
University, Northridge. The invitation coincided with the debate over
California's controversial anti-quota measure, Proposition 209. A
former "Grand Dragon" of the Knights of the Ku Klux Klan, Duke
was also the founder of the self-styled "National Association for the
Advancement of White People." Attempting to soften his racist

Few religious organizations have the funds it takes to afford a good design firm. Even if they do have large coffers it often seems inappropriate to spend money on something that seems intangible at first blush.

The Pacific Southwest Region of the Anti-Defamation League dealt with this challenge in an unusual manner, the result of which you will find in the copy and photos that follow. Not only did the group's intelligent strategy produce a clean effective product, it solidified two important precepts for the organization's board—good design doesn't have to be or look excessive to stand out in a crowd, and good design lends credibility because the reader concludes that the organization cares.

heavenly beings, they will enjoy exceedingly wonderful delights, and if they are born in the presence of a Buddha, they will be born by transformation from lotus flowers. (*The Lotus Sutra*, p. 185)

Katsuji Saito: You must be exhausted, President Ikeda, after your lengthy trip to the United States and Latin America. Your efforts in America, Cuba, Costa Rica, the Bahamas and Mexico to establish bonds of friendship

impressed me as actions truly representative of the practice of the Lotus Sutra.

Takanori Endo: In fact, the Lotus Sutra, which elucidates respect for all differences of social systems, organization, culture and the like, connects people by urging them to conduct dialogue as human beings who are all on an equal footing.

Haruo Suda: Your trip abroad also speaks to the principle of the true entity of all phenomena (Jp. *shoh*

> *It often seems inappropriate for religious organizations to spend money on something that seems intangible at first blush.*

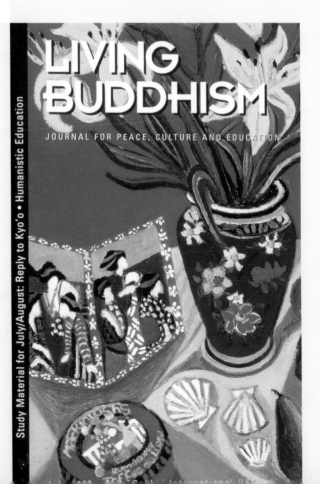

LIVING BUDDHISM

JOURNAL FOR PEACE, CULTURE AND EDUCATION

AUDIT OF ANTI-SEMITIC I

Regional Director David A. Lehrer, Los Angeles Mayor Richard Riordan, Multi-cultural Collaborative Director Joe Hicks, Regional Board President George

Sin
rep
wel
aga
is a
enf
of

For

Anti-Defamation League

Pacific Southwest Region

1996 Annual Report

TRIM SIZE is 8 1/2" x 11" (22 cm x 28 cm)

THIRTY-TWO PAGE, THREE-COLOR ANNUAL

Lustro Dull Cream TEXT STOCK

Garamond BODY FONT

LAYOUT PROGRAM: QuarkXPress

HARDWARE: Macintosh

EDITOR: Cheryl Azar. DESIGN: Helen Duval of Kimberly Baer Design Associates. Both are based in the Los Angeles area.

From the Annual Report, letter from the Regional Board President, George E. Moss and Regional Director, David A. Lehrer: "Since 1913, the Anti-Defamation League has worked tirelessly and effectively to fight anti-Semitism and bigotry through education, legislation and creative programming..."

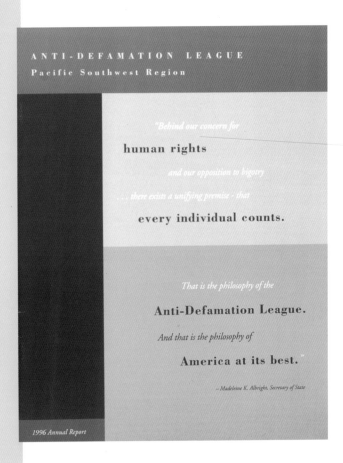

Professional Graphic Design

After many years of producing annual reports that were not designed by the pros, the Pacific Southwest Region of the Anti-Defamation League hired Kimberly Baer & Associates to create the original format and a rock-solid template which, in turn, was delivered to the organization's printer for the more time-consuming process of production. Says Baer, "Helen's template was so tight and organized that even a newcomer could have used it to create a clean final layout. This obviously saved the organization money, but it also enhanced their end-product."

A Ready-to-Use Template

Duval began by selecting a simple set of colors. "We chose two colors, PMS 1675 Rust and PMS 5753 Olive. These, plus black, definitely enriched the look." Duval added further sophistication by requesting a cream-colored paper. A notch deeper than white, it actually appears to be a very subtle fourth color. Duval kept her template to one column for ease of layout. To guide the layout artists, she created various sample spreads and saved them as master pages within her QuarkXPress document.

Dealing With Tough Images

Unless you are dealing with an organization that focuses on nature or the environment, nonprofits aren't necessarily going to provide stunning photography. The Anti-Defamation League was no exception. Instead of scrapping the images altogether, Baer and Duval decided to run them small and float them inside a thin rule. This delicate frame was enhanced by a dark green border on the outside edge of each image. The majority of photos in the 1996 annual run at 1 1/2" x 2 1/2" (4 cm x 6 cm). This does several things for the effect design has on the reader. One, it sets up a rhythm to the page and a pleasing sense of consistency—back to the trust issue discussed earlier. Two, it hides many imperfections in the art itself. And three, since some of the images depict offensive act or objects, such as hate flyers, the reader is at once relieved that the image is not shockingly large and yet, irresistibly compelled to look closer . . . and, of course, to learn more.

A Little Guidance

Part of the beauty of Duval's simple template are straightforward, impossible-to-miss section openers. Says Duval, "There are a lot of sections in this report, so I needed to come up with a design element that notified the reader in a clear fashion—'this is a new topic.' I also tried to create a little interest with subheads and callouts." As she explains, subheads make a large amount of type easy for the reader to navigate. The use of Garamond, a classic face, makes the type reader- friendly—less "bulky" as Duval puts it—especially when the leading is opened up a bit.

Regional Director David A. Lehrer, Los Angeles
Mayor Richard Riordan, Multi-cultural Collaborative

VIGILANCE AGAINST INTOLERANCE

*"Every instance of hate or bigotry is one too many. We must continue our **vigilance against** all forms of **intolerance**, and we must speak loudly as a community when we witness injustice. This report indicates that ADL and concerned Angelenos are making a real difference in this important battle."*

— *Richard J. Riordan, Mayor of Los Angeles, speaking about the Audit of Anti-Semitic Incidents*

AUDIT OF ANTI-SEMITIC INCIDENTS

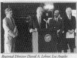

Regional Director David A. Lehrer, Los Angeles Mayor Richard Riordan, Multi-cultural Collaborative Director for Hate, Regional Board President George E. Moss at the press conference announcing the findings of the 1996 Audit.

Since 1979, ADL has recorded and tracked reported incidents of anti-Semitic vandalism as well as assaults, threats and harassments directed against Jews or Jewish institutions. This information is an important resource for public officials and law enforcement agencies and underscores the necessity of ADL's unique work.

For the second straight year, the number of anti-Semitic incidents occurring in the United States declined. In 1996, the total number of incidents reported to the ADL was 1720. This total represented a decrease of 123 incidents or 7% from the 1995 total of 1843. In 1995 the total, in turn, represented an 11% decline from 1994. This two-year drop was the first multi-year decline in ten years.

California ranked third in the nation in the number of reported incidents (186) behind New York and New Jersey. There were 128 reported incidents of assaults, threats and harassment against Jews or Jewish institutions — down 27% from 1995. Incidents of vandalism also decreased state-wide in 1996 - 58 incidents were reported, down 35% from 1995. The total number of reported incidents in Los Angeles County reflected the downward trend — 42 reported incidents in 1996, down 49% from 1995. Noting the decline, ADL Regional Director David A. Lehrer said "It tells us that the combination of community concern, law enforcement action and educational outreach is an effective approach that is reaping results in the traditional areas where anti-Semites are active."

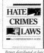

Flyer sent to a home in Los Angeles.

HATE CRIMES TRAINING

In an effort to increase the law enforcement community's knowledge and awareness of extremist group activity, as well as to assist them in recognizing and investigating bias-motivated crimes, the ADL has conducted extensive hate crime training seminars. The ideology and activities of national extremist groups such as the Ku Klux Klan, neo-Nazi Skinheads, armed militias, and Christian Identity groups are examined, as well as hate group activity on the Internet. In addition, the seminars address various factors for identifying and defining a hate crime, constitutional issues in hate crime enforcement, and the residual effect of hate crimes on communities. Over the past year, law enforcement agencies in Los Angeles, Riverside and Ventura Counties and Las Vegas have participated in such seminars.

Report distributed at hate crime training seminars.

ADL ATTACKED IN DAILY BRUIN

This past spring, UCLA's student newspaper, the *Daily Bruin*, printed an anonymous attack on the Anti-Defamation League that consisted of unsubstantiated accusations and gross distortions. Entitled "Anti-Defamation League Infringes on Civil Liberties," the writer of the piece was permitted by the *Bruin* to shield his/her identity "due to possible repercussions." As a result, the paper seemed to be signaling its tacit approval of the writer's position and his/her fear of reprisal. Recognizing the error of its ways, the *Bruin* ran an unprecedented apology. "Principles of fear," it editorialized, "require those who make specific accusations against a particular individual or organization to stand behind those accusations, and not hide behind a cloak of anonymity. Moreover, anonymity deprives readers of information necessary to determine if the allegations made are credible." In addition to its apology, the newspaper also published an article by the ADL refuting the charges and detailing the League's demonstrated record of support for civil rights and liberties.

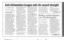

ADL response to attack in the Daily Bruin.

CSUN GIVES PLATFORM TO DAVID DUKE

One of the nation's most prominent racists, David Duke, accepted an invitation to debate the issue of affirmative action at California State University, Northridge. The invitation coincided with the debate over California's controversial anti-quota measure, Proposition 209. A former "Grand Dragon" of the Knights of the Ku Klux Klan, Duke was also the founder of the self-styled "National Association for the Advancement of White People." Attempting to soften his racist

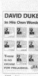

ADL ad in The Sundial.

Living Buddhism

Living Buddhism *is the monthly journal of the SGI-USA, an American Buddhist movement that promotes peace and individual happiness based on the philosophy and practice of Nichiren Daishonin's Buddhism.*

TRIM SIZE: 8 1/4" x 10 3/4"

FIFTY-TWO-PAGE, FOUR-COLOR, COVER; BLACK-AND-WHITE, CONTENTS MONTHLY

White Porcelain Gloss book 100 lb (150 gsm) TEXT STOCK

Palatino BODY FONT

CIRCULATION: 20,000

FEATURE COPY LENGTH: 4,000

LAYOUT PROGRAM: QuarkXPress

HARDWARE: Macintosh

EDITOR: Margie Hall. ART DIRECTOR: Gary Murie. Both are staff members of SGI-USA, headquartered in Santa Monica, California.

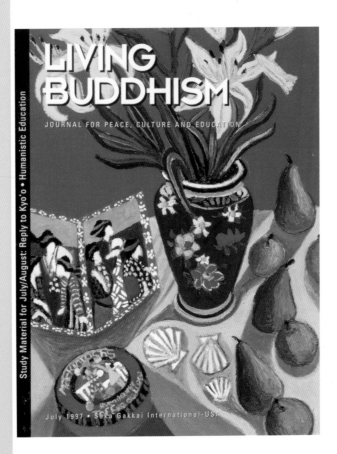

Form in Balance with Content

"Buddhist practices are easily applied to everyday life but studying the philosophy, history, and symbolism of Buddhism is definitely an intellectual pursuit," says art director Gary Murie. "So my goal for the design is to make the dense copy we provide accessible to both the intellectual and the average reader." To do this, Murie keeps his template simple and straightforward. Departments run in three columns, features in two. Leading is kept very open and, to engage the reader, pictures or illustrations run on every page.

"Most publications today are geared toward the hip-hop look of pop culture. Often that sort of design direction looks beautiful but is hard to read. Readability is the main focus of this design."

Dynamic Graphics

When Murie began including illustrations to highlight feature text, he spent a great deal of time communicating ideas for the visuals he wanted to his freelance artists. "A group of three staffers and myself would sit down and carefully read each article. Then we would bat around ideas on the main points to be illustrated. Next we'd send the article and our ideas to our artist. After the artist read the article and our comments there would be a great deal of back and forth. Now that we have longstanding relationships with our illustrators, the process is less tedious." Murie adds that over time a sort of visual shorthand has evolved between him and the artists. "Now," he says, "we speak the same language."

A few examples of great end-product made through this continuing relationship include a series of illustrations for a serial feature titled "Dialogue on the Lotus Sutra" (opposite page, middle). This art brings the heady ideas about life and living into focus for the reader. To show how a person with faith in life takes action to promote positive change, illustrator Larry Ashton has drawn an archer intent on his target. To depict the Buddhist concept that "the true identity of life embodies the oneness of good and evil," Ashton depicts a woman who dreams of herself as a beautiful angel playing the violin and as a centaur carrying a pitchfork and a torch. Color isn't necessary when the art is this strong.

The Art of a Great Cover

In addition to supervising the art direction of *Living Buddhism*, Murie designs SGI's traveling fine-art exhibitions. This work gives him an inside scoop on Buddhist practitioners working at the cutting edge of the national art scene. As a result, works from the exhibition's outstanding artists grace the covers of *Living Buddhism*. Paintings shown here are "Still Life With Orange and Yellow Lilies" (left) by Rowena Perkins; "Honor Your Tears" on the October issue (opposite page, top right), by Donna Estabrooks; June features "Reef Dancers" by Tary Socha (opposite page, top middle); December features "Mardi Gras" by Joyce Martin.

Illustrator: Larry Ashton

Illustrator: Larry Ashton

g a l l e r y

St. Jude Medical Inc. 1996 Annual Report

St. Jude Medical is one of the largest global producers of high-quality medical devices. Their most important development is the St. Jude Mechanical Heart Valve; it has helped improve the lives of more than 750,000 people.

TRIM SIZE is 8 1/2" x 11" (22 cm x 28 cm)
FORTY-FOUR-PAGE, FOUR-COLOR ANNUAL REPORT
BODY FONTS INCLUDE Sabon body text, Trajan headline type
CIRCULATION: 85,000
DESIGN: Larsen Design Office Inc., located in Minneapolis, Minnesota.

To celebrate the twentieth anniversary of the first implant of the St. Jude Mechanical Heart Valve, this annual report focuses on people, specifically those who work to improve the technology and people who have been helped by implants . The cover is especially pleasing as it shows Dr. C. Walton Lillehei, "the father of open heart surgery," along with a broad cross section of patients who are happy and healthy due to the St. Jude's valve and Dr. Lillehei's pioneering work in cardiac surgery. Each photo tells us something important about the patient—something about what he or she loves in life. Some carry props, like a guitar or a pair of skis. Others simply wear their work uniforms. Although these photos are posed, they lack nothing in appeal since they so completely capture the personality of each patient. Notice how engaging the big smiles are!

Heartport Annual Report

"Heartport is advancing the frontiers of cardiac surgery by developing, manufacturing, and marketing systems that enable minimally invasive approaches to major heart surgery."

—Heartport Annual Report

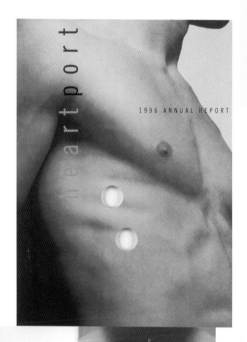

TRIM SIZE is 10 1/2"x 14" (27 cm x 36 cm)
SIXTY-TWO PAGE ANNUAL REPORT
Trade Gothic Condensed BODY FONT
CIRCULATION: 15,000
EDITOR: Jim Weiss. ART DIRECTOR: Bill Cahan. DESIGN: Craig Bailey. Both from the design firm Cahan & Associates, based in San Francisco, California. PHOTOGRAPHY: Ken Schles, William McLeod, and Tony Stromberg.

Heart surgery isn't something people usually want to talk about. However, if the need arises, patients do want to talk about their options. Instead of traditional methodology—reaching the heart by opening the entire chest—Heartport's systems create a path to the heart through two small incisions made between the ribs. This breakthrough became a base for Cahan & Associates' novel annual report design.

Cut into the heavy cardboard cover stock, and through the pages within, are two circular holes approximately the same size as the small openings produced by using Heartport Port Access Systems. Admittedly, a book with holes in it has something other than connections to the serious. One immediately thinks of interactive books for preschoolers, maybe even bowling balls. This playfulness makes the procedure seem more acceptable, even interesting to the lay reader. Powerful and beautiful photographs, like the one of the healthy young man on the cover, get back to seriousness and lend an air of sophistication, artistry, and balance.

This is a frank annual report. In fact, the opening spread explains exactly what happens in traditional surgery. Design follows right along by showing the instrument used to pry open the chest cavity. Notice that the sterile picture of this medical tool is once again balanced by a duotone image of a human chest. This is real, but it's OK. Balanced design allows the reader to absorb the material intellectually rather than emotionally. Color is mainly used for photos of patients who have found the surgery a remarkable, relatively painless experience.

conventional open-chest heart surgery entails sawing open the breastbone and prying apart the ribcage, causing trauma, pain and suffering, lengthy hospitalizations and recoveries, and a long scar

patient profile: rita johnsen

g a l l e r y

Creative BioMolecules
1996 Annual Report

From the annual: "Creative BioMolecules is a biopharmaceutical company focused on the discovery and development of therapeutics for human tissue regeneration and repair. The Company's therapeutics are based on proteins that act in initiating and regulating the cellular events involved in the development of human tissue and organs."

TRIM SIZE is 7 3/4" x 11 3/4" (20 cm x 30 cm)
THIRTY-SIX-PAGE, BLACK-AND-WHITE ANNUAL REPORT
Bembo BODY FONT
CIRCULATION: 15,000
EDITORIAL: Feinstein Kean Partners of Cambridge. DESIGN: Thomas Laidlaw,
 Weymouth Design Inc., located in Boston, Massachusetts.

Talk about using type as a graphic element! This report is one of the most elegant examples we've seen. The cover, which takes the letters from the word "creative" and scatters them about the borders of the design, initiates a pattern that is used throughout to set off departments. The effect reminds the reader of specimens under a microscope—how seemingly solid substances tend to break apart, revealing empty space where, to the naked eye, none appears to exist.

Ultrafem 1996 Annual Report

Ultrafem, a company dedicated to improving women's options in reproductive health care, developed an innovation in feminine protection called "softcup technology," trademarked Instead.

SIZE: 7 1/2" x 7 1/2"
SEVENTY-FOUR-PAGE, FOUR-COLOR ANNUAL REPORT
[BODY FONTS INCLUDE Perpetua, Officina]
CIRCULATION: 15,000
WRITER: Ona Nierenberg, New York, New York. DESIGN: Belk Mignogna
 Associates Ltd. based in New York, New York.

For Ultrafem's first annual report, the BMA design team focused on two questions relating to the company's unique technology, "What do investors want?" and "What do women want?" Obviously, the answer to these musings is Ultrafem. However, the manner in which the answer is conveyed through design is intriguing.

BMA divided the book in two: One side opens to answer the question of investors and potential investors while the other opens to answer the question of the target demographic. Although each side deals with two different aspects of a product that is, at the very least, a challenge to discuss, both maintain a decidedly unique and illustrative feel and answer the question with visual and textual symmetry. Of special note are the painterly spreads that organize the four main topics of each section: "Opportunity," "Progress," "Strength," and "Success."

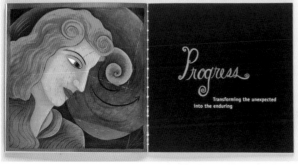

As you can see from these two chapter openers for "Progress," both have a similar feel and incorporate much of the same symbolism yet appeal to both types of readers. The "Progress" spread for "What do investors want?" features lovely feminine eyes that seem to be carefully analyzing research findings and the outside of a nautilus that is divided into parts representing the percentages of women interested in the product. Similarly, the "Progress" spread on the "What do women want?" side features a woman intent on the view. Her face is framed by a graphic representation of the inside of a nautilus shell, the dynamic swirls of which hint at natural forward movement.

Another intriguing visual element is the use of the symbols on both covers (the universal symbol of company success—a rising arrow on a financial chart—and the universal symbol for women) as paragraph marker dingbats.

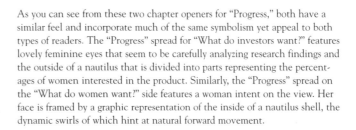

nonprofits

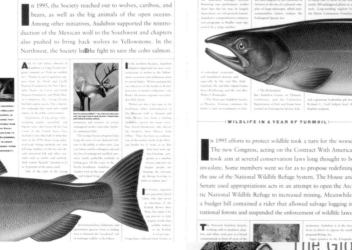

In 1995, the Society reached out to wolves, caribou, and bears, as well as the big animals of the open oceans. Among other initiatives, Audubon supported the reintroduction of the Mexican wolf to the Southwest and chapters also pushed to bring back wolves to Yellowstone. In the Northwest, the Society led the fight to save the coho salmon.

WILDLIFE IN A YEAR OF TURMOIL

In 1995 efforts to protect wildlife took a turn for the worse. The new Congress, acting on the Contract With America, took aim at several conservation laws long thought to be inviolate. Some members went so far as to propose redefining the use of the National Wildlife Refuge System. The House and Senate used appropriations acts in an attempt to open the Arctic National Wildlife Refuge to increased mining. Meanwhile, a budget bill contained a rider that allowed salvage logging in national forests and suspended the enforcement of wildlife laws.

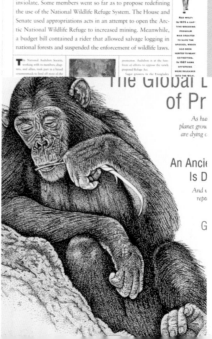

The Global
of Pr

As hu
planet grou
are dying

An Anci
Is D

And
rept

G

Of all our sections, this was the most fun to research. Everyone involved with a nonprofit, from the receptionist to the president, is wildly passionate about mission. In fact, most of the design teams interviewed provide their services pro bono or at cost because they so strongly believe that the work done by their client is of value to the planet and one or many of its inhabitants.

There is more than just good design inherent here—there is a great deal of heart.

You will find that the designs included in this section are diverse. Some are simple and straightforward, making the most of a budget-imposed limited color palette, while others boast amazing four-color photography, dynamic maps, and even expensive gatefolds and die-cuts. Whatever the choice, be assured that there is more than just good design inherent here—there is a great deal of heart.

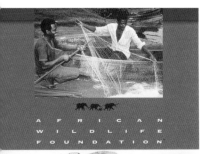

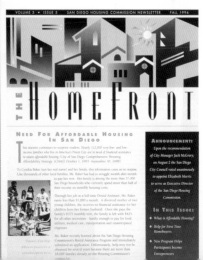

C/H/A/P/T/E/R

10

environmental conservation

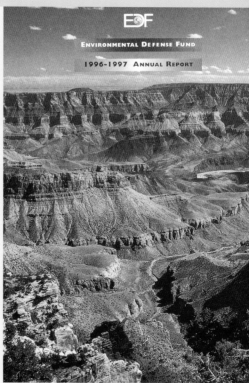

Our chapter on environmental conservation includes some spectacular work. Of particular note is the work of Kinetik Communications Graphics for Conservation International's first "Decade" Report. Designer Sam Shelton told us that in honor of the organization's impressive history, he believed the book should have "plop value" (meaning if you plop it down on a desk it makes a very substantial sound). Conservation International's has both plop value and eye appeal. Every aspect of this design is clean, clean, clean. Along with ample white space, there are beautiful fonts, tight efficient layout, and amazing photo spreads. If this design can't sway even the most non-environmentally conscious reader, then nothing can. You'll also enjoy featured selections that boast dynamic templates and some truly out-of-the-ordinary icons and graphics.

Birds Wild life & Habitat

National Audubon Society

1995 Annual Report

TRIM SIZE is 8 5/8" x 22" (22 cm x 56 cm), folding down to
 8 5/8" x 7 3/8" (22 cm x 19 cm)

SIXTEEN-PAGE, FOUR-COLOR ANNUAL REPORT

Mohawk Vellum, 60 lb (90 gsm) text recycled, STOCK

BODY FONTS INCLUDE Sabon, Paula Wood

CIRCULATION: 7,000

LAYOUT PROGRAM: QuarkXPress

HARDWARE: Macintosh

EDITOR: Michael Robbins of the National Audubon Society,
 based in New York City. DESIGN: New York-based
 Pentagram Design. PARTNER/CREATIVE DIRECTOR: Woody
 Pirtle. ASSOCIATE/DESIGNER: John Klotnia. DESIGNER:
 Ivette Montes de Oca.

*Through a thriving network of grass roots chapters, the National
Audubon Society carries out its exemplary advocacy work for birds
and other types of wildlife.*

Fits in the Palm of the Hand...
and, in a Manila Folder

Previous Audubon Society annual reports are a standard 8 1/2" x 11" (22 cm
x 28 cm) landscape, a format that the nonprofit wanted to adhere to but
found restrictive in terms of design. To meet the client's request, the design
team developed an unusually tall layout that conveniently folds down to
8 5/8" x 7 3/8" (22 cm x 19 cm), a size that fits in file folders. Explains
Klotnia, "Our instinct was to go a step beyond what had been done in the
past, to allow for more graphic design. The other reason for the size choice
was a desire to give the document a newsletter sort of feel, more grass roots
like the chapters themselves. The height added to this 'less precious' look."

With dimensions settled, Klotnia set up his template. "Text seemed too long
with two columns, and three didn't allow enough room for images. So I added
a thin fourth column on the outside of each page for photos and captions."
As Klotnia points out, the fourth column for "odds and ends" also adheres to
the newsletter-type format.

Easy to Read

Note the use of rules, which delineate columns and stories. This treatment
provides visual organization for the reader. Also observe how the beginning
paragraph of each story (opposite page) is run in large type and surrounded by
a frame; this is good for catching the eye of flip-through readers. In addition
to being user-friendly, the use of keylines and frames adds to the ad hoc feel,
each compartment reminding us of the many chapters and people that make
up the core of the organization.

Photo Jungle

Says Klotnia, "The tricky thing about images for this report was the number
of different photographic styles we had to deal with. To reduce this visual
smorgasbord, we ran photos small, balancing them with larger illustrations."

A particularly engaging spread (opposite page, top) features the front and
back of a trout—on opposite pages; this is a fun design trick that hints at
activity beyond the page, as if the annual report is actually in the middle of a
school of fish. The reuse of different parts of the same illustration is a budget-
conscious choice.

In 1995, the Society reached out to wolves, caribou, and bears, as well as the big animals of the open oceans. Among other initiatives, Audubon supported the reintroduction of the Mexican wolf to the Southwest and chapters also pushed to bring back wolves to Yellowstone. In the Northwest, the Society led the fight to save the coho salmon.

[WILDLIFE IN A YEAR OF TURMOIL]

In 1995 efforts to protect wildlife took a turn for the worse. The new Congress, acting on the Contract With America, took aim at several conservation laws long thought to be inviolate. Some members went so far as to propose redefining the use of the National Wildlife Refuge System. The House and Senate used appropriations acts in an attempt to open the Arctic National Wildlife Refuge to increased mining. Meanwhile, a budget bill contained a rider that allowed salvage logging in national forests and suspended the enforcement of wildlife laws.

[VOLUNTEERS MONITOR BIRDS]

Yes, Audubon loves birds—as it has from its beginnings. During the past year, as funding for government resource agencies has been severely cut back, the Society has moved a long way toward restoring its reputation as the most influential private organization in American ornithology. "Protection of migratory birds and their habitats is one of National Audubon's highest priorities," says president John Flicker, pointing out that the Society's ambitious new project, Important Bird Areas (IBA)—which will ultimately involve chapters across the country—will enlist thousands of volunteers to carry out that mission.

[FLAMINGOWATCH]

In February 1995, millions of American television viewers and thousands of students became armchair travelers transported live to the African continent. From their homes and classrooms they became eyewitnesses to what has been called "the greatest bird spectacle on earth"—the annual gathering of millions of greater and lesser flamingos in Kenya's Rift Valley.

A Look Beneath the Surface:

Center for Marine Conservation

1996 Annual Report

The Center for Marine Conservation is a nonprofit organization dedicated to the preservation of marine wildlife and habitats.

TRIM SIZE is 8 1/2" x 11" (22 cm x 28 cm)

THIRTY-PAGE, FOUR-COLOR ANNUAL REPORT

Mohawk Options and Foxriver Quest STOCK

BODY FONTS INCLUDE Garamond, Avant Garde

CIRCULATION: 3,000

LAYOUT PROGRAM: QuarkXPress

HARDWARE: Macintosh

ART DIRECTOR/DESIGNER: Rex Peteet, Mark Brinkman of Sibley Peteet Design, in association with GSD&M advertising. Both are based in Austin, Texas.

That Undersea Connection

Says designer Mark Brinkman, "Since this piece is used mainly to support and promote legislation, we needed to pack in a lot of information." It also had to offer something other than spreadsheets and scare tactics; the Marine Conservation annual needed to remind senators and House representatives about the beauty, fragility, and potential of the world's oceans.

To achieve these goals, Peteet came up with a strong theme, the idea of "looking beneath the surface." One of the most pleasing design elements that relates to this theme is the use of bound-in shortsheets that, when flipped, reveal hidden pictures. Each boasts its own reverse-line illustration of a mechanical milestone in the history of undersea exploration. Brinkman notes that these simplistic images add balance to the activity of the rest of the design and are fast and simple to create.

A Template Less Ordinary

This template is unusual in that it falls into four equal quadrants. The two upper quadrants are reserved for body copy, the inside lower quadrant for graphs, and the outside lower for a secondary story.

Those Sophisticated Extras

A wonderful demonstration of the theme appears in the opening spread (opposite page, top right). A sheet of vellum overlays a fantastic shot of a coral reef. As Peteet says, this literally suggests the act of looking beneath the surface. "As you turn back the vellum flysheet, or implied surface, you reveal the wonderful coral reef and all of the colorful life found there."

Opposite this effect, on the inside front cover, is a beautiful varnish treatment. Culled from a book of Asian patterns, this repeating design looks like waves and ripples, but the black background implies the mysteries of the abyss.

Let Your Photos Do the Talking

Unless hidden under a shortsheet, photos in this annual cover an entire page or spread, allowing the ocean and its inhabitants to sweep the reader away. Running photos large was the easy part; actually obtaining rights for the images was the tricky part. Says designer Mark Brinkman, "Since most of the images we used were taken by *National Geographic* photographers, we literally had to chase them around the world to get clearances and OKs. It was definitely our single biggest challenge."

Pollution Prevention: Bringing the Ocean to Your Front Door

Biological Diversity: Mysteries of the Deepest Realm

National Fish and Wildlife Foundation

1996 Annual Report

From the annual: "The National Fish and Wildlife Foundation is a nonprofit organization dedicated to the conservation of fish, wildlife, and plants and the habitats on which they depend. Among its goals are species habitat protection, environmental education, public policy development, natural resource management, habitat and ecosystem rehabilitation and restoration, and leadership training for conservation professionals."

TRIM SIZE is 8 1/2" x 11" (22 cm x 28 cm)

SIXTY-EIGHT PAGE, FOUR-COLOR ANNUAL REPORT

Quantum Opaque 70 lb (105 gsm) Smooth TEXT STOCK (donated by Georgia-Pacific); Champion International Corporation's Krome Kote C1S, 10 pt. COVER STOCK

ITC Fenice BODY FONT

CIRCULATION: 10,000

LAYOUT PROGRAM: QuarkXPress

HARDWARE: Macintosh

EDITOR: Jenny Pihonak, Sadhya Hall, the National Fish and Wildlife Foundation, Washington, D.C. DESIGN: Annemarie Feld, Feld Design, Alexandria, Virginia.

PHOTO EDITOR: Susan P. Bournique.

National

Fish and Wildlife

Foundation

1996 ANNUAL REPORT

Lots of Sections? Better Get Visually Organized

"There are so many sections in this book," says designer Annemarie Feld, "that I needed an original way to distinguish them." Beginning with the cover itself (left), Feld based her organizational system on illustrations. Traditionally the NFWF uses original work for its covers, and the 1996 annual was no exception. The editorial staff provided Feld with a photo of "Granite Passage" from the William Farley collection (Chicago). Feld noted the strong colors and inherent design elements of the painting and used them to her advantage.

"Granite Passage" is used as the central cover image over a woodcut background, while various sections of the painting serve as table of contents icons and headers for the four chapters covering NFWF operation. Within these chapters, Feld reuses elements from the cover art on a large scale to create pleasing compositions.

In keeping with the wild, natural feel of former publications, Feld used woodcut clip-art icons to fill out the remainder of the table of contents and chapter illustrations.

Don't Box Me In

Instead of separating copy with boxes, Feld keeps the design open—and ultimately, more readable—by using dotted rules to separate copy elements. Note the use of a black dot at the end of each rule (opposite page, middle right), helping to further define the beginning and ending of a particular concept.

The Art of Charts

Charts in the NFWF annual are as colorful and inviting as the rest of the report. Says Feld, "I wanted them to look a little bit painterly, to go with the cover. They even have uneven edges. I guess I could have made them more complicated, but there's so much going on in this report already, I thought anything more would be distracting."

More Copy? More Columns!

Says Feld, "I had a lot of copy to fit so I needed something really flexible. I tried several different layouts before I decided to go with five columns." In practice, she often used the fifth column for graphics or pull quotes. This approach helps draw readers into an otherwise dense page. Note the fun use of paw prints in the fifth column of the right hand page in the spread for the "Save the Tiger Fund" (opposite page, top right).

Spice It Up

Feld creates interesting frames for images that bleed off the page. Because these geometrical shapes are based on the column grid, they retain the internal sense of the document. They also add additional interest without taking up too much valuable copy space.

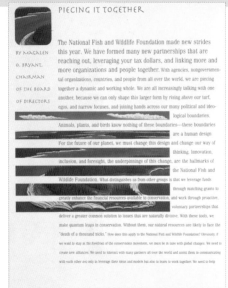

PIECING IT TOGETHER

BY MAGALEN O. BRYANT, CHAIRMAN OF THE BOARD OF DIRECTORS

The National Fish and Wildlife Foundation made new strides this year. We have formed many new partnerships that are reaching out, leveraging your tax dollars, and linking more and more organizations and people together. With agencies, nongovernmental organizations, countries, and people from all over the world, we are piecing together a dynamic and working whole. We are all increasingly talking with one another, because we can only shape this larger form by rising above our turf, egos, and narrow focuses, and joining hands across our many political and ideological boundaries.

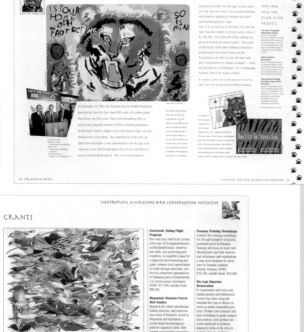

SAVE THE TIGER FUND

WILDLIFE AND HABITAT MANAGEMENT INITIATIVE

DONORS

GRANTS

NEOTROPICAL MIGRATORY BIRD CONSERVATION INITIATIVE

GRANTS

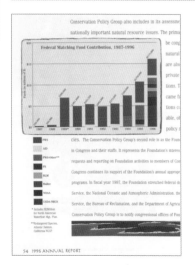

Federal Matching Fund Contribution, 1987-1996

54 1996 ANNUAL REPORT

Conservation International:

The First Decade 1987–1997

From the annual: "Conservation International believes that the Earth's natural heritage must be maintained if future generations are to thrive spiritually, culturally, and economically. Our mission is to conserve the Earth's living heritage, our global biodiversity, and to demonstrate that human societies are able to live harmoniously with nature."

TRIM SIZE is 9" x 13" (23 cm x 33 cm)

SEVENTY-SIX PAGE, FOUR-COLOR-AND-SPOT-COLOR ANNUAL REPORT

Warren Strobe Dull TEXT STOCK

BODY FONTS INCLUDE Today, Baskerville

LAYOUT PROGRAM: QuarkXPress

HARDWARE: Macintosh

DESIGN: Jeffrey S. Fabian, Scott Rier, and Samuel G. Shelton of Kinetik Communication Graphics Inc., based in Washington D.C. PUBLICATIONS DIRECTOR/PROJECT MANAGER: Robin Bell of Conservation International, also headquartered in Washington D.C.

You Can Judge a Book By Its Cover

The cover of *The First Decade* (left) embodies the goals of the organization itself—to protect, enhance, and enlighten. A tree frog is pictured in green duotone. One eye is revealed in stunning color through a die-cut window. When the gate-fold cover is opened, the reader finds two red-eyed tree frogs atop a heliconia flower. In a sense, the gate-fold cover protects the image inside. Since the main cover is created in green only, the reader's perception of "frog" is enhanced upon opening. (In other words, frogs aren't just green.) And, since frog populations are a major indicator of the health of a particular environment, the use of a frog as a symbol for the organization as a whole is apropos and, of course . . . enlightening.

The Setup

"The board wanted *The First Decade* to be a piece that people could hold onto," explains Sam Shelton. "They didn't want it to be a textbook, but they did want to include a series of essays that would serve as a heavy-duty resource guide for members and potential donors."

Worried that the long essays might appear "overwhelming" to readers, Kinetik opted to go with an unusual template. "The idea to create an oversized book was based on the fact we were going to have a great deal of body copy. Even in 8 1/2" x 11" (22 cm x 28 cm), that much text would make the book seem squatty. The longer page allows for a thinner copy column with open leading." Kinetik used outside columns for sidebar information, maps, graphs, and longer-than-average photo captions. This addition provides flip-through readers with ample information concerning the organization, its goals, and its many accomplishments. To make the book even more reader-friendly, the design and client team broke the copy into four categories—science, economics, policy, and awareness. A glance at the graphic on the bottom of each page tells readers which section he or she is in. On a sophisticated design note, check out the use of thin rules dividing body copy and sidebars and framing the outside edge of photos (opposite page, bottom).

Digital Dollars

The cost to print an extraordinary annual report can be astronomical—in both hard dollars and cost to the environment. To cut down on both, this publication went "direct-to-plate," a digital process that eliminates the need for film and the paper and chemicals involved in producing matchprints.

The vast wilderness of the island of New Guinea is home to many and varied groups of traditional people, like the Huli Wigmen, right. The cultural diversity of their forest communities is reflected in the number of languages – more than 875 – spoken in the country. Protecting the cultural heritage of forest peoples is an integral part of protecting the ecosystems they inhabit.

CI's Top Global Priority Hotspots

The Tropical Andes
Madagascar
Brazil's Atlantic forest region
The Philippines
Meso-American forests
Wallacea (eastern Indonesia)
Western Sunda (Indonesia, Malaysia and Brunei)
South Africa's Cape floristic region
The Antilles
Brazil's Cerrado
The Darien and Choco of Panama, Colombia, and western Ecuador
Polynesia and Micronesia island complex, including Hawaii
Southwestern Australia
The Mediterranean region
Western Ghats of India and the island of Sri Lanka
New Caledonia
The Guinean forests of West Africa
Southwestern Australia and Tasmania
Eastern Himalayas

Wilderness Areas

The southern Guianas, southern Venezuela and extreme northern Brazilian Amazon
Upper Amazonia
The Zaire River, Central Africa
New Guinea and nearby islands of Melanesia

conservation organization, articulated both our rationale for working in hotspot areas and the specific activities (science, economics, policy, communications, protected area management) needed to achieve our conservation objectives.

In the past few years, the hotspots approach has gained currency at a global level, and has received attention from other international organizations. This renewed emphasis on hotspots stimulated us to review the hotspots concept, which we did in a workshop held at the CI offices in March 1996. The purpose of this workshop was to reassess the hotspots concept, reaffirm its validity, add or subtract areas as appropriate, and come up with a series of defensible criteria for what constitutes a hotspot. The results were very exciting. Our new analysis indicated that there are some 19 top-priority hotspots, occupying less than 2 percent of the land surface of the planet (see map, pp. 65-67) but harboring 30-40 percent of all known terrestrial species as endemics (found in one area and nowhere else), more than 50 percent of total terrestrial species diversity and roughly two-thirds to three-quarters of the most endangered species of plants and animals. We also identified a second tier of ten slightly less diverse but critically important areas that highlight still further the importance of these hotspots. Included in the second tier are the California Floristic Province (covering most of the state of California), Indochina, the Eastern Arc Mountains of Tanzania, and New Zealand. In any case, the original message echoed loud and clear. A very large percentage (50+ percent) of global terrestrial biodiversity can be protected in a very small percentage (about 2 percent) of Earth's real estate, reinforcing the relevance of CI's original strategic focus on hotspots and reaffirming its validity as our positioning strategy for our second decade and the next millennium.

It is important to note that the CI hotspots emphasize terrestrial ecosystems with some significant inclusion of freshwater aquatic systems and, in some cases, associated coastal marine systems. However, similar hotspots analyses are needed for the freshwater and marine realms so that they are not underemphasized. In fact, our new marine program plans such an analysis for next year, and a freshwater hotspots analysis is under discussion with experts.

It is also important to mention our other priority-setting strategy – major tropical wilderness areas, a concept that we developed in 1988 and 1989 to complement the hotspots approach. The major tropical wilderness areas approach (referred to in Myers' 1988 paper as "good news" areas) again emphasizes high-biodiversity tropical systems, but focuses on the

Conservation International

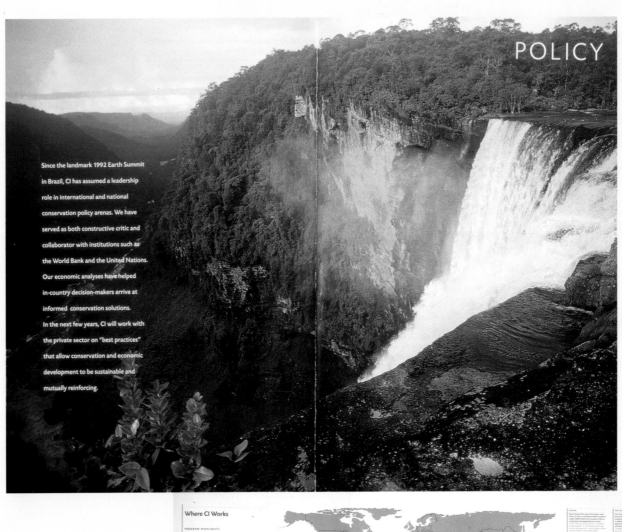

POLICY

Since the landmark 1992 Earth Summit in Brazil, CI has assumed a leadership role in international and national conservation policy arenas. We have served as both constructive critic and collaborator with institutions such as the World Bank and the United Nations. Our economic analyses have helped in-country decision-makers arrive at informed conservation solutions. In the next few years, CI will work with the private sector on "best practices" that allow conservation and economic development to be sustainable and mutually reinforcing.

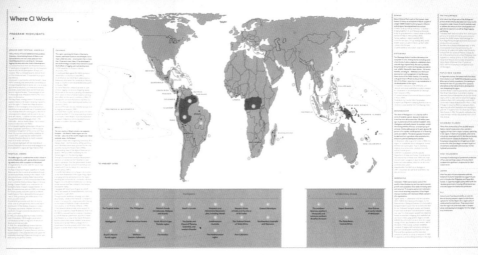

World • Watch

Published by the Worldwatch Institute, World•Watch "tracks key indicators of the Earth's well-being" and is dedicated to providing "policymakers, educators, researchers, reporters, and concerned individuals with the information they need to make decisions that will lead to a sustainable economy."

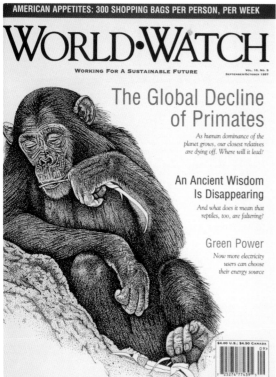

TRIM SIZE is 8 1/2" x 11" (22 cm x 28 cm)
FORTY-FOUR-PAGE BIMONTHLY
Galliard BODY FONT
CIRCULATION: 80,000
EDITOR: Ed Ayres. DESIGN: Elizabeth Doherty. Both are staff members of the Worldwatch Institute based in Washington, D.C.

It is important that the design of a publication reflect the mission it professes. The *World•Watch* template certainly does, but not through the use of color photos as one might expect. There are no horrifying shots of starving youths or slaughtered animals here. Breathtaking illustrations of the world's beauty play a much stronger role. Pen-and-ink drawings laid out with clean sans serif headlines pull the reader into feature spreads, gently reminding them of the real color that will be lost if the world is not properly nurtured.

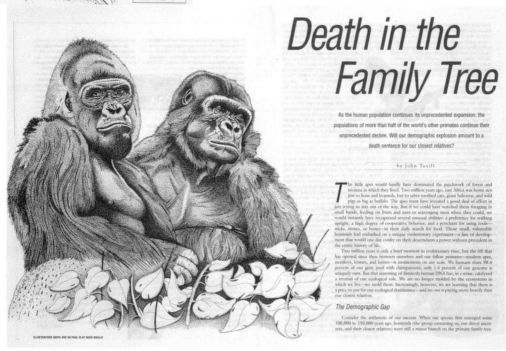

The HomeFront

The newsletter for the San Diego Housing Commission details work of the board and volunteers to provide an "affordable home for every San Diegan."

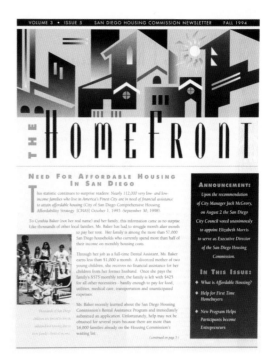

TRIM SIZE is 8 1/2" x 11" (22 cm x 28 cm)

TWELVE-PAGE QUARTERLY

Galliard BODY FONT

EDITOR: Deborah Miller, Community Relations Officer of the San Diego Housing Commission. DESIGN: Roxanne Barnes, Roxanne Barnes Creative Services, based in San Diego, California.

This two-color, budget-friendly publication looks sophisticated and official due to the use of small, clean images and a layout that alternates between one wide column and three narrow ones. For a newsletter dealing with such a serious subject, this is very appropriate. However, designer Roxanne Barnes achieves a warm feel through her choice of graphics. Notice how the cover flag illustration—a stylized neighborhood—is used as a motif throughout and how pictures of new homes are screened back behind copy.

HOUSING TOPIC OF CITY HEIGHTS SUMMIT

by Jim Varnadore

Nearly 200 residents, business and community leaders and government officials set aside a weekend last spring to meet at Wilson Academy to discuss and write a plan that could help reduce crime and improve the economic conditions in City Heights. Housing was a very hot topic.

I was a member of the Housing Issues Team which was comprised of City Heights residents, housing advocates, planners, San Diego Housing Commission and City staff. This team was formed to tackle very important housing issues. In all, the Team discussed ownership, management, the actual condition of buildings in City Heights, area zoning and code compliance regulations, financing, and other issues which were believed to in some way affect the City Heights housing stock.

The Team wrote several suggestions which we believed would help to improve housing in the City Heights area. Among those recommendations was the advocating of more owner-occupied homes in City Heights, more rehabilitation of existing homes, and a moratorium on new multi-unit construction. We strongly believe that this would improve stability and the sense of community in the area.

The Team also recommended improvements in the availability of support services like clinics, dentists, banking, insurance, postal, library, parks, etc. for the commnity. These will enhance the quality of life and attract good residents. Finally, the Team suggested setting up courses in good management for owners and managers, and other courses for residents to help them understand their role in improving life in City Heights. Using both courses would help managers select and retain good residents and expand the pool of good renters. The Team sees this as a win-win approach.

A one-day follow-up meeting of the larger group was held in July. Recommendations from all teams, including Housing, are being presented to the wider City Heights community and to the City Council for their input and review. Then a detailed plan will be written and used as the basis for a City Heights improvement program.

I was pleased to be a part of this process, and strongly feel that if implemented, these recommendations could help restore City Heights to the beautiful, community oriented neighborhood it once was.

Jim Varnadore is a housing advocate who is currently serving as a member of the Housing Trust Fund Board of Directors.

6

HOMEOWNERSHIP PROGRAM EXPANDED

by Carolyn Smith, Executive Director, SEDC

Until recently, there were so few new affordable single family homes developed in the Southeastern area of San Diego that anyone desiring to purchase a new home was forced to look at other communities. Well, I am very happy to report that this is no longer the case. As a result of a "mini building boom," homebuyers seeking to purchase new homes in the Southeastern area of our City now have several new developments to consider.

Additionally, through a collaborative effort between the Southeastern Economic Development Corporation (SEDC) and the San Diego Housing Commission, 30 lucky families will receive financial assistance to purchase their "dream" home in the Southcrest, Mt. Hope or Lincoln Park communities.

Combined, three new single family home developments will provide more than 100 new homes with sales prices between $104,900 and $159,000, very affordable for many first-time buyers.

To support the project, the San Diego City Council, sitting as the Redevelopment Agency, voted on Tuesday May 17 to set aside a total of $450,000 in SEDC funds to provide buyers with silent second loans.

The San Diego Housing Commission will provide assistance in the form of Mortgage Credit Certificates (MCCs) provide an income tax credit to homebuyers and its Buyers Assistance Program which can provide buyers with downpayment assistance.

Recognizing that this project cannot be successful if community residents are not aware of the opportunity, SEDC and the San Diego Housing Commission have developed a comprehensive marketing plan to educate the community. The first event was a homebuyers workshop held at the Neighborhood House Association on Saturday, June 25. This workshop entitled "The ABCs of Homeownership," was co-sponsored by Jensen Mortgage, American Savings Bank, Wells Fargo Bank, the Neighborhood Housing Association, and the San Diego Home Loan Counseling Service. More than sixty potential homebuyers who reside in the community came out to learn how they could access the American Dream of homeownership.

Other marketing efforts include community forums, homebuying counseling seminars, and informative articles in community newspapers.

We at SEDC are very excited about this project and look forward to working with the San Diego Housing Commission and others to help families unlock the door to the home of their dreams.

Carolyn Smith in her office at SEDC

Sharing News

Sharing News is published by Earth Share, a federation of nonprofit organizations dedicated to saving the environment through education and employee giving campaigns.

TRIM SIZE is 8 1/2" x 11" (22 cm x 28 cm)
SIX-PANEL GATEFOLD
Garamond BODY FONT
CIRCULATION: 30,000
EDITOR: Renny Perdue, Earth Share Executive Vice President, based at the headquarters in Washington, D.C. WRITERS: Vanguard Communications, freelance to Earth Share. DESIGN: Hirshorn-Zuckerman Design Group, also freelance.

Never knock a design that is straightforward, easy to read, clean, and inexpensive. This publication opens up to a three-page, six-column spread packed with information, but the use of small clip art, icons, and bullet points make the short paragraphs easy to see and in fact, inviting. This layout, along with a few well-chosen, diverse photos, makes it fun to glance around the page, quickly checking areas of interest.

g a l l e r y

Environmental Law Institute
1996 Annual Report

From the annual: "The Environmental Law Institute advances environmental protection by improving law, policy, and management. ELI researches pressing problems, educates professionals and citizens about the nature of these issues, and convenes all sectors in forging effective solutions."

TRIM SIZE is 8 1/2" x 11" (22 cm x 28 cm)
FORTY-FOUR-PAGE, BLACK-AND-WHITE ANNUAL REPORT
BEMBO BODY FONT
CIRCULATION: 5,000
EDITOR AND PROJECT MANAGER: Stephen R. Dujack, director of communi-
 cations for the Environmental Law Institute, based in Washington D.C.
 DESIGN: CartaGraphics Inc. of Sarasota, Florida.

This clean, economical report has a three-column template. The two outside columns often combine to create framed sidebar information. The outside column is also used for sans serif headlines and statistics.

Continuity is further implemented through the use of black and white images by the same photographer, artist Bruce Barnbaum, a protégé of Ansel Adams. This spread, featuring a live oak forest on Sapelo Island in Georgia, is complemented by Gill Sans in a justified block of type. Note the use of dingbats to separate paragraphs.

**ENVIRONMENTAL LAW INSTITUTE
ANNUAL REPORT 1996**

Live Oak Forest, Sapelo Island, Georgia

THE ENVIRONMENTAL PROFESSION
is the key to making environmental law work. Since its founding a quarter century ago, the Environmental Law Institute has seen improving the professionalism of this corps of attorneys, managers, and policy makers as critical to achieving society's goals for improving the health of the biosphere and its inhabitants. ❦ The challenge in environmental protection is as much in evolving effective means of reaching goals as in the setting of them. Both the formulation of policy and its execution require an environmental profession that is capable of advancing a field that is as complex in its interrelationships as the ecosystem it addresses. ❦ ELI builds professional expertise through its educational programs and its publications. ELI fosters professional dialogue by serving as a convening forum for all sectors. ELI enhances professional ethics by working with practitioners to promote the highest standards of practice, and concern for the health of the biosphere and its inhabitants. And ELI is building a global partnership among professionals to help realize the vision of sustainable development.

Environmental Defense Fund
1996–1997 Annual Report

This 300,000-member nonprofit works to build bipartisan support for environmental recovery by enlisting scientists, economists, lawyers, and public activists.

TRIM SIZE is 8 1/2" x 11" (22 cm x 28 cm)
TWENTY-FOUR-PAGE, FOUR-COLOR ANNUAL REPORT
BODY FONTS include Garamond and Gill Sans
CIRCULATION: 37,500
EDITOR: Joel Plagenz, Environmental Defense Fund director of public affairs, located in New York, New York. DESIGN: Lazin & Katalan, also based in New York.

With the exception of a spectacular four-color cover, this annual report was run in three colors throughout. But three colors seem like four because they run on white 100% post-consumer recycled paper with a tan wash. The template is a strict, tight grid that repeats on every page. The advantage here is savings in design time. The uniformity is broken by a variety of black-and-white photos, some smiling people, and interesting shots of nature habitats. Note the use of gradient blends.

ATTORNEY CHRISTINE SHAVER

When Christine Shaver was at the National Park Service, working to preserve the clean air of the Colorado Plateau, she took her daughters to see the Grand Canyon. They arrived to find a polluted haze hanging in the Canyon, obscuring the grand vistas. "Mom," she remembers her five-year-old saying, "I don't know how to tell you this, but you're not doing a very good job." Today the air is clearer over the Western national parks, thanks in part to Shaver's continued work there.

CIUDAD JUAREZ, MEXICO

With the adoption of EDF's international air quality management plan, businesses in El Paso, Texas, will have an incentive to invest in reducing pollution at facilities such as this brick kiln across the border in Ciudad Juarez, Chihuahua.

Also the capacity of New England's overfished fishing fleet will be reduced gradually. The Federal government will support a vessel buy-out and retirement program and, at EDF's urging, will monitor the program to help insure that other vessels do not replace those removed.

Overfishing also imperils salmon in Washington, Oregon, and California. For the last several years, the Pacific Fisheries Management Council has instituted catch restrictions recommended by EDF and others for highly depleted salmon stocks. EDF is also working to protect and restore two ecosystems that once harbored spectacular runs of salmon, the San Francisco Bay-Delta and the Columbia River Basin, by negotiating water transfers that will help restore natural stream flows.

To save albatrosses, petrels, and shearwaters that are being hooked and drowned when they go after bait on deep-sea fishing lines, EDF and Defenders of Wildlife crafted a policy that could eliminate the unnecessary killing of up to 180,000 seabirds a year. It calls for modified fishing techniques such as the use of more heavily weighted lines that quickly sink the bait out of reach of the birds. The policy was adopted by the International Union for the Conservation of Nature, and a U.S. North Pacific fishermen's association has pledged to use many of the recommended techniques.

With natural fish stocks in trouble, marine aquaculture or "fish farming" is growing rapidly here and abroad. EDF helped organize one of the first international meetings on the troubling environmental impacts of shrimp farming. Shrimp farms can pollute nearby waters and contribute to the destruction of coastal mangrove forests, which are essential habitat for many marine species. EDF is working to ensure that aquaculture develops in ways that do not harm the environment.

CLEARING THE AIR

Too many people breathe unhealthful air, and greenhouse gases tied to global warming continue to build up in the Earth's atmosphere. EDF's Global and Regional Atmosphere program works to reduce emissions, especially from burning fossil fuels, that cause both local and global problems.

A decade ago, an EDF study in Science first proved that sulfur pollution from smokestacks could travel long distances to cause acid rain; this prompted region-wide control of sulfur emissions. Scientists now view the urban smog problem as regional, too, with nitrogen oxides – the major precursors of smog – traveling from sources up to hundreds of miles away. Based on this information, EDF has developed a clean air plan to cut nitrogen oxide emissions throughout the 37-state region east of the Rockies.

Clean air and visibility in the national parks and wilderness areas of the Colorado Plateau will be protected under an agreement adopted this year by Western governors, tribal leaders, and Federal officials. The plan, which EDF helped design, will reduce and then permanently cap total emissions from mobile and industrial sources.

Severe air pollution in the Paso del Norte region around El Paso, Texas, and Ciudad Juarez, Mexico, will be addressed under an EDF proposal adopted this year by U.S. and Mexican officials. Because the two cities share a common airshed, El Paso businesses

ATTORNEY KARL RÁBAGO

Without a doubt, Karl R. Rábago is the only person at EDF qualified to drive a tank. He learned this and other battle skills as a cavalry platoon leader in the U.S. Army. As part of its judge advocates program the Army sent the young Texan to law school. After teaching law at West Point and the University of Houston, Rábago served as a public utility commissioner in Texas and deputy assistant secretary in the U.S. Department of Energy before joining EDF. In his spare time he makes his home more energy efficient – adding double-pane windows, sealing air leaks, and installing efficient lighting.

DAVIS, TEXAS

EDF is encouraging Texas electric companies to provide more power from clean, renewable energy sources. Texas consumers show a clear preference for renewables such as the wind power that this West Texas facility produces.

will be allowed to meet some of their Clean Air Act obligations by investing in measures to reduce pollution in Juarez, where many more cost-effective opportunities are available.

EDF is playing a leading role in international policy on global warming. When more than 100 countries gathered this year to sign the Geneva Declaration on Climate Change, EDF, in alliance with other groups, helped strengthen the U.S. stand in the negotiations and successfully pressed other nations to follow the U.S. lead. The signers agreed to adopt, by December 1997, legally binding commitments to reduce their greenhouse gas emissions.

Population policies could play a key role in meeting targets for greenhouse gas reductions, according to research by EDF scientists and The Population Council. A joint study this year quantified the relationship between carbon dioxide emissions and population growth.

EDF has also sought to dramatize – for both decision makers and the general public – the serious problems that could be caused by climate change. A traveling exhibition on global warming, developed by EDF and the American Museum of Natural History, has been seen by nearly two million people. The exhibition is now at Columbia University's Biosphere 2 Center near Tucson, Arizona.

CLEAN ENERGY FOR OUR FUTURE

Producing energy for homes, businesses, and industry has major environmental impacts. EDF's Energy program works to reduce pollution from energy use.

In several states, electric utilities are being deregulated. Just as

with long distance phone service, consumers may be offered choices. EDF participated in polls commissioned by Texas utilities which showed that customers strongly prefer energy efficiency and renewable energy sources, such as wind and solar power.

In California, EDF was heavily involved in a three-year negotiation on electric utility deregulation. The resulting law is a victory for the environment, providing $400 million to promote clean, renewable technologies in the new competition among electric power providers.

Although air pollution is the most obvious environmental impact of producing electricity, hydropower dams can also have serious consequences. At Arizona's Glen Canyon Dam, heavy releases of water over the dam to meet the daily peak demand for power – coupled with low flows the rest of the day – had devastated beaches and other wildlife habitats along the Colorado River in the Grand Canyon. EDF computer analysis showed how the dam could operate on a more natural schedule of water releases with little effect on electricity users. The Bureau of Reclamation used EDF's model to simulate a natural spring flood and alter the daily flow across the dam, actions that have already helped rebuild what had been destroyed.

In China, where demand for electricity is growing at ten percent a year, more and more coal has been burned to meet the need – in a country that already has seven of the ten most polluted cities on Earth. This year EDF led an intensive training program for managers from 30 Chinese electric utilities, sharing the analytic tools that EDF has used elsewhere to promote cleaner alternatives to coal. The EDF analytic model, Elfin, was

g a l l e r y

African Wildlife Foundation
1996 Annual Report

From the Annual Report: "The African Wildlife Foundation is an international organization that protects natural resources in collaboration with partners in Africa and supporters worldwide." 1996 marked the organization's thirty-fifth anniversary.

TRIM SIZE is 8 1/2" x 11" (22 cm x 28 cm)
TWENTY-FOUR-PAGE ANNUAL REPORT, BLACK-AND-WHITE with ONE SPOT COLOR
 varying in different signatures
Goudy Old Style BODY FONT
CIRCULATION: 5,000
EDITORIAL: Rebecca Villarreal and Julie Vermillion of the African Wildlife Foundation
 and Crowley Communications, also located in Washington DC. DESIGN: The
 Magazine Group, based in Washington D.C. Selected photographs by Art Wolfe.

The African Wildlife Foundation annual report boasts three natural colors—black, rust, and teal. Photos are tinted in either blue or brown, and borders are made up of both. This opening spread, featuring a herd of gazelle, is particularly appealing. Note how the drop cap and a photo of an elephant combine to make a graphic treatment. This drop cap is used throughout the book as an icon for programs.

I/ N/ D/ E/ X

D/ I/ R/ E/ C/ T/ O/ R/ Y

THE PAGES
Cheryl J. Family
Creative Director, Editorial
MTV Networks
(A Viacom Company)
1515 Broadway
New York, NY 10036-5797
212-258-7690

NATPE MONTHLY
Beth Braen
Vice President Creative Services
National Association of
Television Program Executives
2425 Olympic Blvd., Ste. 550E
Santa Monica, CA 90404
310-453-4440

Dog Ear Design
1313 Foothill Blvd., Ste. 6
La Canada, CA 91011
818-790-2268

OCULUS
Pentagram Design, Inc.
204 Fifth Avenue
New York, NY 10010
(212) 683-7000
info@pentagram.com

CHRISTIE'S ART AUCTION NEWS
Christie's Publications
21-24 44th Avenue
Long Island City, NY 11101
718-784-1480

CALARTS CURRENT
CALARTS COURSE CATALOG
Office of Public Affairs
Annita Bonnel, Director
Christopher Meeks, Editor
California Institute of the Arts
24700 McBean Parkway
Valencia, CA 91355-2397

ReVerb
5514 Wilshire Blvd., 9th Fl.
Los Angeles, CA 90036
213-954-4370

NEW PACIFIC WRITING
Editorial Office
University of Hawai'i
English Department
Honolulu, HI 96822

THE GREEN STICKER VEHICLE
Off-Highway Motor Vehicle
Recreation
P.O. Box 942896
Sacramento, CA 94296-0001
916-324-4442

Jim Molina
Senior Graphic Designer,
Contract Graphics
University Media Services
California State University
6000 J. Street
Sacramento, CA 95819-6047

RIDE INC. 1996 ANNUAL REPORT
VSA Partners, Inc.
542 South Dearborn, Ste. 202
Chicago, IL 60605
312-427-6413

COMPASS
Cheryl Mikkelborg
Corporate Communications
Administrator
6750 South 228th St.
Kent, WA 98032
253-395-4692

HARLEY-DAVIDSON INC.
1996 ANNUAL REPORT
VSA Partners, Inc.
542 South Dearborn, Ste. 202
Chicago, IL 60605
312-427-6413

PRINCESS CRUISES
Editor: Julie Benson
Designer: Lisa Juarez
Princess Cruises
10100 Santa Monica Blvd.
Los Angeles, CA 90067-4189
310-553-6330

RANCHO LA PUERTA TIDINGS
Laurie Mansfield Dietter
Graphic Designer
3561 Sydney Place
San Diego, CA 92116

Golden Door/Rancho La Puerta
P.O. Box 463057
Escondido, CA 92046
760-744-6677

ISLAND ESCAPES
Islands: An International Magazine
3886 State St.
Santa Barbara, CA 93105
805-682-7177

FOOTPRINTS
Adventure 16, Incorporated
4620 Alvarado Canyon Rd.
San Diego, CA 92120
619-283-2362

Marjorie Taylor
Taylor Graphics
12407 Caminito Brioso
San Diego, CA 92131
619-530-2440

THE ART OF EATING
Edward Behr
P.O. Box 242
Peacham, VT 05862
802-592-3491

SOUTHERN CALIFORNIA GARDENER
Lili Singer, Editor
Southern California Gardener
P.O. Box 8072
Van Nuys, CA 91409-8072
310-396-3083

Siobhan Stofka
Siobhan Stofka Design
2041 N. Commonwealth, #106
Los Angeles, CA 90027
213-662-7936

PASSAGES
Magellan's
110 W. Sola St.
Santa Barbera, CA 93101
805-568-5400

John Balint
Balint & Reinecke
6 St. Francis Way
Santa Barbara, CA 93105
805-687-3043

SOUTH TEXAS COLLEGE OF LAW
1996 ANNUAL REPORT
Geer Design, Inc.
2518 Drexel Dr., Ste. 201
Houston, TX 77027
713-960-0808

WINDOW ON WHEELER
Laurie A. Flynn
Director Publications &
Public Relations
The Wheeler School
216 Hope Street
Providence, RI 02906-2246
401-421-8100

Hess Design
49 Eliot St.
S. Natick, MA 01760
508-650-4063

Keating & Associates
67 Westwood Dr.
Shrewsbury, MA 01545
508-842-0543

MALOFILM COMMUNICATIONS
1996 ANNUAL REPORT
Belanger Legault
Communications Design
360 St-Jacques, Ste. 510
Montreal, Quebec
Canada
514-284-2323

IMAGINE: JACOR INC.
1996 ANNUAL REPORT
Petrick Design
828 North Wolcott Ave.
Chicago, IL 60622
773-486-2880

NORTHROP-GRUMMAN CORPORATION
1996 ANNUAL REPORT
Douglas Oliver Design Office
2054 Broadway
Santa Monica, CA 90404
310-453-3523

DATELINE NISSAN
Editor, Richard S. Christopher
Nissan Motor Corp. U.S.A.
18501 S. Figueroa
Gardena, CA 90248
310-771-5662

Randy Nickel
Nickel Advertising Design
34071 La Plaza, Ste. 140
Dana Point, CA 92629
714-661-0399

VISIONS
Saturn Corporation
100 Saturn Parkway
Sping Hill, TN 37174
615-486-5055

ACUSOUNDER
Chen Design Associates
650 Fifth Street, Ste. 508
San Francisco, CA 94107-1521
415-896-5338

Acuson Corporation
P.O. Box 7393
Mountain View, CA 94039
415-969-9112

ADAPTEC INC. 1996 ANNUAL REPORT
Cahan & Associates
818 Brannan St., #300
San Francisco, CA 94103
415-621-0915

CARN
Cecile L. Sorra/Editor
Lawrence Ragan Communications,
Inc.
212 W. Superior, Ste. 200
Chicago, IL 60610
312-867-3369

CONSERVATION
Jeffrey Levin
The Getty Conservation Institute
1200 Getty Center Dr., St. 700
Los Angeles, CA 90049-1684
410-440-7325

JOURNAL OF PROPERTY MANAGEMENT
Institute of Real Estate Management
430 N. Michigan Ave., 7th Fl.
Chicago, IL 60614
312-329-6000

CHICAGO VOLUNTEER LEGAL SERVICES
1996 ANNUAL REPORT
Tim Bruce
Froeter Design Co., Inc.
954 West Washington
Chicago, IL 60607
312-733-8895

PORTLAND BREWING COMPANY
1996 ANNUAL REPORT
Adam McIsaac
The Felt Hat
1231 NW Hoyt, No. 401
Portland, OR 97209
503-226-9170

THE WORLD OF KASHI
Karen Moyer
Kashi Company
P.O. Box 8557
La Jolla, CA 92038-8557
619-274-8870

OPERATIONS & SOURCING NEWS
Chen Design Associates
650 Fifth Street, Ste. 508
San Francisco, CA 94107-1521
415-896-5338

Levi Strauss & Co.
1155 Battery
San Francisco, CA 94511
415-501-6070

bLINK
Mike Brown
Editor
EarthLink Network
3100 New York Dr.
Pasadena, CA 91107
(626) 296-5821

CHOICES
Joseph Michael Essex
Essex Two
2210 W. North Ave.
Chicago, IL 60647
773-489-1400

URBAN SHOPPING CENTERS INC.
1996 ANNUAL REPORT
Joseph Michael Essex
Essex Two
2210 W. North Ave.
Chicago, IL 60647
773-489-1400

SCREEN ACTOR
Greg Krizman
Screen Actors Guild
5757 Wilshire Blvd.
Los Angeles, CA 90036
213-549-6652

Ray Ingle
The Ingle Group
11661 San Vicente Blvd., #709
Los Angeles, CA 90049
310-207-4410

CONTRAILS
Stephen Phillips
Bombardier
400 Cote Verta West
Dorval, Quebec H4S 1Y9
Canada
514-855-7412

Sonia Greteman
The Greteman Group
142 North Mosley
Wishita, KS 67202
The Greteman Group

H.J. HEINZ COMPANY
1996 ANNUAL REPORT
Debora S. Foster
H.J. Heinz Company
P.O. Box 57
Pittsburgh, PA 15230
412-456-5778

CALLAWAY'S GRAPEVINE
Beverly Stureman
Callaway Vineyard & Winery
32720 Rancho California Road
Temecula, CA 92589
909-676-4001

BIG BLUE BOX
Susan Edelman
Big Blue Dot LLC
63 Pleasant St.
Watertown, MA 02172
617-923-2583

NOVELLUS 1996 ANNUAL REPORT
Tim Larsen
Larsen Design + Interactive
7101 York Ave. South
Minneapolis, MN 55435
612-835-2271

STANT CORPORATION
1996 ANNUAL REPORT
Stant Corporation
425 Commerce Dr.
Richmond, IN 47374
765-962-6655

SAMATAMASON, INC.
101 South First Street
West Dundee, IL 60118
847-428-8600

SYDNEY'S KOALA CLUB NEWS
Karen Worley
Zoological Society of San Diego
P.O. Box 551
San Diego, CA 92112
619-231-1515

Roxanne Barnes
Roxanne Barnes Creative Services
2400 Keitner Blvd., #215
San Diego, CA 92101
619-544-1124

GERON
Cahan & Associates
818 Brannan St., #300
San Francisco, CA 94103
415-621-0915

CALMAT 1996 ANNUAL REPORT
Douglas Oliver Design Office
2054 Broadway
Santa Monica, CA 90404
310-453-3523

CITY OF HOPE 1996 ANNUAL REPORT
Sandra Levy
City of Hope
208 W. 8th Street
Los Angeles, CA 90014
213-892-7230

HEALTHWISE
Joseph Michael Essex
Essex Two
2210 W. North Ave.
Chicago, IL 60647
773-489-1400

FITNESS MATTERS
American Council on Exercise
5820 Oberlin Dr., Ste. 102
San Diego, CA 92121-3787
619-535-8227

STARLIGHT FOUNDATION
INTERNATIONAL 1995–1996
ANNUAL REPORT: THE SHINING STAR
Deann Hechinger
Marketing & Communications
Coordinator
Starlight Children's, Foundation
12424 Wilshire Blvd., Ste. 1050
Los Angeles, CA 90025
310-207-5558

Daniel Hoh & Associates
Temple Building
14 Franklin Street, Ste. 916
Rochester, NY 14604
716-232-2880

Josanne DeNatale
Cognitive Marketing, Inc.
46 Prince St.
Rochester, NY 14607
716-244-4140

ANTI-DEFAMATION LEAGUE
PACIFIC SOUTHWEST REGION
1996 ANNUAL REPORT
Jewish Anti-Defamation League
10495 Santa Monica Blvd.
Los Angeles, CA 90025
310-446-8000

LIVING BUDDHISM
Gary Murie, Art Director
SGI-USA
525 Wilshire Blvd.
Santa Monica, CA 90401

ST. JUDE MEDICAL INC.
1996 ANNUAL REPORT
Tim Larsen
Larsen Design + Interactive
7101 York Ave. South
Minneapolis, MN 55435
612-835-2271

HEARTPORT
Cahan & Associates
818 Brannan St., #300
San Francisco, CA 94103
415-621-0915

CREATIVE BIOMOLECULES
1996 ANNUAL REPORT
Thomas Laidlaw, Jr.
Weymouth Design, Inc.
332 Congress St.
Boston, MA
617-542-2647

ULTRAFEM 1996 ANNUAL REPORT
UltraFem, Inc.
805 Third Ave., 17th Fl.
New York, NY 10022
212-446-1400

Belk Mignogna Associates
373 Park Ave. South, 7th Fl.
New York, NY 10016
212-684-7060

NATIONAL AUDUBON SOCIETY
1995 ANNUAL REPORT
Pentagram Design, Inc.
204 Fifth Avenue
New York, NY 10010
(212) 683-7000
info@pentagram.com

CENTER FOR MARINE CONSERVATION
1996 ANNUAL REPORT
Mark Brinkman
Sibley Peteet Design
2905 San Gabriel, #300
Austin, TX 78705
512-473-2333

NATIONAL FISH & WILDLIFE
FOUNDATION 1996 ANNUAL REPORT
National Fish & Wildlife Foundation
1120 Connecticut Ave., NW, Ste.900
Washington, DC 20036
202-857-0166

Anne Marie Feld
Feld Design
4900 Leesburg Pick, Ste. 413
Alexandria, VA 22302
703-820-1616

CONSERVATION INTERNATIONAL:
THE FIRST DECADE 1987–1997
Samuel Shelton
Kinetik Communication
Graphics, Inc.
1604 17th St. NW, 2nd Fl.
Washington, DC 20009
202-797-0605

WORLD•WATCH
WorldWatch Institute
1776 Massachusetts Ave., NW
Washington, DC 20036
202-452-1999

THE HOMEFRONT
Roxanne Barnes
Roxanne Barnes Creative Services
2400 Keitner Blvd., #215
San Diego, CA 92101
619-544-1124

SHARING NEWS
Earth Share
3400 International Dr., NW, #2K
Washington, DC 20008
202-537-7100

Hirshorn Zuckerman
Design Group, Inc.
100 Park Ave., Ste. 250
Rockville, MD 20850
301-294-6302

ENVIRONMENTAL LAW INSTITUTE
1996 ANNUAL REPORT
Environmental Law Institute
1616 P. Street, NW, Ste. 200
Washington, DC 20036
202-939-3800

CartaGraphics, Inc.
P.O. Box 15392
Sarasota, FL 34277-1392
941-922-5331

ENVIRONMENTAL DEFENSE FUND
1997–1997 ANNUAL REPORT
Environmental Defense Fund
257 Park Ave., South
New York, NY 10010
212-505-2100

Lazin & Katalan
227 W. 17th St.
New York, NY 10011
212-242-7611
212-633-6941 (fax)

AFRICAN WILDLIFE FOUNDATION
1996 ANNUAL REPORT
African Wildlife Foundation
1400 16th St., NW #120
Washington, DC 20036
202-939-3337

The Magazine Group
1707 L. Street, NW, Ste. 350
Washington, DC 20036
202-331-7700
202-331-7311 (fax)